THE

ART OF REMBRANDT.

A Paper read before the Rembrandt Club,
January 5th, 1885.

BY PROFESSOR HENRY VAN INGEN,

Director of the Art School of Vassar College.

BROOKLYN:
PUBLISHED BY THE CLUB.
1885.

Mr. President, and Gentlemen of the Rembrandt Club:

THE name which you have chosen for your Club has readily suggested to me a theme for my remarks this evening.

The name of Rembrandt takes me back to my early home, and will lead me to say something concerning the art of Holland. After that the name of Brooklyn will easily recall us to America, and we shall for a few minutes consider the prospects of art in this country.

The Dutch Republic, after struggling for forty years against the armies of powerful Spain, had, by the signing of the truce of 1609, been recognized as an independent republic. After an unparalleled sacrifice of life and property, the Dutch people had established their right to a free worship of God and to a free political existence. Had it not been for the heroic resistance of Holland and Zeeland to the Spanish Inquisition, Protestantism in England, as well as on the continent of Europe, would have been crushed out of existence.

The spirit of freedom, inborn in the old Batavian, and respected even by the invading Roman, wrought wonders in the development of the country during this forty years' struggle. Throwing off the yoke of religious and political oppression, it branched out in every direction. A country small in itself and wrested from the sea, its resources were barely sufficient to support its inhabitants at any time. When it was opposed in deadly warfare to the greatest power of the time, its defenders made an ally of the element which until then had been their greatest enemy. Thousands of men, made homeless by the destroying Spanish armies, betook themselves to a life upon the sea. They traversed its surface in all directions, and waged such an effective warfare upon Spanish commerce as almost to destroy it.

The very settling of Brooklyn, or *Breukelen*, in 1636, was a result of the enterprise of these seafaring republicans, of the first free nation which established a chain of dependent colonies around the globe. By the middle of the 17th century, the Dutch Republic had become the first commercial nation in the world. Everywhere was prosperity, the result of industry. It is not strange that the birth of Dutch art and of Dutch freedom

should have been simultaneous. After two generations of continuous bloodshed, every man in Holland had secured for himself the right to follow his own thoughts in matters of religion and politics, and to shape his own future, with the aid of his Heavenly Father and of his own reason.

The most comprehensive definition of art is, that it is the representation of an impression on the mind of the artist. This impression should be independent and spontaneous. In no other way can art be fully developed, or can it maintain its own individual and national life. So long as painting was subject to ecclesiastical dictation, it remained in its infancy, and therefore incomplete. The work of the Dutch was to separate thought and feeling for what they thought beautiful, from the false and dangerous traditionalism, which had often paralyzed art It is for this reason that I consider the study of the art of the Dutch Republic as peculiarly beneficial to the young artist of the American Republic.

The dominating power of the Church, prescribing rules which artists had to follow in the treatment of all subjects, is everywhere visible in the pictures of the old masters. It is quite amusing to notice instances

where the individuality of the artist involuntarily
crops out. In some unimportant part of the picture
he will introduce a few of his own naive impressions;
and from the very fact that they have been usually
suppressed, they are often quite ridiculous. As an
instance of this, I would mention the woman in
Gozzoli's fresco of the "Intemperance of Noah." Another
instance is the depicting of a pair of spectacles upon
the nose of the bishop who reads the service at the
funeral of St. Francis, painted by Ghirlandajo. For a
more striking example, take Raphael's numerous repre-
sentations of the Madonna and Child. We cannot
suppose that he himself meant all of them to be
sacred, religious paintings. A young woman, with her
first child in her arms, is a subject which by virtue
of its simplicity and grace is most beautiful. It
naturally calls for imitation in art, and Raphael
himself, so graceful and gentle, must surely have
been attracted by it. Human nature presents nothing
more attractive to the eye. The modesty of the
young mother, so happy yet so anxious, her love
centred on the child in her lap,—surely, this forms a
subject which cannot fail to touch the emotions. But

now think of repeating this subject, by order, a hundred times, with the addition of some symbolical figures! We cannot wonder that the result, in many cases, was expressionless and sentimental. In order to make a slight variation, to distinguish one from the other, silly additions were introduced and so we have the Madonna "with the Bag," "with the Fish," "with the Cat," and so on. One artist forgot himself so far that, when painting a large picture in which the Holy Spirit was represented in the shape of a dove, he introduced a cat in one corner, watching the bird and ready to devour it.

The Romish Church, although it caused the painting of innumerable pictures, has little reason to pride itself on bestowing any real benefit upon art.

I have already stated that the most comprehensive definition of art is the representation of impressions which the artist has received. To complete this definition, I should add that he may receive these impressions directly from nature, or from contemplating the works of another art. Generally, however, the best art will be that which can be directly traced to nature. The transfer, for example, into a painting, of the beauty

expressed in a poem, is generally detrimental either to the painting or to the poem. The present rage for illustrated works, although it gives employment to many excellent artists, indicates a low stage of artistic development. The truest art, I repeat, is independent and spontaneous. Whence did the Dutch artists receive their impressions? From the country immediately about them; from the events of the history of the late war; and from a true and careful reading of the Holy Scriptures. From the time of Miereveld, who was born in 1567, till 1749, when Van Huysem, the eminent flower painter, died, what an unprecedented number of great artists did Holland produce! Nature, either out of doors or in their homes, was their great inspiration. No school has given us so many able painters, each of whom remained so truly and entirely himself. The freedom of conscience, which was declared in Holland earlier than in any other country, made of each Dutchman an independent thinker and speaker. In his art, also, each master remained his own interpreter of nature. The ever-changing forms and colors of the Dutch sky, its light-fleeting cloud shadows over the landscape, with its sand-hills and low trees—who has not admired

these in the works of Ruysdael? His beautiful picture
of a distant view of the city of Haarlem, which hangs
in the Hague Museum, will forever stand at the head
of quiet landscape-painting. The warm, sunny sky, fre-
quently observed in the ever-changing moods of Dutch
weather, we meet in the works of Cuyp. He loved to
display before others the pride with which his loyal
Dutch heart was filled, whenever he beheld a scene
depicting the prosperity of his native country. The
numerous vessels which, laden with the wealth of all
lands, filled the Dutch rivers, the dykes and fields
stocked with fat, sleek cattle, every object lighted up by
a glowing sunset,—these and all similar scenes, proved
an inspiration to Cuyp's genius. His pictures rival in
light those of Claude, while they have the additional
merit that they are true representations of the artist's
own country. And surely Holland, with its picturesque
old cities and broad rivers, offers any number of mo-
tives to the appreciative artist.

Every traveller through Holland is impressed by the
quantity and quality of its cattle, the pride of the Dutch
farmer, and no small source of his wealth. Who has
ever given us truer representations of these impressions

than has Paul Potter, without doubt the greatest of animal painters? Everyone who has seen his "Young Bull" has beheld a masterpiece. Let me quote a few lines from Thackeray in reference to this picture. He says, in his Roundabout Papers: "Here, in the Hague Gallery, is Paul Potter's pale, eager face, and yonder is the magnificent work by which the young fellow achieved his fame. How did you, so young, come to paint so well? What hidden power lay in that weakly lad that enabled him to achieve such a wonderful victory? Potter was gone out of the world before he was thirty, but left this prodigy behind him. The details of this admirable picture are as curious as the effect. The weather being unsettled, and clouds and sunshine in the gusty sky, we saw in our little tour numberless Paul Potters—the meadows streaked with sunshine and spotted with the cattle, the city twinkling in the distance, the thunder clouds glooming overhead. Napoleon carried off the picture amongst the spoils of his bow and spear, to decorate his triumph of the Louvre. If I were a conquering prince, I would have this picture certainly, and the Raphael 'Madonna' from Dresden, and the Titian 'Assumption' from

Venice, and that matchless Rembrandt of ' The Dis-
section.' "

This decided praise, by a man of such high and re-
fined taste in his own art as Thackeray, must certainly
count for a great deal. It should put an end to the
silly talk of so many would-be critics, who forever harp
upon the lofty idealism of the Italians as compared
with the vulgar realism of the Dutch. Besides, Thack-
eray himself studied art for awhile, and, referring to
this period of his life, he says: " The humblest volun-
teer in the ranks of art, who has served a campaign
or two ever so ingloriously, has at least this good for-
tune of understanding, or fancying he is able to under-
stand, how the battle has been fought, and how the
engaged general won it." These remarks are made in
reference to Rembrandt's " Dissection," and he adds:
" This is the Rhinelander's most brilliant achievement,
—victory along the whole line."

As to marine painting, Willem Vandervelde has
given us many noble representations of the Dutchman's
best ally, the ocean. This he has covered with the
large war vessels of Holland's victorious fleet. His
brother Adriaan painted the peaceful shores of this

ocean. His beach scenes are celebrated for the space they express, the silvery light which illuminates them, and their exquisite execution Not only in every branch of landscape painting did these Dutch masters excel, but in every quality of the art.

The much-vaunted quality, called "values," which some would like to have us believe was added to art only a few years ago, may be found to perfection in Van der Meer's works — I mean the Van der Meer of Delft. His landscapes, as well as his figure pieces, are wonderful for this quality.

Let us now look at the figure painters of Holland, and first of all we ought to mention Frans Hals. What a technique! How sure a touch, as broad and firm at the age of eighty-one, when he died, as during his earlier years! How I detect the imitation of his execution in the works of the young men who return from the Munich school. The much-prized technique of the present schools was more perfectly reached by the Dutch figure painters of 1600. Who has ever excelled the liquid touch of a Metzu, or the character and humor and broadness of handling, of Jan Steen? In minuteness of delineation, combined with broadness

of effect, no one can be the peer of Gerard Dow. But why not forthwith introduce Rembrandt, who is the best representative of Dutch art?

In my mind painting, as distinct from sculpture, is most completely represented by Rembrandt. His manysidedness, his mastery of all qualities which together make the language of painting, place him in the foremost rank of celebrated artists. How narrow has been in many cases the criticism on his work! He has been charged with employing large dark shadows in order to bring out strong and forced lights! The men who have said this have never seen his "Dissection, or Lesson in Anatomy." A gray, silvery light pervades the whole; the heads are delicate, and show high-breeding. They are lightly painted with a free and liquid brush. The drawing is correct and firm. The light portion of the picture far overbalances the shadowy parts. Then in his picture of the Head of a Young Man, in the Hague Museum, no attempt at a large shadow is shown. Nor is there any such attempt in the portrait of Mrs. Six in the Van Loon collection. This is as devoid of shadow as a Holbein; but in solidity and execution Rembrandt never excelled it.

It is as luminous as mother-of-pearl, as transparent and as pure.

May I ask you to give attention for a moment to this etching? By its aid I hope to succeed in convincing you all of Rembrandt's marvelous power. It is, as we all are aware, the "Ecce Homo."

The reading of the account of this well-known event impressed the artist with the grandeur of Christ's attitude of holy resignation, in contrast with the revengeful conduct of the priests, the stupid rage of the people, and the weakness of Pilate. In this picture certainly no part has been sacrificed or thrown into the deep shadow in order to force the lights on our attention.

The story is clearly told. We fairly see the multitude in the distance move to and fro in their endeavor to get a sight of Pilate and the accused prisoner. The nearest men in the crowd expose the physiognomies of such blood-thirsty savages as are to be seen in all mobs. How real is the jesuitical expression of the priest, who is trying to pacify this mob, and who appears to say, " Only be quiet for a while longer—we are settling this matter entirely to your satisfaction and our own"! Then we note the group of priests in front of Pilate, clamoring

15

for justice. The tallest, the Pharisee, asks for the punishment of the man who has blasphemed the Almighty. We see *hypocrite* marked on each line of his self-satisfied face. To his left is the advocate. He is threatening Pilate with disgrace at Rome if he does not give the people their wish and punish the man who has called himself king and has spoken against Cæsar. As for Pilate, did one ever see weakness, vacillation, and indecision, better expressed than it is in his well-shaped but foppish features? He wishes to save Christ, for he really sees no harm in him; but he fears the mob, and moreover, he is afraid of the loss of caste at Rome, which is hinted at by the crafty priest. What tumult, noise and consternation are indicated in the disturbed and varied lines of all the hands and arms in action, and in the distorted and expressive faces! Now look from these figures in the foreground to the group above, in the midst of which the Saviour is placed. What dignity, what purity, and what resignation are shown in this figure! Surely no painter has expressed such qualities better. Nothing seems attempted in this figure; it is so natural, so true, so simple! Every religious picture, excepting some of

the early paintings of Italy and the Netherlands, seems theatrical by the side of it.

Some wiseacres object to the costumes which Rembrandt uses, as not coincident with the time of the event. We can criticise most of the celebrated Italian painters for the same reason. They were no better acquainted with the Jewish customs and costumes than was Rembrandt. Besides, it is a moral and spiritual spectacle which is here represented : the suffering of the purest and holiest for the sins of the wicked ; the triumph of worldly power and of sin over goodness and truth ;—this is a moral lesson belonging to all ages and all nations. When the story and the various expressions of the figures are so powerfully given as in this scene, little does it matter if some minor details of costume are incorrect.

Where did Rembrandt acquire this power? Pliny tells us that Lysippus, the Greek sculptor, consulted Eupompus, the painter, as to which great master he ought to follow. "Do you see that crowd of people?" the painter asked him ; "that is your model. It is nature which you ought to follow." This doctrine of Eupompus, who lived 350 B. C., was the same which

Rembrandt followed. He reached perfection by the constant study of the people and the nature around him. Human passions are the same at all times and among all peoples.

Another of Rembrandt's etchings shows the same dramatic power: it is the "Resurrection of Lazarus." In it we almost see the rising figure of Lazarus follow the movement of the uplifted hand. How grand and simple is Rembrandt in his conception of this subject! How theatrical were many of these same scenes as treated by the Italians of the sixteenth century! Take, for instance, Sebastian del Piombo's "Resurrection of Lazarus." After seeing Rembrandt's picture, Piombo's seems ostentatious. It shows Roman pomp and the influence of antique Roman sculpture.

It is this individualism, this "protestantism" of Rembrandt's art, which I would recommend to the student. I would not have it supposed that I do not appreciate Italian art. My aim is, just now, to point out in the art of the past the expression which will be most beneficial to the art of the present; and to give a hint of the way in which the art of this country may reach a higher development than any art which has preceded it.

A painting addresses itself to us by means of three qualities. When we see these three evenly distributed through one work, and all brought to some degree of beauty, then we meet an excellent example of the fine art of painting. These qualities or powers are: first, form, or, as we technically call it, *the composition* and *the drawing;* secondly, color and light,—shade or chiaroscuro; thirdly, the mental and moral quality of the painting—or the story. The first two qualities comprise the technique of art. They may be called the language of painting. The superiority of one of these qualities over the others, as found in works of art, has resulted in the historical division of art into separate schools.

The history of art teaches us that all peoples in their first attempts desired to place the beauty of the work in the story. The development of art in a people is the same as in an individual. When a child receives his first pencil and piece of paper he begins to draw figures, that he may tell us a story with them. He does not, as many people suppose, endeavor to make a good imitation of objects. He uses merely a few crude and often grotesque representations of things, in order to tell us something that he has seen or thought.

19

As he grows older he improves his art-language, or the forms in which he encloses his story. Often a struggle takes place between the story itself and his manner of expressing it. He generally ends, if he lives long enough, by considering the technical parts of his work as of more importance than the intellectual part. In this way he falls into a senseless mannerism, and this is the end of him as an artist. This course of the individual we find stereotyped in the phases of the art-development of the various nations and periods of history.

Many of us are direct descendants of that people whose political, religious and artistic love of freedom I have sketched. We enjoy just as free and independent surroundings as did they, and therefore we should profit by the lessons which their history has taught us.

In art we have almost reached the stage at which, as I have said, a struggle commences between the real story of the picture and the manner of expressing it; or, as I should more theoretically express it, between the intellectual beauty and the optical beauty of the work. The first—the intellectual beauty—represents the aim of art; the second quality—the optical beauty—represents the means of art.

The art of America dates back only a very short
period of time. Copley, Trumbull, West, Allston, In-
man, Cole, Mount, Morse, and others, were the first
American artists. Then followed some who are still
living—Weir, Huntington, Church, etc. Each one of
these men aimed at the high ideal which art ought to
fulfill, and tried to reach it by his individual efforts.
A few of them studied abroad, but at a time when art
in Europe was based on the most romantic principles.
The pictures of most of them look weak, and lack
thoroughness of drawing and form, when they are
compared with the foreign pictures of the present time.
They lack the qualities of a fine chiar-oscuro; and for
this reason they have not that appearance of reality,
which is so attractive in the works of the modern
European schools.

The young American artists of to-day, perceiving
this lack of execution in the art of their country, have
gone abroad, to study in the large art-centres at Paris
and Munich. Many of them have since returned and
have exhibited their work at home. After a careful
and unbiased examination of their pictures we must
come to the general conclusion that too many among

them, in their pursuit of art, have mistaken the means for art itself. Although they have acquired only what they call technique, they consider this the whole of art. Most of the works which they have exhibited are mere studies in the handling of the brush, painted from what they call a picturesque arrangement. Some of them show us a cleverly-handled painting of a most hideous, but perhaps picturesque-looking man or woman. They appear to select the most detestable-looking models, and then try to see how well they can represent them with the fewest possible touches.

Now, this last quality, ease of execution, is a fine element in art. That of the Munich portrait-school is based on the style of Frans Hals, the Dutch painter. But the new school is too well satisfied with calling only one part of the art, the whole of it. People say that painting is the art of imitation. Without this technical imitation there can be no visible picture. You may have the most poetical thought or conception; yet, if there is no adequate execution, the world will never be the wiser for it. This is very true. These artists forget, nevertheless, the true aim of art.

The aim of painting is not merely to represent the

natural beauty of objects, but also the moral and intellectual beauties, the representation of which will, so to speak, render virtue visible. The objects selected by the artist ought to familiarize us with optical beauty and harmony, and thus form our taste; while the subject will help to make us better and happier. Believing this to be the true aim of art, may not this Club contribute its share to the ultimate consummation of art in this country? See to it whenever you can that all instruction in the practice of art shall be properly given. Let it be intrusted to a liberal and thoroughly educated artist. His method should be theoretical, and broad enough to meet and to guide the various individual likings and feelings of the different pupils. He should try to develop the individuality of each student, and to make each see through his own eyes.

Rembrandt gave a good hint on this matter. We are told that he had the *atelier* of his pupils divided by means of screens, into separate apartments, each holding one student. The aim of this arrangement was, that each should follow his own bent, and not be tempted to imitate the method of the others.

While students are learning the language of art,

surround them with inspiring and beautiful models. Establish collections and give exhibitions of art works. In regard to the establishment of a permanent collection, I should say that nothing is more capable of forming our taste—which is, in reality, the sentiment for the beautiful—than productions of art, in which we can observe, study, and become familiar with all the elements which together produce this beauty. If works of art, however, lack this beauty, their influence will be dangerous, for they will help to introduce bad taste. Moreover, since examples of bad taste also find admirers, these vices in art, receiving favor from some, will not only introduce bad taste, but will also encourage it. For this reason it becomes necessary to watch assiduously the beginning and the growth of such collections, and to reject, whether gifts or otherwise, everything which is not artistically valuable. If such a plan had been properly carried out, we should not now find on the walls of the Metropolitan Museum in New York the daubs of the so-called Dutch school. Not one representative picture is to be found amongst them. No student can ever derive benefit from such stuff. A similar mistake was made in the buying of the

Cesnola collection. Even supposing that some of the lot is genuine, there are too many repetitions. A few of these specimens of early art are sufficient for the study of archæology. As a means of inspiration and emulation they are, of course, worthless. After securing a few of these archaic specimens, the rest of the money, now wasted in this purchase, might have procured a complete collection of casts from ancient and modern sculptures. Such a collection has been placed in the Berlin Museum.

A few weeks ago, taking up the Sunday *Tribune*, I read as follows :

" It is an encouraging sign that more exhibitions have been held during the past year than ever before, despite the continuance of business depression."

Now, every artist knows that he cannot paint more than one picture a year, which will show a continuous progress in his artistic power. The other pictures which he shows in these many exhibitions during the same year are "pot-boilers"—sketches or studies. The examination of sketches is very interesting to artists and to connoisseurs, but is unintelligible to the general public. The uninitiated observe nothing in the sketches except

coarseness of execution, not being capable of noticing their suggestiveness. I have no doubt that the present rage for daubing on the part of those who have not the least taste or talent is aggravated by the increase of the number of exhibitions and the low standard of art displayed in them. A sketch belongs on the wall of the studio or in the portfolio, and it should not be displayed to the eye of the barbarian any more than the manuscript of the poet, with all its erasures and proofs of hard labor.

By all means, then, surround the student, while he is learning his art-language, with fine works of art. Furnish him with lectures on history, especially that of his own country, on literature, and on the history and theory of the fine arts. In this way let his power of expression and his taste be simultaneously developed. If he possesses the true republican spirit, he will produce genuine American art. Suppose him called upon to paint an historical picture,—"John Brown going to execution, and on his way kissing a negro baby." After carefully reading accounts of the event, he will sit down in meditation. This may last for days, or it may last only an hour, but sooner or later the whole

scene will appear before his artistic imagination. While under the influence of this idea, he will take up his tools, and in a few hasty strokes he will make memoranda of the vision before his mind. This will exhibit the principal group, consisting of the old hero, the child and its mother, about in the middle of the composition. This group will be in full light, a light so broad and bright as to throw a halo around the martyr; not a halo of gold, as in the Catholic pictures, but such a light as Rembrandt saw and knew how to borrow from nature itself. Having these hastily executed memoranda by his side, the artist will continue to work out his idea of form and expression. Rather than to portray the very act of the kissing, he selects the second preceding it. If he depicted the act itself, part of the head of John Brown would be concealed by the child's head, and it is this man's head that must form the noblest part of the work; besides, the shape of the mouth in the act of kissing affords no pleasure to the eye of the spectator. The artist, in showing the entire face and head, has an opportunity for expressing all the character of the man, his courage, and his devotion to a high aim. The expression of fanaticism

he can soften by a gentle, benevolent smile, as the man's face approaches that of the child. Upon John Brown's head the artist spends all his power of invention, observation, and execution, for he intends that this shall, for all time to come, represent his idea of this martyr to the cause of freedom. The group made by these three figures he paints in a three-quarter view. This arrangement gives him an opportunity to show a fine outline of all the figures. It moreover affords him a chance to place his background, consisting of the prison wall, in a slanting position. No good composer will ever hurt the feelings of the spectator by having him run flat against some wall, placed directly across the painting. As to the background itself, the artist will, of course, if he can collect the necessary data, make it like the natural scene; but he will draw no attention to it, nor will he take much pride in the accuracy of this or of any other accessory. There certainly is no greater merit in painting the pair of slippers which John Brown is said to have worn at that time, than in painting any pair of shoes.

Pardon me if I digress from my subject for a

moment, to remark that, whenever we hear much talk about the difficulties overcome by an artist in order to collect all the historical data for his picture, we may be sure that the merit of the picture, when finished, will consist almost exclusively in these trivial details. We all remember how many years Holman Hunt studied in the Holy Land, that he might make his picture, the "Shadow of the Cross," correct in all details. We also remember what an utter failure the picture was. But let us return to our young American artist.

After giving all the necessary beauty of form, expression, light and shadow, and color, to the principal group, the artist will so manage the shadow of the prison that it will throw a deep shade across the group of men who follow John Brown down the steps of the building. By this means he will gain two points: this shadow will form a strong contrast to the light on the group in front, by which means this group will be sustained, and its light will be heightened; it moreover will aid in heightening the moral effect, by illuminating the martyr and by darkening his executioners. The three-quarter view which the artist has selected for the main line of his picture, enables him to place

the soldiers, who are needed for history's sake alone in the corner of the canvas, where they will not be conspicuous. The color of their blue uniforms is an ugly color to manage well.

I have already stated that, while the artist is occupied in finishing his painting, he constantly refers to his first hastily executed sketch, in order to work all the while under the influence of his first impression. This suggests a passing reference to the so-called Impressionist School. It requires much more power to finish elaborately a great composition, and to adhere throughout to our powerful first conception, than simply to paint a sketch while the first conception or impression is before our mind. It really seems an imposition to exhibit such hasty jottings as works of fine art, and to hide their shortcomings under the high-sounding name of the Impressionist School.

But now our artist's canvas is ready to receive the final touches. By his training, he knows that differences in subject require differences in treatment. It is not necessary that he should finish the details in an historical painting as minutely as in a painting of still life. He should care for neither the glitter of the

newly polished bayonets, nor the neatness of a soldier's clothing. Above all, he knows that he should not paint these trifling things so true to nature, that it will be impossible for him to attain the same degree of imitation in the representation of the heads and hands of the human figures. On the contrary, he finishes the whole with a firm, large touch, delicate in the parts where the most feeling needs to be displayed, strong where deep lines and shadows are needed. No silly finish of detail or imitation of texture is called for in an historical work. Being aware of this rule, when he puts his finishing strokes to the work, he makes it appear as if the whole was the work of magic, and done without any effort. His picture is finished, and it is a success. The perfect harmony between the execution and the grandeur of the subject, the fine disposition of light and shadow, make it a work of beauty.

Our young artist, born and bred on American soil, has proved these truths: if a country wishes to achieve triumphs in art, it should work out its own development; it should seek for inspiration only from such works as have been produced in the same independent and honest ways.

CPSIA information can be obtained
at www.ICGtesting.com
Printed in the USA
390263LV00013B/141

Childhood
in Transition

Experiencing Marginalisation
and Conflict in Northern Ireland

Siobhán McAlister

Phil Scraton

Deena Haydon

November 2009

ISBN: 978 0 8538 9962 4

© Queen's University Belfast, Save the Children, The Prince's Trust

CDS N111993

Prince's Trust
Northern Ireland

CONTENTS

4 Foreword

6 Acknowledgements

7 About the Authors

8 Preface

11 Theoretical and Methodological Contexts

22 Northern Ireland: Transition from Conflict

35 Images of Children and Young People

46 Personal Life and Relationships

57 Education and Employment

69 Community and Policing

82 Place and Identity

92 Segregation and Sectarianism

106 Violence in the Context of Conflict and Marginalisation

117 Services and Support

136 The Rights Deficit

147 Findings and Summary of Key Issues

157 Appendix

158 References

FOREWORD

To be a child or young person is simultaneously exciting, challenging and difficult. Childhood to youth to adulthood is a progression through stages or periods of biological, social and emotional development. From birth, the progress of the baby-toddler-child-young person is socialised, conditioned and monitored as an adult 'in the making'. Beginning with relationships in the family and the community, and reinforced by religious, cultural and institutional practices, children can experience inclusion or exclusion depending on whether they are perceived to conform or deviate from what is expected of them at particular ages. In the socialisation of children, care and protection co-exist with discipline, regulation and punishment. Whatever the social context and cultural traditions experienced by children, their journey through childhood is one of continuous transition. It is transition on several levels – physiological, social, institutional and emotional. Physical growth and development, especially through puberty, is the most visible manifestation of transition. Within different cultural and religious traditions key moments are recognised and marked by rituals and ceremonies. The State intervenes not only in monitoring child and adolescent development but also through nursery, primary and secondary schooling. The emotional impact on children of their transition through each stage of formal education is significant, especially when they are assessed and ranked in terms of what is considered 'normal' social and intellectual progression.

In Northern Ireland there is a further, overarching and profound form of transition. It is a society still emerging from thirty years of Conflict involving State and non-State armed groups. As well as killings, physical injuries and the trauma of war, the Conflict involved the suspension of normal powers of law enforcement and the due process of the law, and the internment and incarceration of politically-affiliated prisoners. Eventual ceasefires and the initiation of the Peace Process led to the 1998 *Good Friday (Belfast) Agreement* and political devolution to the Northern Ireland Assembly. The process of political transition, marked by the stop-start of the Assembly, has progressed but the anticipated devolution of justice and policing remains to be achieved. While political transition has evolved at a range of levels, and through a variety of institutions, the legacy of the Conflict remains a significant aspect of life in Northern Ireland. Generations have grown up under the spectre of war and the trauma of bereavement, displacement and violence. There has been minimal recognition of the longer-term consequences of transgenerational trauma or of the persistent impact of deeply-divided, segregated and sectarian communities.

There has been formal acknowledgement of the needs and rights of children in Northern Ireland through: recognition in the *Good Friday (Belfast) Agreement* that young people from areas affected by the Conflict face 'particular difficulties'; the establishment of the Commissioner for Children and Young People; the development of a *Strategy for Children and Young People*; the appointment of two Assembly junior ministers with responsibility for children within their remit; the inclusion of children's rights in the proposed *Bill of Rights for Northern Ireland* and the regional children's services plan. Yet there remain serious concerns regarding the translation of these commitments and initiatives into

practical provision which will improve the lives of children and young people living in the most marginalised and divided communities. The relationship between the unusually high levels of persistent poverty and the legacy of the Conflict is profound but has yet to be addressed effectively by government departments. This has led to increased frustration and alienation within communities and a lack of trust in the political process. A perceived lack of political commitment to the needs and aspirations of children and young people has the potential to undermine their eventual participation in the democratic process.

It is instructive to note the comments made by Alvaro Gil-Robles, European Commissioner for Human Rights, following his visit to Northern Ireland in 2005. While recognising the positive 'quality-of-life' transition for many people, he raised concerns regarding the relationship between material deprivation, social exclusion and 'community justice'. Social inequality, he considered, was palpable as 'others, across the religious divide, have less demonstrably benefited from economic advances ... one cannot but suppose that tensions and distrust will linger longer in disadvantaged, socially isolated communities ... exclusion and poverty facilitate the continuing control of such communities by criminal and paramilitary structures'. In responding to such marginalisation, it is essential that there is among political leaders and state institutions the will, commitment and imagination to give clear political leadership as well as necessary resources to facilitate effective changes within these communities.

This research, within communities in Northern Ireland most affected by poverty and the legacy of the Conflict, raises concerns not only about long-term inequalities and infrastructural under-resourcing, but also regarding the systemic denial of children's rights. Just as some media commentators and political opportunists have demonised children and young people, seemingly seizing on every opportunity to condemn rather than understand, they have also been unremitting in their criticism of what they term the 'rights agenda'. Yet the State is a signatory to the *UN Convention on the Rights of the Child* and is obliged to implement agreed international standards. This it has failed to do. The in-depth research that follows challenges the marginalisation, demonisation and criminalisation of children and young people by presenting evidence from their daily experiences and from adults living and working in their communities. It reflects the often harsh reality of life for children and young people as they negotiate the aftermath and legacy of the Conflict in the context of limited opportunities. The voices of children, young people and their advocates, challenge optimistic representations of transition in Northern Ireland and illustrate the alienating consequences of social, political and economic exclusion. The research also exposes the extent of rights abuses and establishes a framework for political action at a crucial, defining moment in the contemporary history of Northern Ireland. Its findings and implications should contribute significantly to public education, policy change and law reform as full devolution is achieved.

Save the Children; The Prince's Trust; Queen's University Belfast

ACKNOWLEDGEMENTS

This project arose from discussions about the experiences of children and young people living with the legacy of the Conflict in the most economically deprived communities in Northern Ireland. It was a partnership project between Save the Children (NI), The Prince's Trust (NI) and Queen's University. We are especially indebted to Sheri Chamberlain, former Director of Save the Children (NI) and to Siobhán Craig, former Director of The Prince's Trust (NI). Sheri's drive and commitment to this project was, and remains, inspirational. More recently we are grateful to Marina Monteith at Save the Children (NI) and Ian Jeffers at The Prince's Trust (NI) for continuing to support the work.

Sincere thanks to all the organisations who participated in the research, to community representatives, community workers, community contacts and NGO representatives who assisted with the research. Because of the sensitivity of the work and our commitment to preserving anonymity we are not acknowledging you by name but our gratitude is no less heartfelt. Our colleagues at Queen's, particularly the *Childhood, Transition and Social Justice Initiative,* have also been supportive as has the Queen's publications team, in particular Andrew Norton.

Our greatest debt, however, is to the children and young people who were so generous with their time. From those young people on The Prince's Trust schemes who assisted with formulating the key research themes to those who attended focus groups and personal interviews, thank you so much. All who participated demonstrated insight, consideration and resolve in sharing their experiences and intimate stories. Their testimonies speak profoundly for a generation. They are voices that must not be silenced nor denied if Northern Ireland is to become an inclusive and peaceful society offering real opportunities for personal and political participation while effectively promoting and protecting the rights of children and young people.

Phil Scraton, Siobhán McAlister and Deena Haydon
Childhood, Transition and Social Justice Initiative
Queen's University Belfast
October 2009

Deena Haydon is a Postgraduate Researcher within the *Childhood, Transition and Social Justice Initiative* at Queen's University, Belfast. Her doctorate considers the potential of a rights-based agenda in addressing the issues faced by children identified as 'at risk of offending'. Initially a primary school teacher, she became Senior Lecturer in Education and Early Childhood Studies and Head of Research in the School of Education at Edge Hill University. She was appointed Principal Officer for Research and Development at Barnardo's and then worked as an independent research consultant in Northern Ireland. Her main research interests are: anti-discriminatory policy and practice; sex/sexuality education; PSE and Citizenship; parenting and family support; youth justice; and children's rights. Based on a commitment to linking research, theory and practice, her publications include reports, journal articles, book chapters, resources for children and practitioners, consultation responses, and submissions to the UN Committee on the Rights of the Child. She co-authored: *The Illusions of Post-Feminism* (Taylor and Francis); *Getting Personal*; *Citizenship and PSHE*; and *Dealing with Issues* (all Folens) and wrote the children's version of the report *Children's Rights in Northern Ireland* (NI Commissioner for Children and Young People). She is author of *Developing a Manifesto for Youth Justice in Northern Ireland – Background Paper* (Include Youth).

Siobhán McAlister is a Research Fellow within the *Childhood, Transition and Social Justice Initiative* at Queen's University Belfast. She worked and studied in Middlesbrough in the North-east of England until 2002, where she undertook her PhD research focusing on a critical ethnography of youth underclass and social exclusion theses. She was a member of the inter-disciplinary Queen's University team researching the state of children's rights in Northern Ireland for the Northern Ireland Commissioner for Children and Young People. She was a researcher with Youth Action Northern Ireland examining the lives and experiences of young women and a researcher in the Institute of Child Care Research. She has co-authored academic articles and various research reports including: *An Independent Analysis of Responses to the Department of Education's 'Priorities for Youth' Consultation* (Department of Education Northern Ireland); *'Don't be so formal, I'm normal': A research report on the mental health of looked after children/care leavers in Northern Ireland* (Voices of Young People in Care); *Still Waiting: The stories behind the statistics of young women growing up in Northern Ireland* (Youth Action Northern Ireland); *Children's Rights in Northern Ireland* (Northern Ireland Commissioner for Children and Young People).

Phil Scraton is Professor of Criminology in the Institute of Criminology and Criminal Justice, School of Law, Queen's University, Belfast and Director of the *Childhood, Transition and Social Justice Initiative*. His postgraduate teaching includes: *Children's Rights*; *Comparative Youth Justice*; *Gender, Sexuality and Violence*. His most recent books are: *'Childhood' in 'Crisis'?* (Routledge); *Hillsborough: The Truth* (Mainstream); *Beyond September 11* (Pluto Press); *Power, Conflict and Criminalisation* (Routledge); *The Violence of Incarceration* (Routledge). *The Incarceration of Women* (Palgrave Macmillan) is in preparation. He edited a recent special issue of *Current Issues in Criminal Justice* on the criminalisation and punishment of children and young people. Recent co-authored research reports include: *The Hurt Inside: The Imprisonment of Women and Girls in Northern Ireland* and *The Prison Within* (NI Human Rights Commission); *Children's Rights in Northern Ireland* (NI Commissioner for Children and Young People). His current research includes funded projects: *Childhood, Transition and Social Justice* and the international comparative project *Children of Imprisoned Parents*. He works closely with community-based initiatives and is Chair of the Board of *Include Youth*.

PREFACE

A long history of conflict and political violence has shaped Northern Ireland's political, economic and cultural landscape. Several generations of children have been directly and/or indirectly exposed to the consequences of pervasive sectarianism, violence, hostility and death. The legacy of conflict has impacted severely on communities that have endured persistent violence, economic hardship and inadequate service provision. In research conducted for the Northern Ireland Commissioner for Children and Young People (NICCY), *Children's Rights in Northern Ireland* (Kilkelly et al. 2004), the legacy of the Conflict was highlighted as a significant cross-cutting theme. It noted the comment by Olara Otunno, Special Representative of the United Nations Secretary-General for Children and Armed Conflict who, in 2000, called on the Government:

> ... to provide more support for families and parents affected by violence, living in segregated environments and hampered in their own ability to build bridges with neighbouring communities. Educators and other members of civil society working to encourage cross community links need to be given adequate and sustained support. (ibid: xvi)

Poverty was another cross-cutting theme in the NICCY research. An analysis of statistical data reveals that areas enduring the most serious violence, death and injuries during the Conflict are also some of the most economically deprived wards in Northern Ireland. Research reveals that one in three children in Northern Ireland 'is going without basic necessities, such as healthy food, clothing and a decent home because parents can't afford them', one in four 'lives below the Government's official poverty line' (Save the Children 2007: 2). When compared to Great Britain, children in Northern Ireland are more likely to experience persistent poverty (Monteith et al. 2008: 3). Within the jurisdiction there are communities blighted by structural, long-term material deprivation evident in poor housing, high unemployment, low wages, under-resourced social amenities and diminished opportunities. Children of the unemployed, children of lone parents, children living in large families, children living in households with a disabled adult or a disabled child, and children living in the west of Northern Ireland are particularly vulnerable to experiencing poverty (Save the Children 2007: 7-10). Poverty affects children's physical, social and emotional development as well as their educational, employment, social and economic opportunities. Children living in poverty are more likely to live in areas experiencing multiple problems - such as general decline, rubbish, vandalism, violent attacks- (ibid: 18). The number of conflict-related deaths and injuries has been greater in the most disadvantaged areas, illustrating the 'strong, but complex, relationship between poverty and conflict' (Hillyard et al. 2005: xx).

The priorities of most concern raised by the NICCY research focused on: failure to implement the *UN Convention on the Rights of the Child* and other international human rights standards; family life and alternative care; health, welfare and material deprivation; education; leisure, play and recreation; policing and youth justice. The most significant issues raised in this research included:

- lack of safe social space and leisure facilities and a failure by providers to consider what 'safe communities' mean for children

- a common perception that children playing together in public spaces posed a threat within their communities and were engaged in anti-social behaviour

- the poor quality of age-appropriate health care provision for children and young people, particularly concerning mental health needs

- the criminalisation of children, discriminatory policing and punishments and exiling by paramilitary groups

- failure to respect children's views and privacy at home, in school, in care and in custody and their exclusion from decisions that affected their lives

- the negative impact of religious segregation in schools and between communities.

Criticisms voiced by children and those who worked with them indicated serious under-resourcing - particularly in appropriate mental health provision. The research also established that institutions had failed to adopt appropriate strategies for change consistent with, and responsive to, international rights standards. There was a lack of information available to children to encourage participation in decisions affecting their lives. Further, there had been minimal progress towards informed and inclusive consultation.

Otunnu was clear that 'children's voices must remain priority concerns throughout the building of peace and that the voices of young people should be heard throughout the process'. He recommended that 'children's rights should be incorporated into the new Northern Ireland Bill of Rights'. Concerned that children and young people, as victims and perpetrators,

were affected directly by the violence associated with conflict, he urged all parties to 'maintain children's issues at the forefront of political and public attention and action during the consolidation of the peace process'. The appointment of a Children's Commissioner for Northern Ireland gave wider recognition to the special circumstances of children and, after a lengthy process, the Human Rights Commission incorporated recommendations on children's rights into its 'advice' to the UK Government: *A Bill of Rights for Northern Ireland* (NIHRC 2008).

Based on the experiences of the most marginalised and vulnerable children and young people, Save the Children's research, policy and consultation work over the last ten years has identified the impact of the Conflict on all aspects of their lives. This includes commissioned research into: how schools supported children in relation to the political conflict (Leitch and Kilpatrick 1999); the reality of life for children living in interface areas in North Belfast (Leonard 2004); the impacts of poverty on children and their families (Monteith and McLaughlin 2004; McLaughlin and Monteith 2006; Save the Children 2007; Monteith et al. 2008; Horgan 2009); protecting children and young people's rights in the Bill of Rights for Northern Ireland (Horgan and Kilkelly 2005). The Prince's Trust has developed interventionist programmes in Northern Ireland with young people considered the 'hardest to reach' and most in need of support in their transition from school to work.

Given shared concern about the findings of the NICCY research, and the commitment of Save the Children and The Prince's Trust to working with the most marginalised children and young people, a partnership action research project was

developed with Queen's University Belfast. This aimed to:

- draw on existing research and evidence regarding material deprivation, economic marginalisation and social exclusion

- conduct primary research with children and young people affected by conflict and identified as the most marginal and excluded in urban and rural environments

- conduct primary research with community representatives working with children and young people 'at the margins'

- identify positive outcomes in the delivery of operational programmes established to identify and meet the needs of marginalised children, young people and their families

- explore the relationship between economic marginalisation, social exclusion and poor mental health.

The project, *Understanding the Lives of Children and Young People in the Context of Conflict and Marginalisation*, set out to explore the conditions and circumstances specific to Northern Ireland regarding the legacy of conflict and transition to a 'post-conflict' society. It was committed to developing research with the most marginalised and 'hard-to-reach' children and young people - reflecting their concerns and aspirations about securing safer, inclusive and participatory communities. What follows are the findings of the project's primary research, conducted in six communities across Northern Ireland during 2008.

Chapter One sets the theoretical and methodological context to the research,

including discussion of key concepts and providing an overview of the research process. Chapter Two considers the current political context in Northern Ireland, the transition to 'peace', issues raised by other contemporary research with children and young people and Government responses to the children's rights deficit. Chapters Three to Eleven provide detailed accounts of the primary research, drawing on interviews and focus groups in the six selected communities. The chapters reflect the overarching themes raised by the research: images of children and young people; personal life and relationships; education and employment; community and policing; place and identity; segregation and sectarianism; violence; services and support; the 'rights deficit'. The final chapter overviews the research findings and specifies key issues to be addressed.

Phil Scraton, Siobhán McAlister and Deena Haydon

Research team: *Understanding the Lives of Children and Young People in the Context of Conflict and Marginalisation.*

THEORETICAL AND METHODOLOGICAL CONTEXTS

Social constructions of childhood and youth

Under internationally agreed standards, including the *UN Convention on the Rights of the Child*, all people under 18 years are 'children' afforded special protections and rights. It is self-evident that, socially and culturally, 'childhood' and 'adolescence' are imprecise periods during which social and intellectual developments progress alongside biological and physiological growth. Tracking, measuring, assessing and ranking child development in terms of age-related expectations underpins institutional policies and service provision. Mayall (1994: 3) comments: 'the notion that children are best understood as incomplete, vulnerable beings progressing with adult help through stages needed to turn them into mature adults ... has great power both theoretically and as a force shaping children's lives, through the operation of health, welfare and legal policies and services'. It also appeals to 'common-sense'.

Significant adults (for example parents, teachers, clergy) are expected to guide and support children through these developmental stages, steering them towards 'acceptable' roles and responsibilities. Socialisation maintains and reproduces stability and social order. Directly and indirectly, it accommodates change, promotes conformity to established 'norms' and disciplines those who challenge authority. Conformity brings approval and failure to conform invites rejection. Resistance to adult authority is rarely identified and celebrated as young people taking control of their lives, or as evidence of strength of character in challenging power relations. Rather, it is considered 'risky' or 'problematic' behaviour, requiring sanction or punishment.

While they have 'minds of their own', a powerful expectation is imposed on children to follow adult-prescribed roles during their socially constructed 'preparation' for adulthood - reducing childhood to something 'less than' adulthood, regarding young people as 'adults-in-waiting'. To quote Qvortrup (1994: 4), in this expectation of conformity and preparation for adulthood, children are perceived as 'human becomings' rather than 'human beings'. Invariably, given the powerful defining role of adults, children are excluded from decisions and arenas through which the quality of their life is determined. Adults, it is assumed, know, understand and accomplish the 'best interests' of the children for whom they have responsibility.

Central to child development is the vexed and complex issue of children's 'competence' and ability to act responsibly. Legislation imposes ages at which children are assumed to be able to make informed decisions. The age at which they are generally assumed capable of accepting personal and social responsibility is 16-18 (for example, they are legally entitled to purchase alcohol at 18, vote at 18, give sexual consent at 16). In contrast, the age of criminal responsibility in the UK is much lower (10 in Northern Ireland, England and Wales, 8 in Scotland). This illustrates a tension between viewing children as not having the fully developed capacity to reason, as vulnerable and in need of protection and perceptions of children as potentially wayward, in need of control and professional intervention. That a child of 10 is presumed to have the capacity and lived experience to premeditate dangerous acts and foresee their consequences is questionable, especially when compared with the ages at which they are assumed to

be competent in other areas of their lives. A low age of criminal responsibility also inflicts punishment via criminal justice disposals, rather than providing necessary support through adequate and appropriate welfare interventions.

Public debate about childhood and youth retains the constant theme that 'today's' children and young people are more rebellious, less disciplined, more antisocial, less considerate than their predecessors. Adults hark back to a 'Golden Age' – usually represented as *their* childhood – when children were compliant and responsive, 'knew their place', 'accepted responsibilities without question' and were 'seen and not heard'. In this period 'authority', meaning adult authority, was obeyed without challenge. Communities were served by formal agencies and regulated through informal but consensual arrangements. Childhood 'innocence' was protected while its potential wildness (particularly in the phase defined as 'adolescence') was harnessed through the imposition of non-negotiable disciplinary codes plus the threat and use of physical coercion.

The proposition that children's and young people's involvement in 'crime', 'deviance' and 'anti-social behaviour' is the result of a recent collapse in social, cultural and moral values is not new. In researching and writing a 'history of respectable fears', Pearson (1983: 207) notes each generation's belief that their childhoods were better-disciplined, safer and more respectful. Such reminiscences amount to a 'simple nostalgia' for a lost way of life. In contrast, he maps persistent myths of moral decline, particularly regarding the deviance and delinquency of children and young people.

What follows the images and assertions of 'recent moral decline' are calls for tougher legislation and stronger regulation to combat a perceived trend in social policy and legislation towards leniency for perpetrators at the expense of the interests of their victims. As Muncie and Fitzgerald (1981: 422) state: 'in times of rapid social change when traditional values are shaken up and disturbed, the ensuing public disquiet is resolved by the media identifying certain social groups as scapegoats or folk devils' - portrayed and received as 'visible symbols of what is wrong with society'.

In 1972, Cohen's research into 'mods' and 'rockers' showed how particular groups of young people had come to be labelled 'deviant' – the 'folk devils' of their generation. Their style, language and behaviour were taken as evidence of deviant behaviour, threatening discipline and order in their communities. Media portrayals of such folk devils had become so powerful, the public outrage and moral indignation so strong, that fact and reality were subsumed in the fiction and fantasy of sensationalist news reporting. Once the 'folk devil' was mobilised in media and political debate, the process of amplification generated a broader 'moral panic' undermining the 'values and interests' held dear in 'society' (Cohen 1972: 9). Thus 'moral barricades' were constructed and defended by 'editors, bishops, politicians and other right-thinking people' while 'socially accredited experts pronounce their diagnoses and solutions' (ibid). Cohen concluded that 'stylised and stereotypical' media folk devil representations institutionally carried 'serious and long-lasting' repercussions for 'legal and social policy or even in the way society conceives itself' (ibid).

Moral panics bring hostile and disproportionate responses from within state institutions leading to increased surveillance, containment and regulation of targeted groups. They are both reactive and reactionary, resulting in concrete strategies, techniques and resources across a range of state institutions. In a wide-ranging study, Goode and Ben-Yehuda (1994: 31) show how harsh institutional responses gain public sympathy and acceptance in a climate fuelled by 'heightened emotion, fear, dread, anxiety, hostility and a strong sense of righteousness'. Behaviour is portrayed as seriously 'wounding to the body social', and individuals or groups publicly held responsible are condemned as 'evil'. The consequences are authoritarian and punitive: 'tougher or renewed rules, more intense public hostility and condemnation, more laws, longer sentences, more police, more arrests and more prison cells ... a crackdown on offenders' (ibid). Invariably, what follows are stronger 'powers of state control ... enabling law and order to be promoted without cognisance of the social divisions and conflicts which produce deviance and political dissent' (Muncie 1996: 55). The generation of fear, suspicion and hatred 'triggered and sustained by moral panics stigmatises, criminalises, ostracises and exiles the "other", the "outsider", the "outlaw"' (Scraton 2007: 233).

By the early 1990s it was generally accepted that 'an unprecedented crisis of public morals' prevailed with 'fears' expressed 'in a language ... indistinguishable from that of generations which are long dead' (Pearson 1993/4: 191). This view displayed an 'extraordinary historical amnesia about even the more recent past' (ibid). Media and political commentators had become obsessed with the 'petty criminal' and

'anti-social' behaviour of children and young people, the 'breakdown' of the traditional family, the 'collapse' of school discipline, the 'permissiveness' of early sex and the 'violence' of 'feral' youth. Muncie (1999: 3) notes how 'emotive and troubling images' of youth ranged 'from notions of uncontrolled freedom, irresponsibility, vulgarity, rebellion and dangerousness to those of deficiency, vulnerability, neglect, deprivation or immaturity'. According to right-wing US social scientist, Charles Murray, an 'underclass' had been created, populated by the uneducated and the unteachable, typified by 'lone mothers', 'fatherless communities', 'joyriders', 'ram-raiders', indiscriminate violence, drug and alcohol abuse and base morality. 'The New Rabble' had arrived and 'dysfunctional' families were at its core (Murray 1994: 12).

Reflecting on the 1990s society inherited by his Government, then Prime Minister, Tony Blair (2002) commented: 'crime was rising, there was escalating family breakdown, and social inequalities had widened'. Neighbourhoods were 'marked by vandalism, violent crime and the loss of civility'. Beyond the safety of the home, people were 'confronted by abuse, vandalism, anti-social behaviour'. 'Duty' and 'respect' had diminished and the 'moral fabric of community was unravelling'. It was a rhetoric of 'social disintegration' ill-served by an outmoded, slow-to-respond criminal justice system. Inter-agency initiatives were neither efficient nor effective and punishments no longer reflected the seriousness of offences. A Government priority was a 'new, simpler and tougher approach to anti-social behaviour' to combat 'petty crime and public nuisance that causes so much distress' and to address 'vandalism, graffiti, low-level aggression and violence' (ibid).

One tangible outcome of New Labour's law and order rhetoric was the 1998 *Crime and Disorder Act*, emphasising discipline and regulation based on community responsibility, multi-agency early intervention and moral renewal. By targeting 'anti-social behaviour' through coercive, zero-tolerance policing the net of criminalisation was widened. These interventions soon exacerbated rather than eradicated social exclusion. Goldson (2000: 52) notes the shift towards regulatory interventions 'promot[ing] prosecution', 'violat[ing] rights' thus 'criminalis[ing] the most structurally vulnerable children'.

In 2003 the Government White Paper, *Respect and Responsibility – Taking a Stand Against Anti-Social Behaviour*, listed six illustrative 'activities' constituting 'anti-social behaviour': harassment and intimidating behaviour; behaviour that causes alarm or fear; noisy neighbours; drunken and abusive behaviour; vandalism, graffiti and other deliberate damage to property; dumping rubbish or litter. While applied to the behaviour of all people, regardless of age, it soon became apparent that in the existing climate of fear and intolerance children and young people were disproportionately targeted. An essential element of implementing the legislation was 'naming and shaming' those as young as 10 served with Anti-social Behaviour Orders (ASBOs). Had they been found guilty of a criminal offence, their identity would have been protected.

Northern Ireland has not been immune to debates about 'problem youth'. Soon after introduction in England and Wales, social policies and new legislation are often transferred. Thus, in 2002, the Northern Ireland Office (NIO) identified the most significant community safety factors as 'street violence, low level neighbourhood disorder and anti-social behaviour' (NIO 2002). The NIO's account of the introduction of Anti-social Behaviour Orders in England and Wales, while inaccurate, made clear its priority in extending them to Northern Ireland: 'ASBOs were introduced to meet a gap in dealing with persistent unruly behaviour, *mainly by juveniles*, and can be used against any person aged 10 or over' (NIO 2004: 4, emphasis added). The *Anti-Social Behaviour (Northern Ireland) Order* was introduced in August 2004.

The rhetoric connecting 'crime', 'anti-social behaviour' and the 'prevention of offending', places considerable emphasis on children 'at risk'. As Wyn and White (1997: 22) state, the term 'at risk' rests on the assumption that 'a majority of young people are "on target", making transitions towards adulthood in the appropriate ways'. Further, they note, 'the concept of youth development provides a rationale for the notion of a 'mainstream' and young people who 'do not conform to the standards of this mainstream are identified as those at risk, requiring specific attention to bring them into line …' (ibid: 51-52). Constructions of 'risk' are powerful because they 'lead to calls to do something about it' (Smith et al. 2007: 219) and provide legitimacy for state intervention.

Identifying children 'at risk' has an established and controversial recent history. Reflecting on risk classification in US public education programmes, Kohl (1993: 231) presents the 'labels' adopted in associating risk and low educational achievement: 'disadvantaged, culturally deprived, underachiever, non achiever, low ability, slow learner, less able, low socio-economic status, language impaired, drop-out-prone, alienated, marginalised, disenfranchised, impoverished,

underprivileged, low-performing and remedial'. What is clear from the adoption of such labels, and evident in many youth justice interventions, is the focus on individual factors, deficits or maladjustments (France 2007). Responses to these 'problems' prioritise changing individuals' behaviours rather than challenging and adapting the institutional processes that contextualise the lives of children and young people.

Following the introduction of the 1998 *Crime and Disorder Act* in England and Wales, the Government's Social Exclusion Unit established targets for measurable reductions in anti-social behaviour. The Youth Justice Board adopted a 'Risk Factors Screening Tool' (YJB/CYPU 2002), later developed into 'Onset' and 'Asset' assessment methods for young people at risk of offending or young people who have offended, respectively (YJB 2006). Research suggests that the assessment of risk focuses on individual behaviour and personal 'choices' rather than considering the impact of social circumstances and material context on the lives of children and young people (Gray 2007). Within 'early intervention' targeting those identified as 'at risk', the priority is 'prevention of offending', public protection and diversion from criminal activity. Reinforcing a 'deficit' model, individuals, their families and communities are pathologised. Key issues remain unaddressed, such as: identifying economic, social, and educational need; providing appropriate family support; ensuring that children and their families access the health and support services they require; providing safe, age-appropriate play and leisure facilities and youth services; structural change in the social and

economic circumstances of disadvantaged communities.

In keeping with the critique of a 'Golden Age', the belief that there was a time in industrial societies when children made an easy and uncomplicated transition to 'adolescence', followed by an equally straightforward transition to adulthood, does not bear scrutiny. While it is inappropriate to draw direct parallels between different societies and communities, it is important to recognise that, within societies and communities, cultures, subcultures and counter-cultures change over time. What is clear, however, is the persistent image of the 'folk devil' applied to young people who deviate from conformity, challenge authority and reject aspirations not of their own making. Also enduring are 'moral panics' associated with this imagery and its negative consequences, reflected in authoritarian policies and legislation.

This is not to deny that some children and young people can and do intimidate others, become involved in offending behaviour and commit acts of violence. On the street, in school, at home, the behaviour of some is sometimes 'anti-social'. What is not so clear is the impact of perception and social reaction. This Introduction proposes that the creation and reproduction of children and young people as 'folk devils' has a significant history. For those who experience marginalisation at several levels – through poverty, racism, sectarianism, sexism and homophobia – potential criminalisation, demonisation, targeted policing and regulation are ever-present features of their daily lives. In defining, assessing and responding to the assumed 'threatening' and 'anti-social behaviours' of children and young people, it is essential to locate understanding about their behaviour

within the social, cultural, political and economic contexts which shape and delimit their experiences. It is also important to listen to the accounts given by children and young people about their experiences of those contexts - of feeling and being socially excluded, of being labelled 'delinquent' or 'anti-social' and of being heavily regulated within and beyond their communities.

The significance of rights

In definitions of rights, distinctions are made between 'legal' and 'moral' rights. A legal right is 'an entitlement … acknowledged by an existing law in a specific state' - legal rights are context-specific rights which are actually possessed (Franklin 2002: 20-21). A moral right 'enjoys no legal endorsement' - commonly termed human rights or natural rights, such rights are claims for rights 'which it is believed … all human beings should possess by virtue of their common humanity' (ibid: 21). Not dependent on the domestic law of particular States, human rights are 'a universal entitlement of human beings, without regard to their claims as citizens to legal rights' (ibid). 'Human rights' principles include: 'treating everyone with respect and dignity; being fair and open when making decisions; working towards equality while valuing difference; ensuring everyone can reach his or her full potential' (Willow 2008: 191).

In 1959 the United Nations *Declaration on the Rights of the Child* was introduced. It stated that 'the child, by reason of his [sic] physical and mental immaturity, needs special safeguards and care, including appropriate legal protection, before as well as after birth'. It was followed thirty years later by the *United Nations Convention on the Rights of the Child* (UNCRC),

establishing children under 18 as 'rights-holders' in all aspects of their lives. With other international standards, the UNCRC provides benchmarks against which legislation, policy and practice concerning children can be measured. Its standards relate to how States should provide for and protect their children and how they should ensure children's participation in all aspects of their lives. The UK Government ratified the UNCRC on 16th December 1991 and it came into force on 15th January 1992.

The UNCRC combines economic, social and cultural rights with civil and political rights. General principles include: respecting children's rights without discrimination of any kind (Article 2); ensuring that the best interests of the child are a primary consideration in all actions concerning the child and that the child receives such protection and care as is necessary for her/his well-being (Article 3); recognising that every child has the inherent right to life, and that State parties ensure the survival and development of the child to the maximum extent possible (Article 6); assuring to the child capable of forming her/his own views the right to express these views freely in all matters affecting them, with their views being given due weight in accordance with the child's age and maturity (Article 12).

Distinctions are often made between 'welfare rights', which 'prioritise the provision for children's welfare needs and the protection of children even if this involves restricting children's choices and behaviour' (Franklin 2002: 21), and 'liberty rights' which 'focus on children's right to self-determination' and enjoyment of freedom in decision-making, even when this involves choices perceived not to be in the child's best interests (ibid). Liberty rights are often contested on the basis of

children's capability, or 'competence', to make and exercise choice. In debates about children's rights, there is a tension between acknowledging children's physical and emotional vulnerability and dependence on adults to meet their basic needs or safeguard their welfare, and their *structural* vulnerability as a social group that has minority status. Although not all children have the same experience of 'childhood' - as this is mediated through the contexts of their gender, sexuality, class, race, religion, culture, abilities, age and locality - they are consistently defined as different from, and subordinate to, adults. Generally they are denied access to power, excluded from decision-making processes, and deemed 'incompetent' at interpersonal and institutional levels (in families, schools, health services). Because they are not able to vote until they are 18 their views and experiences have no direct impact on the democratic process.

The role of the State in promoting and protecting children's rights is another contentious issue. Within the UNCRC, the State is expected to provide safeguards and protect the rights of individual children. In the UK and Northern Ireland, however, increased emphasis on the regulation of behaviour in public spaces has led to legislation inhibiting individual rights (such as the right to freedom of movement). Also, there has been discussion about whether some UNCRC rights can be considered 'rights' - they are more social ideas (about how children should be treated and what they should be granted if governments took rights seriously) than individual moral and legal rights. There is no 'test' providing guidance about what rights children have, or should have (Fortin 2003: 17-18).

Despite these limitations, Fortin argues that the language of rights 'is a politically

useful tool to ensure achievement of certain goals for children' (ibid: 18). Children's rights: 'offer a vehicle or a means to articulate the needs of children while also articulating the corresponding obligations on duty-bearers to fulfil them' (Kilkelly 2008: 11). Rights are an 'important advocacy tool', bringing 'legitimacy to pressure groups, lobbies, campaigns, to both direct and indirect action, in particular to those who are disadvantaged or excluded' (Freeman 2007: 8).

Researching in marginalised and conflicted communities

Given the focus of the research – understanding the lives of children in the context of marginalisation and conflict – it was essential to develop an inclusive and sensitive methodological approach. What follows is an overview of the empirical work, demonstrating how the research was conceptualised and conducted, and how the data was analysed. Apart from the qualitative methods used, as Chapter 2 demonstrates, a range of secondary documentary data was also analysed to set the empirical research in context.

Preliminary focus groups

To place children and young people at the centre of the research, preliminary focus groups were carried out with 24 young people aged between 16 and 25 years. All were unemployed and had underachieved in education. Some had recently left care and some were young offenders or ex-offenders. Their recent experiences of childhood and transition through youth into young adulthood were invaluable in shaping the focus of the research and in identifying key themes to be explored in the main project. The preliminary focus groups also enabled the piloting of data

collection methods. Ideas and stimulus material for data collection were developed, altered or removed as a consequence of responses in these groups.

Literacy difficulties and occasional low levels of concentration reinforced the value of stimulus material and oral information was recorded on a flip-chart, enabling conversations to flow. There were no constraints on participation and the participants were free to leave and re-join the group, reinforcing an open and flexible approach to data collection. While keen to participate, some young people were reluctant to give their names. The decision was taken to use verbal consent in the main phase of data collection and to assure anonymity.

Research sites

Selection of research sites was determined by communities that were heavily affected by the Conflict and also ranked high on indicators of economic deprivation. Through material deprivation indicators, area data, statistics on 'Troubles-related deaths' (Fay et al. 1998) and discussions with those working in the community and voluntary sector, twelve research sites were selected. The final sample was narrowed to six communities, urban and rural, one in each of the six counties of Northern Ireland. Five communities self-defined and were recognised as predominantly 'Catholic' or predominantly 'Protestant'. Reflecting the main political allegiances of these communities, where appropriate the terms 'Republican/ Nationalist' or 'Loyalist/ Unionist' are used throughout the report. One community was 'mixed', albeit segregated. It was decided that none of the research sites would be in Belfast because of the volume of research already conducted in the City's communities and

the lack of research in smaller towns and villages.

Community representatives

Through focus groups and personal interviews, 65 adults across the six communities participated. Defined as 'community representatives', their work in the communities included: generic and specialist youth and community work; health; child care and family support; formal and informal education; youth training; community restorative justice; community development; criminal justice; community or resident forums. Some worked generically with children and young people, others focused specifically on those deemed 'at risk', 'in need' and/ or experiencing social exclusion. They were identified primarily through searches of local directories of community-based child and youth organisations. Letters introducing the research were accompanied by an information leaflet providing full details about the objectives of the study and what their involvement would entail. A follow-up telephone call provided further information as required and, where possible, a meeting was arranged. Key issues covered in the meetings included: history and background to the area (specifically the impact of poverty and the Conflict); their work (including barriers and enablers); services for children and young people in the community (including gaps in provision); issues facing children and young people growing up in the community; further contacts in the community.

This was a lengthy process involving numerous visits to each community over several months. Time in the communities provided a grounded understanding of place and identity. It also provided

familiarisation with local provision, the layout of the area, internal (often invisible) tensions and divisions, places where young people 'hung out'. During this time, trust and rapport was established and consolidated. Representatives who had influence in the communities familiarised the researchers with their local community, supported the research through vouching for its credibility, encouraged others to participate and facilitated meetings in their premises. Planned interviews with individuals often developed into meetings with several people. This demonstrated interest in the research, commitment to children and young people in the community, and that these communities often felt excluded from research or consultations and were keen to have their voices represented.

Relationships between the researchers and the community representatives also reflected a commitment to reciprocity. The research team provided research papers and reports, deprivation statistics and area data that could be used by the community representatives in funding proposals and documents about their work. Those organisations working directly with children and young people were provided with an 'information pack' containing: information about children's rights; useful websites and resources; a poster of the UNCRC Articles to display in their building; copies of the resources used by the researchers when working with children and young people; 'certificates of participation' for children and young people; 'leaflets of help' containing information about local support and information services. Community representatives were also alerted to calls for funding and given information about useful

contacts, relevant programmes and training events.

Discussions with community representatives provided background information, perspectives and contexts relating to each community (particularly in relation to the impact and legacy of the Conflict and gaps in services for children and families). Without the support and dedication of those working with and for children and young people in each community, access to children and young people would have been difficult. Some of the young people involved in the research were particularly 'difficult to reach', and securing the trust of their workers was crucial to their participation.

Children and young people

In addition to the preliminary focus groups, 196 children and young people aged between 8 and 25 participated in the research. While recognising that the UNCRC defines all under-18s as children, those involved in the research distinguished between 'children' as under-13s and 'young people' as 13-25. The main focus on young people is the age range 13-17. Table 1 (Appendix, page 157) provides a breakdown of participants.

The limitations of school-based research, especially with children and young people labelled 'difficult pupils', is well-established (see Punch 2002; France et al. 2000; Tisdall et al. 2004). Thus children and young people were accessed through youth and community groups or organisations. Community representatives also informed children and young people about the research and arranged some meetings. Access to all age groups in each community was not easily established. The relatively small number of older young

people (18-25 years) involved indicates the difficulties in accessing this age group, given that they were no longer at school and were not generally involved in youth/community provision (Geraghty et al. 1997; Haydon and McAlister 2009; McAlister et al. 2007; Youth Council for Northern Ireland 2004).

A combination of methods was essential and included focus groups as well as one-to-one interviews. Similar processes were used within each community to gain informed consent, ensure the comfort and well-being of children and young people and explore key themes. Prior to data collection, each child or young person was given an information sheet outlining: the researchers and their contact details; the research and why it was being carried out; the issues to be discussed and time commitment; their right not to participate and to withdraw at any stage; processes concerning data protection, anonymity and confidentiality; how the information provided might be used. These issues were discussed in detail within focus groups and with individuals before discussions started and verbal consent was gained from each individual.

Focus groups ran between 45 minutes and three hours (including breaks). As the research emphasised a participatory approach and questions were open-ended, focus groups provided an interactive method of data collection, enabling participants to define and prioritise issues. They capitalised on the interaction within the groups and provided a means of breaking down some of the power imbalances inherent in social research (see: Kitzinger 1995). In practice, the participants talked openly and freely, interacting more with each other than with the researcher. This ensured that

they asserted greater control over the discussions, defining issues on their terms. The researcher acted as a facilitator, guiding rather than constraining the discussion.

Interaction and conversations within the groups allowed for issues not considered by the researchers to be raised. Disagreement within groups often led some participants to challenge the viewpoints of others. This happened regularly in discussions about children's rights, 'insiders' and 'outsiders', and poverty. Discussion and disagreement among participants led to a deeper understanding of issues than is possible in one-to-one interviews. Focus groups also provided a useful means of exploring sensitive topics as participants had the opportunity and space to explore such issues in a less threatening, group environment. Challenges and ethical considerations concerning group dynamics, confidentiality and privacy that might arise during focus group interaction were identified by the researchers and discussed thoroughly with each group.

In facilitating the focus groups, comfort and refreshment breaks were agreed and participants were free to come and go throughout. This was useful in ensuring that consent was ongoing, and there was no pressure to request withdrawal. All who did leave during discussions returned. Considerable attention was given to developing 'child-friendly' methods of data collection, and a range of interactive tasks was compiled to stimulate focus group discussion about specific topics. Young people engaged primarily because the issues, rather than the methods, were meaningful and relevant to their lives. Those who were often described as 'difficult to engage' stayed for the duration,

participating openly and freely. As one young person noted:

> "Sittin' here now [in the focus group] we have the right to be heard, we're bein' heard, but if this was out on the street and we were tryin' to tell people, we wouldn't be heard."

In addition to focus groups, interviews were also conducted with individual children and young people who were not part of groups and had experienced particular 'vulnerabilities'. Asked questions about the same topics as those in focus groups, they gave detailed personal accounts of life experiences that could not have been achieved through any other method of data collection.

Following completion of the focus groups or one-to-one interviews, an information leaflet about local advice and support services was provided for each participant. The research team contact details were listed, should they require further help or information. Individuals were also given a small poster listing the UNCRC Articles and a Save the Children booklet entitled *Wise up on having your say: young people's right to be listened to.*

Data analysis and presentation of findings

Most interviews and focus group discussions were tape recorded, with participants' consent, and transcribed verbatim. Where this was not possible, one of the research team took detailed notes. Transcripts were analysed to identify themes and a loose conceptual framework was developed. Each line, paragraph or section of text was coded, with new codes added and others merged until saturation was reached. Data analysis within each thematic category enabled key messages, commonalities and differences

to be identified. This was followed by an interpretive analysis through which data across all categories was read. This enabled the identification of cross-cutting and related themes, as well as underlying issues pertinent to the experiences of all children and young people or specific groups.

The sensitivity of the research presented ethical issues regarding the presentation of data. To retain anonymity, many community representatives did not want to be identified by profession. Thus, the generic term 'community representative' is used throughout the report. This is imperative to ensure that those involved in research are not harmed or placed at risk because of their participation. Particular concerns related to discussions about paramilitary or dissident activities in communities and criticisms of employers/ professions. Consequently, it was agreed from the outset that communities would not be named other than by County. In drafting the report, however, it became evident that participants may be identified by their quotes or reference to specific events. Where this is the case, particularly in discussions about violence, counties have not been named.

NORTHERN IRELAND: TRANSITION FROM CONFLICT

Recent political context

Signed by the UK and Irish Governments, the *Belfast/Good Friday Agreement* (NIO 1998) provided the constitutional foundation for devolution through a democratically elected Northern Ireland Assembly. According to Harvey (2003: 1002) the Agreement was 'complex' and 'imaginative', establishing a workable 'political framework' in the context of 'an international agreement between the UK and Ireland ... mapped onto domestic law and practice'. While safeguarding and promoting human rights, it prioritised: sustainable economic stability and growth; equality and social inclusion; normalisation of state security operations and practices; representative and accountable civil policing; review of criminal justice; disarmament of all paramilitary organisations; the early release of politically-motivated prisoners.

Following elections in 1998, and the establishment of full delegated powers in December 1999, the Assembly experienced continual controversy (particularly regarding arms decommissioning by paramilitary organisations). Consequently, the Executive was suspended in October 2002 for the fourth time and UK Government direct rule was resumed. In October 2006, the *St Andrews Agreement* (NIO 2006) led to the resumption of devolution seven months later and the election of a four-party Executive of twelve Ministers. The UK Secretary of State for Northern Ireland retained responsibility for 'excepted' and 'reserved' matters, the latter including criminal justice and policing.

An independent commission on policing also emerged from the 1998 *Agreement*. Its objective was to secure a police service 'professional, effective and efficient, fair and impartial, free from partisan political control; accountable, both under the law for its actions and to the community it serves; representative of the society it polices, and operat[ing] within a coherent and cooperative criminal justice system, which conforms with human rights norms' (Patten 2000). In November 2001 the Police Service of Northern Ireland (PSNI) succeeded the Royal Ulster Constabulary (RUC). In 2007 Sinn Féin, the elected Assembly's second largest political party, formally agreed to participation in the governance of policing throughout Northern Ireland and to advocate an acceptance of the PSNI in Nationalist and Republican communities.

The impact and legacy of the Conflict

Between 1969 and 1999, 3,636 people died in the Conflict, 2,037 of whom were civilians (McKittrick et al. 1999: 1477). During that period Northern Ireland's population was approximately 1.5 million. A 2003 household survey on poverty and social exclusion found that half of those interviewed knew someone who had been killed. An estimated 88,000 households were affected by the loss of a close relative, and 50,000 households contained at least one resident who was injured. Approximately 28,000 people were forced to leave work and 54,000 households were compelled to relocate through intimidation, threats or harassment (Hillyard et al. 2005: 6). Approximately 80,000 men, women and young people were imprisoned (ibid: 8). The impact of internment without trial and imprisonment during the Conflict was borne disproportionately in poor communities. Incarceration had significant consequences for families, especially children, who experienced financial

hardship, mental ill-health, difficulties maintaining relationships with imprisoned parents, and problems adjusting to their parent's release (Spence 2002; Jamieson and Grounds 2002).

While much has been written about the impact of the Conflict on communities, whatever their cultural tradition or location, scant attention has been paid to children and young people. Smyth et al. (2004: 90) note that, of those killed, 40 per cent were under 25. Between 1969 and 2003, 274 children aged 17 or under and 629 young people aged 18-21 lost their lives. Almost three quarters of those under 18 killed were Catholic, a fifth were Protestant (ibid: 18-20). The majority lived in areas experiencing the highest levels of deprivation and poverty. Children, particularly in Nationalist/ Republican communities, witnessed house searches by the British Army, forced entry into homes and arrests in the early hours of the morning by armed police, imprisonment of parents or parents going 'on the run', violent confrontations and death on the streets. A community bereavement counsellor stated: 'House raids are over to a point and the physical harm is over; but the emotional harm is there and it's not recognised' (Kilkelly et al. 2004: 243). Her concern was that, while severe forms of violence have lessened, children whose past trauma went unrecognised and untreated have become parents.

Within some communities children regularly experienced the impact of injury, death and bereavement. Their fear of violence extended to informal 'policing' by paramilitaries who administered severe physical punishments to those involved in alleged 'unacceptable' behaviour in their communities. Based on police statistics, Smyth et al. (2004: 88-89) note that

between 1988 and 2002, 496 young people under the age of 20 received paramilitary punishment beatings and 388 were shot, usually through the knees or thighs - 24 per cent of Loyalist punishment beatings and 32 per cent of Republican punishment beatings were inflicted on young people under the age of 20 (ibid). Cessation of punishment beatings and shootings were part of the agreed withdrawal of paramilitary activity in communities. Yet police statistics reveal that between 1999 and 2009 there were 1,958 casualties from 'paramilitary-style' shootings and assaults (PSNI 2009). These figures are likely to under-estimate paramilitary attacks given that only the most serious are reported to the police. Further, threats and intimidation continue to be directed towards children and young people accused of 'anti-social behaviour', particularly in economically deprived urban areas associated with high levels of conflict-related violence (Kilkelly et al. 2004; Smyth et al. 2004; Hansson 2005; Haydon 2007; Roche 2008).

Smyth et al. (2004: 96-98) suggest that research, media reports and organisations responding to the effects of the Conflict tended to focus on areas and neighbourhoods 'relatively more exposed to events in the Troubles than average'. This led to infrequent experiences - being the victim of a punishment attack, joyriding or severe trauma - receiving widespread publicity. Routine events, such as being stopped and questioned by the police or attacked on the way home from school and the pervasiveness of sectarianism, were ignored and unaddressed. Consequently, less dramatic but more prevalent experiences were 'normalised', resulting in 'chronic anger, lack of trust in adults, isolation and feelings of marginalisation,

bitterness at the other community or at the police, distrust of all authority, feelings of exclusion and marginalisation or lack of contact with or knowledge of the "other" community' (ibid: 99). Vulnerability 'is not only experienced by individuals, but also by whole families and communities'. Recognising the significance of trans-generational trauma, Smyth et al. conclude that 'adults on whom children and young people could ordinarily turn to for support or protection are more often than not exposed to the same traumatic events that the children are, and are themselves traumatised and sometimes incapacitated – either in the short or long term' (ibid: 109).

Health and well-being

Since the initiation of the Peace Process there has been an increase in the diagnosis of conflict-related trauma: 'it is only with the development of a peace process that most people have been able to acknowledge their own personal traumatisation' (Gilligan 2006: 326). The 'emotional effects of the Conflict' were particularly severe in economically deprived and under-resourced communities. Yet, as noted in O'Rawe's (2003) audit of child and adolescent mental health provision, appropriate and adequate service provision were, and remain, seriously deficient. Health professionals and community workers note 'collateral damage' of the Conflict (Kilkelly et al. 2004: 112), stating that among children and young people living in some of the most deprived communities there is evidence of 'anxiety, depression, deliberate self harm and escalating suicide rates'. They identify the immediate need for mental health support - particularly for those children and young people in conflict with the law. A children's caseworker stated:

When you're raising mental health care for this generation, post-conflict, we're dealing with a huge age range of people who've been the bereaved, the injured, been the children of those who were killed. And another generation who are the children of the children … the impact of the trauma, which they're calling trans-generational trauma … it's affecting children's education, their mental health and their ability to participate in society (ibid: 243-4).

Speaking from direct experience, another health care professional concluded:

Some of the most vulnerable young people in our society, children who have been exposed to indescribable levels of trauma and abuse, are having decisions made based on resource availability rather than need … due to the crisis in the service, we can no longer keep them safe. They may end up on the street or another suicide … no-one is really listening. No-one is doing anything (ibid: 113).

Across Northern Ireland, over 20 per cent of children under 18 suffer significant mental health problems (Chief Medical Officer 1999). According to Kilkelly et al. (2004: 113), despite forming 25 per cent of the population, under-18s are allocated less than 5 per cent of the mental health budget. O'Rawe (2003) notes that in 2001-02, due to lack of discrete facilities, 130 children were admitted to adult mental health units. Proportionately, this was five times the number for England and Wales. In 2003-04 children occupied 2,386 bed days in adult psychiatric wards (DHSSPS 2005a) – settings noted by Inspection teams to be unsuitable (DHSSPS 2005b: 13-14). The Bamford Review found that child and adolescent mental health services

were 'wholly inadequate … characterised by overwhelming need and chronic under-investment' (McClelland 2006: 13).

Between 1999 and 2003, the Northern Ireland suicide rate was higher than in England and Wales, and lower than Scotland and the Republic of Ireland (DHSSPS 2006: 7). The figures for 1991-2004 show a rate twice as high in economically deprived areas, and in communities that had suffered the highest levels of economic deprivation and persistent violence throughout the Conflict (DHSSPS 2006: 12-13). There was a significant increase in recorded suicides from an average of 150 each year (2000-2004) to 213 in 2005. The following year 291 was the highest number of suicides recorded for any one year (Tomlinson 2007).

Given the 'post conflict' rhetoric, a key issue has been failure to identify the long-term consequences of trans-generational trauma. Issues such as 'difficulties in concentrating' or 'aggressive behaviour' are regularly 'misinterpreted by others, being seen as deliberately disruptive behaviour' (Smyth et al. 2004: 43). The inter-relationship of unaddressed conflict-related trauma, interpersonal violence within families, continuing paramilitary intimidation, forced exiling, economic marginalisation and social exclusion constitute 'special circumstances' for children, young people, their families and communities in Northern Ireland.

Additional difficulties include limited access to high quality, age-appropriate childcare and family support. This extends to lone parents, families living in poverty, parents of older children, migrant workers and parents of children with disabilities (Haydon 2008). Horgan (2005: 12) argues

that lower *per capita* spending, higher levels of child poverty and subsequent family difficulties, have resulted in a disproportionate allocation of resources to statutory protection rather than investment in much-needed preventative interventions.

Segregation and social divisions

Within and between communities, a range of general and specific cues are used to categorise individuals according to religious identity - names, accent or dialect, school uniform, football team affiliation, designer label. Perceptions of difference and negative attitudes towards the 'other' are based on assumptions that the 'other community' is treated more favourably (Leonard 2004). Communities are demarcated by flags, murals and symbols in a display of identity, territory and control of space. Segregation, in public housing and schooling, remain defining features of social, political and cultural experiences and opportunities.

Approximately 95 per cent of Northern Ireland's social housing is segregated by religious affiliation (NIHE 2006). According to the 2001 Census over half the population lives in exclusively Catholic or Protestant neighbourhoods. Recent figures from the Northern Ireland Office indicate that there are 53 'peace lines/walls' in four towns and cities (*BBC News*, 1 July 2009), and this number has tripled since the ceasefires (*The Guardian*, 28 July 2009). In a 2003 survey, 72 per cent of respondents with children or grandchildren under 19 years of age stated that they would choose an integrated school if there was one close to where they lived (Millward Brown 2003: 6-7). Yet, in 2007-08, only 6 per cent of the school population was enrolled in integrated nursery, primary or post-primary schools (DENI 2008: 2). Leisure facilities and other services within

predominantly Catholic or Protestant communities are not accessed by children and young people living outside the community (Hansson 2005: 28; Byrne et al. 2005; Shirlow and Murtagh 2006).

Almost half of those interviewed in research exploring the impact of fear in Belfast interface communities, stated they would not travel through an area housing the 'other' community during the day, rising to 88 per cent at night (Shirlow 2003: 86). One in eight respondents had denied themselves, or younger family members, necessary healthcare because the nearest health facilities were located in areas outside their community (ibid). Actual and feared intimidation, abuse, verbal and physical violence remain key factors in sustaining exclusivity and maintaining geographical boundaries. This is illustrated further in Shirlow's research which revealed that, of the 18-25 year olds surveyed in Belfast, 68 per cent reported they had never had 'a meaningful conversation' with anyone from the 'other' community (*Sunday Tribune*, 28 August 2005). Intimidation and fear reinforce the legacy of 'no-go areas', where individuals may be targeted because they are perceived to belong to the 'other' community.

Although there has been a significant reduction in violent sectarian incidents, children and young people living in 'interface' areas (those geographical points where segregated cultures meet) continue to be involved in sporadic outbreaks of violence or 'disturbances'. These include verbal attacks and throwing stones, bottles or fireworks (Hansson 2005). Leonard's research, with children and young people in Loyalist and Nationalist interface areas of North Belfast, illustrates the durability of sectarianism and the consolidation of physical boundaries marked by continuing

hostility. While children generally considered confrontations had calmed - 'less bombings and shootings' - some sensed 'more hatred than in the past' (Leonard 2004: 105). There was a 'sense of inevitability and permanence about the conflict'. All were 'pessimistic about the possibility for conflict resolution in Northern Ireland' (ibid). Reflecting on day-to-day negotiation of social space and possible cross-community interaction, 'peace ... remained a distant vision' (ibid: 107). Likewise, young women living in a variety of urban and rural communities across Northern Ireland reported feeling disillusioned with the peace process and pessimistic about the promise of peace (McAlister et al. 2007).

While the 14-year-olds in Leonard's study often found rioting exciting and an escape from boredom, more profoundly it provided 'a mechanism for demonstrating religious/ sectarian identity ... a way of emphasising the internal cohesiveness of the group' (Leonard 2004: 44). Smyth et al. (2004: 104) consider such confrontations enabled and reflected continued recruitment by paramilitaries. Leonard (2004: 7) also notes the complexity of 'territory' and its relationship to religious and political identity. The relatively small area of North Belfast 'contains around 24 interfaces' and 'eight of the official Belfast peace lines'. Children identified 'strong ties, family, friends and neighbours' as the most positive aspects of life in their neighbourhood. In contrast, negative aspects included: the area's appearance; lack of amenities; availability of alcohol and drugs; joy-riding; paramilitaries; rioting. 'Fear of verbal and physical intimidation and violence' inhibited children's freedom of movement and neighbourhoods 'outside the children's immediate locality' were 'labelled as spaces

of risk and fear' (ibid: 76; see Hansson 2005).

Despite teachers and pupils referring to schools as places of safety, Leonard (2004) details how schools close to interfaces remained flashpoints for serious violence, including attacks on school buses, vandalising or torching teachers' cars, and sectarian attacks in and close to school grounds. Children attended school behind locked gates under the supervision of security guards. Playgrounds were not used because of stone-throwing over the high fences. Children moving between home and school were regularly verbally abused and spat on. While these experiences are more pronounced for those living in interface areas, they are not exclusive to these areas. Kilkelly et al. (2004) found that children and young people in various locations across Northern Ireland reported sectarian abuse on their way to and from school.

In addition to inter-community conflict, children and young people also experience intra-community violence. Within some Loyalist communities, exacerbated by a protracted feud between two paramilitary groups, forced exiling has led to children and families leaving their homes, schools and friends. Between August and October 2000, for example, 263 families were exiled from one Loyalist community. They included 269 children, 178 of whom were aged 11 years or under. A community-based working group recorded that approximately 1,000 individuals were affected as 'many families are not living at home and are dispersed throughout the area because of death threats made on their lives' (Inter-Agency Working Group on Displaced Families). Throughout this displacement children witnessed intimidation and assaults, the ransacking

of homes and the destruction of furniture. According to Smyth et al. (2004: 83), in Republican communities tensions between dissident, anti-Agreement groups and the IRA were less significant, but recent events suggest this is changing.

The dual impact of poverty and the legacy of the Conflict

Hillyard et al. (2005: xx) state that the 'relationship between poverty and conflict' in Northern Ireland's history is 'strong' yet 'complex'. The Conflict severely undermined economic investment and development, exacerbated child poverty, and contributed to high levels of mental ill-health resulting in impaired employment opportunities (Horgan 2005: 13). Poverty in Northern Ireland is heavily concentrated. In 2006, of 566 wards, 25 (4.4 per cent) recorded child poverty above 75 per cent compared with 180 out of 10,000 (1.8 per cent) wards in Britain (McLaughlin and Monteith, 2006). Under-resourcing has been a long-term and institutionalised issue. Magadi and Middleton (2007) found that one third of children in Northern Ireland live in income poverty and one in ten live in severe poverty. In the period 2001-2004, 21 per cent of children were trapped in persistent poverty, compared to nine per cent in Britain (Monteith et al. 2008: 3). Lone parent families and couples with children have relatively lower income levels than those in Britain and low welfare benefit levels leave families below the UK Government's poverty threshold. Essential goods, food, clothing and services cost more than in Britain, compounding income deprivation.

While children and young people under 18 receive free health care, families living in poverty have unequal access to health care services and poorer health outcomes (Chief

Medical Officer 2007). Travellers and minority ethnic families also experience direct discrimination, intimidation and assault. As discussed above, mental ill-health remains a major issue, particularly in economically marginalised communities. The implications for children living in poverty in Northern Ireland are well-documented (see: Save the Children 2007; Horgan 2009). They endure poor quality accommodation, often in environments with high rates of crime and poor physical conditions. They are subjected to higher accident rates, poor diet, parental stress, physical and mental ill-health and lower life expectancy. Educational attainment is low. Poorer children report that they do not receive the same quality of education as those living in advantaged areas and their experiences of school are 'narrower and less rich' (Horgan 2007: 1). In disadvantaged areas, boys as young as nine are already disengaged from school (ibid). Further, they have limited access to safe play areas and public leisure facilities. Given that poverty remains pervasive in areas most affected by the Conflict, children and young people living in these areas experience multiple deprivation. This affects their childhood opportunities, self-esteem and relationships.

The regulation and policing of children and young people

Since the mid-1990s numerous meetings, consultations and conferences have considered the 'unfinished business' of the past, attempting to identify and resolve political differences regarding policing. Much debate has focused on the related issues of operational policies, priorities and practices within an ambiguous notion of 'normalisation'. The Patten Report (2000), however, envisaged transition towards a new framework for policing that might address problems of power and accountability prevalent in Britain and other democratic states. Despite extensive and 'inclusive' consultations conducted by Patten across communities in Northern Ireland, and the high profile of a vibrant children's sector, the most significant identifiable group in daily contact with the police - children and young people - was not consulted. This is not untypical. When 'community groups' or local residents' associations meet with police or community safety officers to discuss policing their neighbourhoods, children and young people are rarely invited despite their behaviour often being the main topic for discussion.

Issues raised by young people regarding their experiences of the police consistently present disturbing alternative accounts to official commentaries. As Radford et al. (2005: 360) note, despite the wealth of research on policing in Northern Ireland 'the relationship between the police and young people has not been subject to extensive consideration'. What follows is evidence drawn from key, independent studies of young people and policing. Hamilton et al. (2003) surveyed 1,163 young people aged 16 to 24 and held 31 focus groups. During the previous 12 months, 56 per cent of young men and 28 per cent of young women participants had contact with the police. Their experiences were predominantly negative, with a quarter expressing a high level of dissatisfaction with the PSNI. They were constantly stopped for questioning and frequently moved on; interventions they perceived as intimidation and harassment. Targeting children and young people 'included physical violence, a constant police presence and being watched,

confiscation of goods and verbal abuse' (ibid: 6). Fifty-eight per cent reported unacceptable behaviour by the police, mainly in the form of disrespect and/or impoliteness.

Ellison (2001: 133) refers to these police interventions as 'adversary contact' leading to police-community tensions. He found that males aged 14 to 17 were three times more likely to be stopped and searched than were 18 year-olds. Children from 'socio-economically disadvantaged areas' were more than twice as likely to have been stopped and searched. There was a marked difference in perceptions of the police between young Catholics and young Protestants: '92.6 per cent of Catholic males who have been stopped and questioned by the [then] RUC "too many times to remember" believed this to constitute harassment, compared to 60.3 per cent of Protestant males' (ibid: 133). Ellison's research was conducted post-Patten. He notes significant support among young Catholics for change. While a fifth of Protestant young people agreed with slight reform, the majority supported the *status quo*. More recently, Ewart et al. (2004: 8) found that young people who identify as Catholic were more likely to consider police reforms had 'not gone far enough', while those identifying as Protestant were more likely to consider reforms 'went too far and discriminated against Protestants'.

Alvaro Gil-Robles, European Commissioner for Human Rights, raised concerns about the relationship between poverty, social exclusion and 'community justice' in Northern Ireland. He recognised post-Peace Process improvements in quality of life for many people while noting that

'others, across the religious divide, have less demonstrably benefited from economic advances ... one cannot but suppose that tensions and distrust will linger longer in disadvantaged, socially isolated communities ... exclusion and poverty facilitate the continuing control of such communities by criminal and paramilitary structures' (Gil-Robles 2005: 50). He concluded:

> All individuals have a right to be free of such oppressive influence. Crime, violence and parallel 'community justice' would appear, however, to remain low-level cancers at the heart of Northern Ireland's poorest communities ... tackling this phenomenon, through both social and economic investment and effective policing, will necessarily be a long and difficult process. It must, however, remain a priority.

In the submission by the UK Children's Commissioners to the UN Committee on the Rights of the Child, the Northern Ireland Commissioner noted that punishment beatings have 'not been traditionally dealt with as child abuse by the relevant authorities'. She considered that further action should 'be taken by the police, social services and other relevant agencies to protect children and young people from abuse by adults within their own community' (UK Children's Commissioners 2008: 16).

Responding to the civil policing deficit, community-based restorative justice schemes offer an alternative to community punishments. Established in Loyalist and Republican communities, they deal with alleged low-level crime and anti-social behaviour by young people. This involves negotiations within communities regarding paramilitary punishment beatings,

control of children's movement within communities, 'naming and shaming' of young people and their alleged offences. Their aims include: challenging and reducing offending or harmful behaviour in communities, developing opportunities for reconciliation of offenders and victims, and encouraging safe environments in a context where there is lack of trust within communities relating to intervention by statutory agencies. The positive contribution of these schemes was acknowledged in 2006 by the Independent Monitoring Commission as well as in an independent evaluation of Community Restorative Justice Ireland (CRJI) and Northern Ireland Alternatives (NIA) (Mika 2006).

With children's 'anti-social behaviour' receiving significant media coverage, Anti-social Behaviour Orders (ASBOs), controversially introduced in England and Wales, were promoted politically as an effective alternative to criminal justice interventions and punishment beatings in Northern Ireland. Yet little recognition was given to the success of functioning community-based restorative justice schemes. In its submission to the NIO consultation document, *Measures to Tackle Anti-social Behaviour in Northern Ireland*, a young people's organisation observed that ASBOs had 'the potential to demonise and further exclude vulnerable children who already find themselves on the margins of society and the communities in which they live' (Include Youth 2004: 5). Further, and carrying potentially serious consequences, was the relationship of ASBOs to paramilitary punishments of children.

ASBOs and evictions were proposed in circumstances where naming, shaming, beatings, shootings and exiling persisted. As a children's NGO focus group

concluded of punishment attacks: 'It's seen and represented as justice. It's concrete and immediate … a quick fix. It doesn't work. It's brutal, inhuman and ineffective and doesn't challenge anti-social behaviour' (Kilkelly et al. 2004: 229). The Northern Ireland Human Rights Commission (NIHRC 2004: 8) noted: 'Information regarding the identity, residence and activities of those subject to an order [will] be in the public domain and could lead to the breach of a right to life were paramilitaries to act on that information'. Community negotiations regarding paramilitary and vigilante interventions in the lives of children and young people had been initiated and were making progress. I was within this delicate climate of political and social transition that anti-social behaviour legislation was imposed.

In June 2005 European Human Rights Commissioner Alvaro Gil-Robles expressed 'surprise' at the Executive's 'enthusiasm' for the 'novel extension of civil orders', not least 'particularly problematic' Anti-social Behaviour Orders (Gil-Robles 2005: 34). He raised four principal concerns: 'ease of obtaining such orders, the broad range of prohibited behaviour, the publicity surrounding their imposition and the serious consequences of breach'. Given the limiting form of conditions in many cases, breach was 'inevitable'. In effect, ASBOs were 'personalised penal codes, where non-criminal behaviour becomes criminal for individuals who have incurred the wrath of the community'. As the UK Government sought to defend its policies against such critiques, the Northern Ireland Office published a consultation document on community safety seeking to expand, rather than reduce, the use of civil orders (NIO/CSU 2008). Proposals included importing heavily criticised

policies and legislation from England and Wales – the introduction of dispersal zones, 'information sharing', individual support orders, parental compensation orders, parent support contracts, parenting support orders.

The severe criticisms levelled against these policies include: a disproportionate focus on children, young people and families living in economically deprived areas; increased pressure on 'vulnerable families'; added strain on child-parent relationships (Donoghue 2008); deepening distrust of the police; undermining relations between young people, the police and adults in the community (Crawford and Lister 2007; Garrett 2007; Sadler 2008). Again, the 'special circumstances' of Northern Ireland appear to be ignored in yet another example of policy transfer from England and Wales. Relationships between some communities and the 'new police force' remain strained, and the dispersal of children and young people to the boundaries of the community will increase the potential of victimisation through sectarian attack. Given the media's demonisation of children and young people, 'fear of crime' has been reinforced by an assumption that their presence on the streets causes public 'alarm' or 'distress'. Addressing public perception of crime through designating specific streets as dispersal zones will exacerbate and encourage negative stereotyping and increasingly punitive measures directed towards children and young people. Rather than meeting the *Community Safety Strategy's* stated objective of focusing on social inclusion, the likely outcome is increased exclusion, marginalisation and alienation within targeted communities.

Children's rights in Northern Ireland

Given the recent history of conflict and on-going marginalisation of children and young people, the implementation of children's rights and compliance with international standards is particularly significant. The first Northern Ireland Commissioner for Children and Young People (NICCY) was appointed in 2003 with the principal aim of safeguarding and promoting the rights and best interests of children and young people. In 2006 the Office of the First Minister and Deputy First Minister (OFMDFM) produced a ten year *Strategy for Children and Young People*. It stated: 'We are committed to respecting and progressing the rights of children and young people in Northern Ireland and will be guided and informed by the *UN Convention on the Rights of the Child*' (OFMDFM 2006a: 23). However, the Strategy is not a plan for implementation of the UNCRC as it does not include mechanisms to ensure compliance by all government departments with children's rights standards.

Northern Ireland does not have a Minister for Children. Two Junior Ministers in OFMDFM were given responsibility for children and young people within their portfolios in June 2007. In January 2008 one stated:

> As champions for children we are committed to ensuring that their voices are heard and that we adopt an integrated approach across government in tackling the many issues which face today's youth. Child poverty is a key priority for the Executive and we are committed to delivering excellent public services to improve children's life chances and help break cycles of

deprivation as well as supporting parents so they can confidently guide their children through the various stages of life. (Northern Ireland Executive 2008a).

A Ministerial Sub-Committee for Children and Young People has identified key priorities, including: child poverty; early years; vulnerable young people (looked after children, those engaged in anti-social behaviour and in contact with the criminal justice system, those experiencing mental health issues, children with disabilities); safeguarding, including support for parents, families and carers, children with special educational needs. Each government Department has identified a 'champion for children and young people' at senior level. Within the *Programme for Government 2008-2011*, OFMDFM is responsible for driving a 'programme across Government to reduce poverty, address inequality and disadvantage' in which one of the targets is to 'ensure the central role of the rights of the child' (OFMDFM 2008: 36). The Department of Health, Social Services and Public Safety (DHSSPS) has responsibility for ensuring that 'children are cared for, live in safety, are protected from abuse, receive the support they need to achieve their full potential, become more independent and grow into well-adjusted adults, taking their place in the community' (ibid: 24). DHSSPS also has responsibility for promoting healthy lifestyles, addressing the causes of poor health and well-being and achieving reductions in health inequalities and preventable illnesses (ibid: 37). Objectives for the Department of Education include helping children and young people achieve through education (ibid: 39) and raising standards in schools (ibid: 49).

OFMDFM has established a Participation Network to support engagement with children and young people in decision-making processes by statutory agencies, local government and government departments. Launching this initiative, one of the Junior Ministers stated:

> Our children have a very positive and real contribution to make to our society. We value them, we want to listen to them and we want to empower them to be able to change the world around them. By finding new ways to consult effectively and directly with them on issues affecting their lives, we hope to both improve the quality of their lives as well as ensuring we deliver services that meet their needs (Northern Ireland Executive 2007b).

In 2002 the Children and Young People's Unit (CYPU) was established within OFMDFM: 'to ensure that the rights and needs of children and young people living in Northern Ireland are given a high priority'. The CYPU is responsible for overseeing implementation and evaluation of the ten year Strategy For Children and Young People and supports the Junior Ministers in their responsibilities relating to children and young people's issues. The Unit sponsors and monitors the Commissioner for Children and Young People, and co-ordinates responses on behalf of Northern Ireland government departments to the UN Committee on the Rights of the Child and other treaty bodies whose work relates specifically to children.

Different government departments, however, adopt different approaches concerning the status of UNCRC rights, with limited co-ordination of legislation and policy. There has been no audit of existing legislation to ensure compliance

with the UNCRC. Nor has a framework been developed to assess whether new legislation affects children's rights. While the recent process of reporting to the UN Committee on the Rights of the Child provided an opportunity to monitor implementation of the UNCRC, much of the data presented in the UK Government's (2007) Report did not critically analyse the *impacts* on children's lives of legislation, policy, strategies or allocation of funding.

As part of the reporting process, a *Northern Ireland NGO Alternative Report* (Haydon 2008) assessed the situation for children and young people. It noted a range of significant issues affecting children and young people as a social group, as well as the rights violations experienced by specific groups such as children living in poverty; those from minority ethnic communities, including Travellers; looked after children and care leavers; LGBT young people; children and young people with disabilities; children in conflict with the law.

Taking this and other submissions into consideration, in its Concluding Observations the UN Committee (2008: paras 10-20) raised a number of concerns relating to implementation of the Convention in the UK: the Convention has not been incorporated into domestic law in the UK or Northern Ireland; it is not used as a framework for development of strategies; the independence and powers of Children's Commissioners are limited; lack of budgetary analysis makes it difficult to identify how much expenditure is allocated to children and whether this serves to effectively implement legislation and policies affecting them; low level of knowledge about the Convention amongst children, parents and professionals.

The Committee was concerned that certain groups of children 'continue to experience discrimination and social stigmatisation' (for example: Travellers; migrants, asylum-seekers and refugees; LGBT young people; those belonging to minority groups) (ibid: para 24). It was particularly concerned 'at the general climate of intolerance and negative public attitudes towards children, especially adolescents, which appears to exist in the State party, including in the media, and may be often the underlying cause of further infringements of their rights' (ibid). The Committee regretted that the principle of the best interests of the child 'is still not reflected as a primary consideration in all legislative and policy matters affecting children', especially in juvenile justice, immigration and freedom of movement and peaceful assembly (ibid: para 26). In relation to respect for the views of the child, the Committee was concerned 'that there has been little progress in enshrining Article 12 in education law and policy' (ibid: para 32).

Further concerns relating to issues within families (ibid: paras 40-50) included: failure to explicitly prohibit corporal punishment in the home; lack of appropriate assistance, notably for those in a crisis situation due to poverty; and high prevalence of violence, abuse and neglect of children. Health-related concerns (ibid: paras 54-62) included: inequalities in access to health services; limited access to required treatment and care for young people with diagnosable mental health problems and that 'in Northern Ireland – due to the legacy of the conflict – the situation of children in this respect is particularly delicate' (ibid: para 56); high rate of teenage pregnancies; incidence of alcohol, drugs and other toxic-substance use by adolescents. The Committee expressed

concern that 'poverty is a very serious problem affecting all parts of the UK ... and ... is a particular concern in Northern Ireland, where over 20 per cent of children reportedly live in persistent poverty' (ibid: para 64).

The Committee's concerns regarding education (ibid: para 66) included: persistence of inequalities in achievement for children living with their parents in economic hardship; problems enrolling, continuing or re-entering mainstream education or alternative provision for some groups (for example: Travellers, asylum-seekers, 'drop-outs' and non-attendees, teenage mothers); inadequate participation of children in all aspects of schooling; bullying, which may hinder attendance and learning; high numbers of permanent and temporary exclusions; segregated education and academic selection at the age of 11 in Northern Ireland. The Committee was concerned that 'the right to play and leisure is not fully enjoyed by all children' and that a reduction in playgrounds has the effect of pushing children into gathering in public open spaces – a behaviour that 'may be seen as anti-social according to ASBOs' (ibid: para 68). Commenting specifically on ASBOs, the Committee raised concern about: 'the ease of issuing such orders, the broad range of prohibited behaviour and the fact that the breach of an order is a criminal offence with potentially serious consequences' (ibid: para 79a). It stated: 'ASBOs, instead of being a measure in the best interests of children, may in practice contribute to their entry into contact with the criminal justice system' (ibid: para 70b), noting that 'most children subject to them are from disadvantaged backgrounds' (ibid: para 79c).

The response of the two Junior Ministers to these Concluding Observations was an affirmation of their commitment to children's rights:

> We are committed to respecting and progressing the rights of children and young people here and will be guided and informed by the UN Convention on the Rights of the Child ... The concluding observations can assist us in our continuous drive to improve the lives of children and young people and help us identify the key issues affecting them. (Northern Ireland Executive 2008b).

This response affirmed a cross-party commitment in the Northern Ireland Assembly to children's rights consistent with international standards. The earlier sections of this chapter established the complex social, cultural and political circumstances that contextualise transition from conflict to peace. Devolution has been a significant and contested element during the early period of transition. The debates regarding the establishment of a Bill of Rights for Northern Ireland, alongside the Assembly's obligations under human rights legislation and Conventions, remain unresolved. International standards, however, although subject to interpretation are non-negotiable in terms of implementation. The primary research that follows raises crucial questions regarding the key principles of 'best interests of the child', implementation, non-discrimination, protection and participation. While Freeman (2000: 279-80) notes that a 'chasm' exists 'between the [UN] Convention and practice' he also asserts that a 'regime of rights is one of the weak's greatest resources'. With this in mind, and the commitments made by UK Government and Assembly Ministers to a rights agenda, the primary research explores whether the reality for children

IMAGES OF CHILDREN AND YOUNG PEOPLE

'Angels' and 'demons'?

Across the age groups it was generally agreed that adults view and treat children positively. This was reflected in the words and images used by adults: "adorable", "helpful", "wee angels", "cute", "kind" and "loving". Most young people believed that adults thought children were "innocent" and/or "vulnerable". Adults, they commented, assumed that children were "easily led", "don't understand" and "believe everything they're told". Consequently, children could "get away with anything" and the "blame" or responsibility for 'bad behaviour' was always redirected to parents (inadequate discipline and supervision) or to teenagers (bad influence). Young people gave examples of the type of 'anti-social' behaviour in which children were involved but for which they were rarely held responsible:

> "If somebody threw a brick or somethin' at a winda and cracked a winda in the shop or somethin' and they came and blame youse and we say, 'No it wasn't us, it was your wee man there'. They'd be like, 'No that's a wean [child], a wean wouldn't be doin' that there, with all the age of him, he wouldn't be able to do that there'." (Co. Derry, aged 15-19)

> "They're always [seen as] more positive unless they're with us, then they say we're makin' them do stuff to get into trouble." (Co. Fermanagh, aged 16-21)

When discussing the negative images or attitudes held by adults about children, young people used soft terms such as "naughty" and "cheeky". Children, however, disagreed. While young people stated that adults held positive views of children, those under 13 gave examples of negative views and treatment, often noting the common

phrase used by adults: "children should be seen and not heard". They resented the assumption that they did not understand issues solely because of their age. The most commonly cited examples of negative terms directed towards children were: "annoying", "a nuisance", "loud", "spoilt" and "a pain". Contrary to the views of young people, children also noted the various ways they were blamed and punished, including being sent to their room, slapped or "hit with the wooden spoon". Hurtful comments made by adults towards children included:

> "My mum tells me I'm ugly."

> "My mum says: 'One day I wish I could be proud of you'."

> "I wish that child wasn't mine." (Co. Antrim, aged 9-11)

There was recognition that some adults supported young people, understood their lives and their behaviour. Children and young people in most communities reported that "some" adults viewed and treated young people well:

> "We'd nowhere to go and then other neighbours that we woulda stood beside their house woulda came out and brought us plastic bags and say, 'Any rubbish ye use, put it in that and just keep the noise down, there's weans in bed'." (Co. Derry, aged 22)

However, across the age groups it was agreed that adults generally considered young people to be anti-social and intimidating - young people were rarely viewed positively. The many words and terms used by adults to describe young people were those that featured prominently in the media: "hoodies", "wee hoods", "anti-social" or "ASBO kids", "thugs", "louts", "hooligans", "gangsters"

and, more generally, "troublemakers". Children, in particular, associated images of young people with certain behaviours - smoking, drinking, taking drugs and "acting hard". Many children interviewed shared adults' negative perceptions of young people. Indeed, some were so negative that when role-playing a children's rights exercise, they decided they would ban young people aged 13-20 from their community. A small number of children felt intimidated by young people who hung around the streets or used, and often damaged, children's play areas.

In focus groups young people from all communities felt they were seen as a persistent "problem" or threat. They were "targets" for blame and resentment:

> "They [adults] yap at ye if you're doin' anythin', like kickin' the ball outside their house." (Co. Antrim, aged 15-20 yrs)

> "If you're in a shop they'd be watchin' ye [and] kind of grip the handbag a wee bit tighter." (Co. Armagh, aged 12-21 yrs)

> "We're gettin' shouted at an' all because they *assume* that we're goin' to be doin' things." (Co. Derry, aged 16-17: their emphasis)

> "They try to avoid you an' they feel threatened just if we walk up to them or talk to them." (Co. Fermanagh, aged 13-15)

A minority of young people accepted they were "no angels" and occasionally they would "act up". The majority, however, suggested they were misunderstood and all were "tarred with the same brush". Given the lack of available facilities and little money, most young people spent their free time with friends on the streets within their communities. Yet, they were often viewed as a problem and moved on:

> "If you stand around in groups on the street or somethin' they feel intimidated and they pick on you, even if you're not doin' nothin'." (Co. Derry, aged 15-19)

> "If we were on the street they'd think we were up to no good. But most of it's just standin' at the shops, and we're just chattin'." (Co. Derry, aged 21)

Some considered this to be age discrimination, noting that when groups of adults stood on street corners they were not treated with suspicion or disdain. One group who lived in a community with no youth facilities, no football pitch and no park, and were hesitant to leave the area for fear of sectarian attack, considered that their behaviour was misunderstood:

> "When we're on the corners we're just gettin' together, havin' a laugh. But straight away they see it as a threat … Anti-social behaviour is simply congregatin' in a group. Just bein' together with your pals is targeted as anti-social. You want to tell them [police, older people] that you're bein' social, not anti-social. They wouldn't get it!" (Co. Fermanagh, aged 16-21)

How young people were perceived had clear implications for how they were treated and responded to by adults. They felt shunned, ignored, avoided and feared. Adults constantly shouted at them and phoned the police, who moved them on:

> "You can't even stand about without bein' moved on – 'I'd like your address for breathing'. They'll be askin' for your blood group next!" (Co. Fermanagh, aged 16-21)

In all communities, young people felt they had no right to public space - their freedom of movement was regulated and restricted because of their age and stereotyping. They were identified as a 'problem' to be solved, rather than integral members of the community with particular needs.

Discussions with young people demonstrated how the media had fuelled assumptions about their behaviour. Groups out on the streets were labelled 'gangs' or 'gangsters'. Those wearing hooded tops were perceived to be a threat. Their presence and style had become synonymous with crime and/or anti-social behaviour:

> R: "Say there was a group of young people standin' in the street, what do you think adults might think about them?"
> YP1: "They're gangsters."
> YP2: "Look at them wee hoodies." (Co Antrim, aged 10-13)

> "If you're wearin' a hooded top and you always have your hood up, they think we're up to mischief." (Co. Derry, aged 15-19)

Children also adopted the language of 'hoodies' and 'gangsters' when talking about young people in their communities: "All the wee hoodies and gangsters came into the park". They appeared to be unaware that soon they would be viewed similarly.

Anti-social behaviour was part of everyday language. Simply 'standing around' was deemed anti-social. Those considered most likely to be associated with such behaviour were identified by appearance and style. Young people discussed the judgements and assumptions, based on appearance, to which they were subjected:

> "… if we're standin' on the streets with hoodies an' all, they think we're goin' to batter old women." (Co. Derry, aged 16-17)

> "Here people think that because you dress in tracksuit bottoms you're a hooligan. But they don't know you personally, what you're really like." (Co. Fermanagh, aged 16-21)

One group suggested it was their lifestyle and everything associated with 'being young' that caused concern and led to their demonisation:

> YP1: "It's just the look of us."
> YP2: "It's your appearance. It's the way you dress - wearin' hoods, whereabouts you hang about - street corners, the types of things you're into - like cars and all this here. You know, they just automatically assume." (Co. Derry, aged 15-19)

Changing perceptions: from 'childhood' to 'youth'

Among all young people interviewed there was a strong belief that children were treated more favourably and received more positive attention, love, care and protection:

> "Adults love wee people. They love wee weans." (Co. Derry, aged 12-15)

> "They [parents] didn't smoke in front of ye cos ye were a wean, but now they smoke in front of ye." (Co. Derry, aged 8-14)

> "Whenever you're a child they tell you that they love you. But when you get older they just say, 'Get out of my sight!'." (Co. Armagh, aged 9-15)

Their comments reflected personal experiences in their families. More broadly,

in their communities and in wider society, they believed that children received more care, consideration and support. In part this related to assumptions about childhood 'innocence' and a perception that children "get away with anything".

Young people identified a time in their lives when adult responses changed, becoming less positive and supportive: "Adolescence"; "When you hit teenage years"; "When you start high school". This experience was often sudden and dramatic:

> "The wee ones get away with a lot more and that's goin' up to the age of 11 or 12. But once you hit 13, 14, 15 you're a nightmare." (Co. Derry, aged 22)

> "When you hit your teenage years they start goin': 'Oh they're bound to be up to somethin!'" (Co. Derry, aged 16-17)

> "There's like this time when you go from bein' thought of as a child that's positive to bein' a hood or a hooligan." (Co. Fermanagh, aged 16-21)

Young people were expected to "have more sense" than children, to take more responsibility for themselves and their families. Often this included an expectation to be more independent through paid work:

> "When you're a younger wean and you ask for money you get it. Now when you ask, you are told to get a job." (Co. Derry, aged 15-19)

Increased expectations on young women within the home included shopping, cleaning and childcare, which limited their social life:

> "Adults will want ye to babysit … it's wile annoying, like, because we get

asked to babysit. We have a life, but they just make us watch their weans."

> "When mummies have girls they expect them to clean the house and help with the babies an' all." (Co. Derry, aged 8-14)

The perceived withdrawal of adult care and support coincided with increased pressures and difficulties in young people's lives. Many described the sudden transition from feeling sheltered and protected to taking on onerous responsibilities and making life-defining decisions. They were also expected to 'fit in' while going through emotional and physical changes, often without advice or support:

> "Going to high school you need to wise up – it happens too quickly. You had to be more mature. You're trying to fit in. You start cursing and all that." (Co. Armagh, aged 9-15)

> "Growin' up too because when you're a wean sometimes you play with dolls an' all. Then you're grown up and you have to leave all these things behind because people will think you're weird cos you have to be into other things when you're like 14 or somethin'. Ye have to learn and go to school, cos in primary school ye do fun things." (Co. Derry, aged 8-14)

Young women discussed the significance of making friends to avoid being labelled "a loner". Isolation often led to bullying and 'image' was crucial:

> "Not fittin' in, with people sayin' you're fat." (Co. Antrim, aged 10-13)

> "Some people, if they've strawberry blonde hair, they're bullied or other people mock them." (Co. Derry, aged 14)

"Your hair had to be perfect, you had to be skinny. You know, everybody woulda went on about their weight." (Co. Derry, aged 21)

The pressures to smoke, drink alcohol and have sex also related to 'fitting in'. One group considered that image was specific:

"What to wear, what the fashion is, what to drink and all that there." (Co. Tyrone, aged 14-25)

Some young people stated that their decisions about sexual behaviour were not always fully informed, often reflecting negotiation of identity in relation to their peers:

YP: "They think 'If everybody else is doin' it and I'm not doin' it, then I'll get wile stick'. Then they do it, then."
R: "Is there pressure about that?"
All: "Aye."
YP: "Ye wanna be a lad don't ye?" (Co. Derry, aged 16-17)

Responsibilities and expectations brought concerns about the longer-term future:

"It's hard to know what you're goin' to do in the future, about your work, what you're goin' to do and where you're goin' to go - tryin' to get a job and your own house and all." (Co. Derry, aged 8-14)

Many felt that parents and adults offered little understanding, help or support:

"They don't know what it's like being our age, in this year. Like, times change." (Co. Tyrone, aged 14-25)

Another group noted that, in contrast to their childhoods, there was little support for young people experiencing physical and emotional changes:

R: "What types of things do young people find hard growing up here?"
YP: "… all the changes you're goin' through."
R: "Like physical and emotional changes? Is there people there that you can talk to about that?"
YP: "No, you'd be too showed, embarrassed to talk to people."
YP: "When you're a wean you get help." (Co. Derry, aged 8-14)

Difficulties recounted by young people as they moved from 'childhood' to 'youth' coincided with intensifying pressures regarding their assumed disruptive or anti-social behaviour. This complex mix of internalised turmoil, external expectations and public condemnation inevitably resulted in feelings of hurt, sadness and low self-esteem.

Making sense of the representation of youth

Children and young people identified 'bad' behaviour as the most significant influence in shaping adults' negative views of young people:

"They see some teenagers doing bad things." (Co. Down, aged 9-10)

Second, was stereotyping:

"Once you have your hood up, you're a hood." (Co. Derry, aged 12-15)

Third, was the impact of media representations of young people:

"They see bad things in the newspapers or on the TV news." (Co. Down, aged 9-10)

"My granny would say, 'Oh these young ones these days now, that's all they do - drink and take drugs and get people

pregnant'. That's the way she would speak. I think it's because of readin' the newspaper." (Co. Derry, aged 21)

Fourth, were adults' memories of their own childhoods:

"Because they know from experience when they were younger." (Co. Armagh, aged 12-21)

"They did it when they were teenagers." (Co. Down, aged 10-11)

"They were picked on so they pick on us now." (Co. Derry, aged 16-17)

Finally, inter-generational power was significant:

"Because we're smaller than them … we're small and they're big." (Co. Armagh, aged 9-15)

"Because we're smaller … more younger than them … they have more power." (Co. Fermanagh, aged 16-21)

While young people acknowledged that the negative behaviour of some impacted on the image of all, children interviewed were less likely to differentiate between individual and group behaviour. They believed it was young people's unacceptable behaviour that resulted in negative labelling. All ages, however, raised the significance of stereotypes (although not necessarily using the word). Negative perceptions related to how young people dressed and where they 'hung out'. All agreed that the media influenced widely-held negative views about young people. They noted that, with the exception of sport, positive stories about young people on the television news or in local newspapers were rare. Stories featuring young people were predominantly negative,

focusing on drinking, fighting and/or gangs:

All: "Aww newspapers."
YP1: "They write some shite."
YP5: "Aye, when it snowed, they just like put them [young people] on the front page."
YP1: "Aye, for snowballin' cars. I think the papers can write whatever they want. They blame children for takin' drugs when they don't."
YP5: "Hey tell her about the AK47 - the toy gun."
YP1: "There was some boy with a picture of a toy gun, an AK47, on bebo and they put it on the front page of the paper."
R: "Do they ever come and talk to you and get your side of the story?"
YP1: "No, ye just get scooped."
R: "Is there any good coverage about young people in your local newspaper?"
YP8: "Just sports."
YP1: "Sure there was this big write-up in the paper about flags along the road. And we took them down an' all, and there was never anything said."

The story about the newspaper that featured an image of a young person with a gun, was also told - and believed - by a group of adult community representatives. They stated that "youths have taken over this area … children have no respect for anything or anyone". This was contrasted with their shared view that the area was constantly in the media and that reporting was always negative and often unfair:

"The estate is constantly in the media. Something bad happens here, it is instantly reported. But when similar things happen in other areas, there is no mention of it. Anything about the area is always negative, there is nothing about the good."

As noted above, young people also described their involvement in negotiations to remove flags from the estate and the bordering main road. There had been considerable media coverage about the problems associated with flags. Yet when the young people agreed to their removal, there was no mention or acknowledgement of this response.

Across the communities, there were many examples of young people's commitment to activities or schemes with positive outcomes. However, the common perception of young people remained predominantly negative. In one community, for example, a group of young people organised and facilitated several community meetings about alcohol awareness. They invited young people, parents, publicans and local councillors to develop a code of practice. While many young people attended, the initiative received minimal support from parents. Only one publican and no local councillors attended. Although the good work of this youth group was recognised nationally, and they were awarded a prestigious prize, there was no recognition within their community:

> YP1: "Sure the councillors that are in [the area], no-one even knows who they are. Like we invited one of the councillors down to that publican talk as well. Didn't even come."
> YP3: "Invited them to the openin' of the drop-in, they were invited to go to London to watch us receive an award and they didn't even acknowledge that we'd won it, to say congratulations."
> YP1: "We writ them a letter and they never even writ a reply to say thanks for the offer."
> R: "And how does that make you feel when that happens? Obviously, it's a big

thing winning the award?"
> YP7: "It's just like they don't care."
> YP3: "We were the only youth group in Northern Ireland that won and not being recognised by your own politician but bein' recognised by the Home Secretary ..."
> YP2: "It was a bit of a disappointment like - they hadn't even the *respect* to come into the office, and it's round the corner from where they live, and say 'God, you won this, well done'." (Co. Tyrone, aged 14-25: their emphasis)

The programme co-ordinator commented: "That was a knock-back to the young people. People don't let them know that they are important."

Young people were concerned that their behaviour was judged by adults' personal experiences of growing up. Reflecting on their own past, however, appeared not to give adults any deeper understanding of young people's realities and pressures. There was considerable discussion about this failure or unwillingness to understand. Instead, young people felt judged and treated negatively simply because they were identified as different, younger and without influence. In the words of one young person: "They [adults] don't know the person inside ... they see what they wanna see" (Co. Down, aged 17-20).

The impact of negative perceptions

Children and young people were "happy" and felt "good about themselves" when adults' perceptions and responses were positive. They discussed the impact of perceptions on feelings of self-worth and emotional well-being. When responses were positive, they felt loved, cared for and included:

"You feel they [adults] really care about you." (Co. Down, aged 10-11)

Affirmation from adults encouraged positive responses:

"It would make them [children and young people] want to do something more, like more good to make them [adults] think they were good." (Co. Derry, aged 8-14)

Negative perceptions and responses, however, led to "sad" feelings. Sadness was used generally as a catch-all term and included: "unhappy"; "upset"; "depressed"; "hurt"; "insecure"; "paranoid"; "self-conscious"; "unloved"; "bad about yourself". Those of all ages outlined how constant negative perceptions impacted on their emotional well-being. Some felt paranoid about how they were viewed, discussed and stared at by adults in their communities and in local shops, where they felt that there was an expectation they would "do something wrong". Others had lost self-confidence and self-esteem because they were constantly questioned and doubted. Many linked negative perceptions and feelings to suicide:

"Suicidal – like you want to kill yourself." (Co. Antrim, aged 9-11)

"… it would make you wanna do somethin' like kill ourselves or somethin'." (Co. Down, aged 10-11)

"They try to make you feel down all the time … It's probably with some people the same type of thing [as what leads to suicide]. It puts them under a lot of pressure - instead of tryin' to ignore it, they do these things." (Co. Derry, aged 15-19)

"It just gets to you all the time, undermines you. It's feelings of

insecurity that leads to suicide." (Co. Fermanagh, aged 16-21)

The most frequently cited response to negative perceptions was "anger" because they were misjudged, "stereotyped" and "not given a chance". Young people stated that, because they were not respected, they lost respect for those who judged them and hit back in anger - thus reinforcing the negative label:

"You think 'What's the point in even tryin' bein' good if they [adults] only point out the bad points'." (Co. Derry, aged 16-17)

"It just makes us do more … If they have a name, they may as well live up to it." (Co. Armagh, aged 12-21)

"People get drunk and wreck the place because of the way they're treated." (Co. Derry, aged 12-15)

"You're gonna be bad if you're expected to be bad … If the police are always fuckin' annoyin' ya, you're gonna be bad and you're gonna hate the law." (Co. Fermanagh, aged 13-15)

Many children and young people recounted how they felt excluded, unloved and unwanted. In some cases, this extended to feeling "hated" by adults within their communities:

"They just hate us." (Co. Fermanagh, aged 13-15)

"They think we're scumbags." (Co. Armagh, aged 12-21)

"Not loved and not liked." (Co. Derry, aged 9-11)

"As if you don't belong in the world." (Co. Antrim, aged 10-13)

The persistent experience of antagonism, distrust and rejection by adults diminished young people's self esteem. Without respect from adults within their communities, and experiencing suspicion, some children and young people felt provoked to react:

> "You make ways to get attention.
> You act up – even a bad response is a response." (Co. Armagh, aged 13-24)

While some adult community representatives and a few children considered young people were ambivalent about how they were perceived, this was not reflected in the focus groups. Because they felt labelled, that they could "do nothing right", the enjoyment and excitement of being young and growing up was lost. This is reflected in the following exchange:

> R: "How do you think that makes young people feel [when it is always thought that they are up to no good]?"
> YP1: "Angry. You're not given a chance."
> YP2: "Like you can't go out and have a laugh with your friends."
> YP3: "Always gettin' the blame for *everything*." [their emphasis].
> R: "When you say everything, what do you mean?"
> YP3: "Other people are always right. We're never right. We're always wrong, we're always in the wrong."
> YP1: "You feel like everyone feels they are superior to you." (Co. Derry, aged 16-17)

In addition to the impacts emotionally and on young people's future actions, several - particularly young men - were concerned that negative assumptions about their behaviour could lead to criminalisation. They recalled instances of the police being called because young people were hanging about on the streets. This led to them being questioned or "lifted" [arrested], and to direct conflict with the police because they felt unfairly targeted and harassed. While longer-term consequences were understood by young people, adults seemed not to understand:

> "They ring the police an' they don't realise it affects our lives. We get into trouble with the cops an', before you know, it's jail. An' then it's really hard to get a job." (Co. Fermanagh, aged 16-21)

Alongside police targeting, some young people experienced the uncompromising threat of dissident paramilitaries who continued to assert control through intimidation and punishment:

> "They [adults] blame us for stuff and we get a bad name for it … and there's cops comin' up round here and there's paramilitaries lookin' round all the time and they blame ye." (Co. Derry, aged 15-19)

Overall, children and young people considered that the negative reputation imposed on young people was unfair and uninformed. The constant pressure of rejection and exclusion, together with direct threats of violence, undermined self-confidence and, simultaneously, provoked angry reactions. While some turned in on themselves, indicated by regular comments about suicide, others responded through violence and anti-social behaviour. Yet all agreed that positive responses from adults within the community drew positive reactions from young people. The experiences of one group were so pronounced that they resolved to be different as adults and to treat the next generation differently:

"Whenever we grow up, the way we're treated now, we'll be able to say 'Look at the way I was treated'. We'll be able to treat them better and treat them with respect. We should treat the next generation the way we *should* have been treated." (Co. Derry, aged 16-17: their emphasis)

Changing negative perceptions

Most young people wanted adults to think differently about them, to understand their lives and realities, and not to perceive them as a threat:

> R: "Would you like adults to think differently about young people?"
> YP: "Aye."
> R: "How would you like adults to think about young people?"
> YP: "To think 'Oh, they're just playing, carrying on, being noisy' … Most of them [young people] are ok, if you ask them to move on they do. They're just noisy." (Co. Derry, aged 13)

To promote a positive view of young people and better relations between young people and adults, the groups offered four suggestions. Most common was the encouragement of interaction and communication between young people and adults. This would enable adults to know and understand young people more intimately, thus challenging negative assumptions. One group suggested that young people should have the opportunity to inform adults about the impact of negative perceptions:

> "They [young people] should tell them, show them how they feel when they [adults] do that and tell them what they say can be hurtful." (Co. Derry, aged 8-14)

A less subtle suggestion was:

> "The children could show the adults who's boss, pick on them, see how they like it." (Co. Antrim, aged 10-13)

Another group noted the difficulties in improving social interaction:

> "Change the attitudes of adults, try to bring them into the club and get them to mix with the youngsters - but we've tried that before and most of them aren't interested, they just want rid of the weans [children]." (Co. Antrim, aged 19-20)

Some community representatives from the same area, however, had a similar impression about young people as that voiced by young people about adults: "Young people just aren't interested - they prefer to hang about the streets and terrorise residents".

Within the research sites there were positive examples and experiences of programmes involving both young people and adults. These highlighted the potential of intergenerational work, if it is sensitively organised and adequately funded.

Central to children's and young people's views about changing negative perceptions was greater provision of activities and facilities to constructively occupy their time: "If we're not about, they can't blame us" (Co. Derry, aged 15-19). They also confirmed that some children and young people needed to improve their behaviour and challenge prevailing negative stereotypes. While some groups suggested that this could be done by "young people doing things round the community" (Co. Derry, aged 8-14), others commented that their contributions to their community were not recognised. They suggested that

the media and community representatives had a responsibility to report "the good things we do". One group noted they were not inclined "to be out plantin' trees in people's gardens" (Co. Fermanagh, aged 13-15), especially if they were not recognised already for their positive contributions to community life.

Many young people, particularly those negatively labelled in their communities, believed little could be done to change adults' perceptions other than conforming to their demands and expectations:

> "Stay in the house, then they couldn't say nothin'." (Co. Fermanagh, aged 13-15)

> "Go to mass on Sunday, do chores and do nice things … shop for other people and then they'd all think you're a wee goodie goodie." (Co. Derry, aged 16-17)

These quotes suggested that acceptance could be achieved only by rejecting the excitement, adventure and enjoyment associated with being a young person. One group suggested that, if they behaved as badly as their reputation implied, adults would appreciate how mild they actually were:

> "It would change if we went pure [completely] bad like everywhere else do … there's somethin' on [TV] last night about anti-social behaviour in England and they're worse than us. People that come down from Belfast couldn't believe how good we were, sayin' there was no house breakin', cars stolen and that." (Co. Fermanagh, aged 13-15)

Key Issues

- *Children considered that they were respected and supported within their families and communities.*

- *For many young people, rejection and exclusion by adults was a common experience in their families and in their communities.*

- *Expectations and responsibilities placed on young people in the home, school and community, were not matched by appropriate information, advice and support.*

- *Young people experienced difficulties in the transition from 'childhood' to 'adolescence' – a period of physical and emotional change and a perceived loss of adult protection and support.*

- *Young people considered the labelling of their behaviour as 'anti-social' or 'criminal' by sections of the media to be unfair and unfounded. This was deeply resented.*

- *In all focus groups conducted with children and young people, there was evidence of diminished self-esteem impacting on their emotional well-being. While some young people responded through being hostile, angry and volatile – often bolstered by alcohol – others withdrew into themselves.*

- *Well-conceived and adequately resourced intergenerational initiatives challenged negative reputations and stereotypes that prevailed within communities.*

- *Promotion and protection of children's rights is central to development of positive interventions, opportunities to challenge discrimination and stereotyping, secure free association, promote participation and create conditions for good health and well-being.*

PERSONAL LIFE AND RELATIONSHIPS

Being heard and taken seriously

Regarding involvement in decisions that impacted on their lives, children (under 13s) gave predominantly positive responses. Older groups, however, were less positive. Children considered that adults were most responsive when they needed help, advice, support, or when they were worried, hurt or in trouble:

> "They listen when you're worried, or if you fall." (Co. Down, aged 9-10)

> "When sometimes somethin's hurt them [children], like if somethin's happened in school or somethin' and you look upset, they would listen and tell ye what to do." (Co. Derry, aged 8-14)

While these comments are not directly about children's voices in decision-making, they are important examples of being listened to and taken seriously. Others, however, felt that adults' responsiveness was dependent on their judgements about the 'value' of what was being said or the views of the individual:

> "They listen when they think you're doin' something good." (Co. Derry, aged 8-14)

> "They only listen to the good ones." (Co. Derry, aged 12-15)

> "It depends, if they're interested in what ye have to say, they will [listen]." (Co. Derry, aged 15-19)

All age groups, across the communities, explained the importance for children and young people of being consulted, included and respected. Their priority was that an issue could be important and/or serious. Children, in particular, were concerned about issues of safety and protection. Completing the sentence, 'Children's views should be taken seriously because …', the following are illustrative of issues raised around the theme of safety:

> "If there was any glass in the park, and the council didn't listen, then children could get hurt." (Co. Down, aged 10-11)

> "Cos if somethin's wrong then they'll [children] say instead of coverin' it up." (Co. Derry, aged 14)

Regarding safety, one group stated that adults had a responsibility to listen. Another felt the necessity to "get it out of their head – you might be thinking it over and over and over again – you could go mental" (Co. Down, aged 9-10).

One group of young people considered it a "right to express our views" (Co. Fermanagh, aged 16-21). While a group of children thought that their contributions were distinct and valuable as a direct consequence of their age: "Children can be more imaginative so could have better ideas" (Co. Down, aged 10-11).

'Being listened to' led to those interviewed feeling positive about themselves, cared for and taken seriously. For children it meant they had less to worry about, felt safer, received more advice and support thus reducing the likelihood of "bad things" happening to them. Young people framed their responses around being 'respected' by adults. Yet the majority of children and young people considered that adults did not involve them in decisions, nor take their views seriously:

> "They don't listen when you tell tales about when somebody hits you." (Co. Antrim, aged 7-10)

> "Say when they're busy, they're too busy to listen." (Co. Derry, aged 8-14)

Children and young people often felt pre-judged by adults, without having the opportunity to voice their views. One group agreed:

> "They [adults] think we are a joke and just mess about ... Adults brush over our ideas." (Co. Tyrone, aged 12-25)

When views were sought, young people considered that this was often tokenistic:

> "It would make ye think that people, they *ask* ye your opinion but don't take any of it in - that it's goin' in one ear and out the other and, 'Sure, it's only a young person, they'll probably be standin' at the corner at the weekend anyway'." (Co. Derry, aged 22: her emphasis)

For children, the exclusion of their views by adults brought sadness and anger. Young people identified several consequences: "acting up" and "retaliation" to gain attention; experiencing disrespect and/or insignificance:

> "[Like] a waste of space." (Co. Fermanagh, aged 13-15)

> "... you feel like you'll get nowhere in life. That nobody cares, and they don't." (Co. Derry, aged 16-21)

Asked to provide a definition of 'respect', there were some age-related differences. Children had difficulty defining respect. They offered examples of people "doing things" for them or children being "mannerly and not bein' cheeky" (Co. Derry, aged 14). Five prominent themes emerged from the groups – positive treatment, help and support, listening, trust and reciprocity. The most frequently cited was "being treated well" and "treating others well". This included "being given things", not being discriminated against or judged negatively and being treated equally and fairly:

> "Speakin' to people like you would like to be spoken to." (Co. Tyrone, aged 14-25)

> "To be treated like an equal." (Co. Armagh, aged 13-24)

Helping others and being helped by others as a reciprocal process was also significant. Many, across all age groups, identified listening as a key element of respect:

> "They take everythin' into consideration, like what you're sayin' to them, and then they give you respect and you give it them back." (Co. Antrim, aged 10-13)

> "Listenin' to what people have to say and takin' into account what people say ..." (Co. Derry, aged 15-19)

Young people especially identified 'trust', 'listening' and reciprocity as crucial to respect between themselves and adults. As one group noted, "it's about give and take" (Co. Derry, aged 16-17). There was clear recognition that respect had to be earned to be returned:

> "Be nice to us and we'll be nice to you." (Co. Fermanagh, aged 13-15)

> "If they don't respect you, you don't respect them." (Co. Tyrone, aged 14-25)

> "You help me, I help you." (Co. Antrim, aged 18-20)

> "If you don't respect somebody, they'll not respect you." (Co. Armagh, aged 12-21)

However, there were contradictions. Some children felt that they should respect all adults, irrespective of how they were

treated by them, as this was both expected and appropriate:

> "You show respect to those who respect you but you *should* respect other ones [adults]." (Co. Derry, aged 8-14: their emphasis)

Groups of young people were less accommodating:

> "They're [adults] always goin' on about respect, showin' them respect, but where's the respect for us? Don't think so!" (Co. Fermanagh, aged 16-21)

When asked who respected them, they struggled to offer a response. Of those who did, children were more likely to identify a family member and/or a professional (such as the police or a health professional), while young people talked of friends and/or an individual community/youth worker.

When asked who they respected, more examples emerged. Across all groups, responses (in order of frequency cited) included: friends; a community/youth worker; family members; individuals in the community. Friends were particularly important - for some, friends were the only people they could trust, talk with openly and rely on. In these relationships, respect was identified as reciprocal. The significance and value of friends for children and young people's emotional well-being was considerable:

> "If they [friends] told me something I'd be there for them. I'd think more of them because they asked for help." (Co. Derry, aged 9-11)

> "We hang about in groups because we respect each other and we can talk to each other. We listen to each other." (Co. Fermanagh, aged 16-21)

> "Like if somethin' ever happened to ye, someone would always be there for you, to watch your back. They'd always be there for ye ... We talk to each other. It's better to tell people than to keep it inside you, it messes your head up." (Co. Derry, aged 15-19)

Children and young people regularly identified an individual community/youth worker for whom they had respect and by whom they felt respected. 'Trust', 'care' and 'understanding' were central to their accounts of those who "always have time for us" and who "understand your problems". The following quotes demonstrate the meaning and value of individual community/youth workers to children and young people:

> *YP1*: "I respect [Name], I love her to bits."
> (All agree)
> *YP2*: "I respect all the leaders."
> *R*: "And why do you respect them?"
> *YP3*: "Cos they do stuff with us. It's not just we come and sit, they play games with us."
> *YP2*: "They don't like just sit around and watch ye and they've got a good discipline. Like, if somethin' happens they bar ye. But they don't bar ye forever."
> *R*: "So they're fair?"
> *YP2*: "Aye, they're fair."
> *YP3*: "Sometimes if you've done somethin' bad you would agree to get barred." (Co. Antrim, aged 10-13)

It is clear from this short exchange that youth workers, in contrast to other adults in their lives, are important because they negotiate and listen to children and young people. The children noted that those who break rules accept their 'punishment'

because it is fully discussed and considered fair.

Another group living in an area without youth provision, who felt shunned by most adults in their neighbourhood and had particularly poor relations with the police, spoke of the significance of their relationship with a community police officer who had initiated a youth programme:

> R: "So what makes him different?"
> YP1: "Cos he does care about us, ye know."
> YP5: "He wouldn't put the hands on [hit] ye or nothin'."
> YP6: "He knows us."
> YP2: "He done good stuff for us ya see."
> R: "So if someone does good stuff for you …"
> YP9: "They get it back."
> YP5: "They get respect."
> YP1: "Sure [Name of officer] would even tell ya that himself. We always be good, so we do. He stuck up for us against [person] that didn't like us and all, so he didn't have to."
> R: "What we're tryin' to look at here is what makes a good relationship with somebody and what doesn't make a good relationship."
> YP6: "Respect."
> All: "Yeah." (Co. Fermanagh, aged 13-15)

The group no longer viewed this person solely as a police officer because he did not treat them as stereotypes of young people. To them, he was a community worker rather than a police officer. He cared about them, understood them, defended them and, ultimately, respected them. The project was small-scale, with an uncertain future, yet its impact on a group for whom there was no other provision was profound

and illustrated the importance of respectful relationships (regardless of the actual project activities).

The interviews revealed how straightforward it can be to gain the respect of children and young people, and how adults can have a positive impact on their lives. Making time for children and young people, and not judging them unfairly, engendered respect and trust which was often lacking in their homes, schools and communities. It also provided constructive relationships and support that many did not have in their day-to-day life experiences.

The impact of poverty and the Conflict on families

Poverty and/or the legacy of the Conflict were dominant themes in interviews with community representatives about the family lives and circumstances of children and young people. Indicators of deprivation, or need, were commonly cited. These included: child poverty and limited circumstances created by low incomes or insufficient benefits; prevalence of child physical abuse and neglect; disproportionately high numbers of lone parent households and high numbers of children receiving free school meals.

The depth of poverty was starkly illustrated by a former head-teacher who revealed that, in the 1990s, 91.4 per cent of children in his school had received free school meals. The area had the worst level of DMF (decayed, missing, filled) teeth in Northern Ireland. Another representative from this community noted the high number of children entering the care system and a third commented on families "surviving on nothing":

"Families cannot afford to put good quality healthy food on the table. There used to be kids who came to the Youth Club who had not had a proper meal … In some families basic needs are not met – warmth and food."

A primary school head-teacher in another community revealed that 55 per cent of pupils received free school meals. Half were registered as having Special Educational Needs and "as a school, we report high incidence of head-lice and concerns about hygiene. Nutrition too can be a cause for concern". An after-school programme in a third community negotiated with funders to finance healthy snacks and meals, recognising it was "the only dinner for some of the children". In a fourth community, a youth project also ran a healthy eating scheme: "For some kids, five rounds of toast is their evening meal".

These examples of poverty were neither isolated nor exceptional cases. In discussing poverty, the following comments were common:

"… unemployment and benefit dependency is high. There are also a lot of single parents and second generation parents that don't work."

"Poverty is embedded, it is multi-generational poverty … There are three generations of unemployment in the area and a low wage economy in the [region] more generally."

Multi-generational poverty resulted in organisations working with parents and, eventually, with their children when they became parents. It was widely recognised that the impact of poverty was far reaching - affecting the physical and emotional health of both parents and children as well as children's educational experiences,

aspirations and future life chances. In particular, there was a clear understanding that poverty placed considerable pressures and demands on families, impacting on parents' ability to cope. It was recognised that children were "traumatised by poverty" and "grow up accepting a poverty perspective".

There was also considerable discussion about the consequences of the Conflict for families. In one community, previously a major site of recruitment by paramilitary groups, "hundreds of young men from the area went to prison which had a profound effect on family life and on the community". Further, the community sustained a high number of Conflict-related deaths and injuries, bereavement and trauma. The impact on family life in terms of parental depression, alcoholism and intergenerational trauma was raised in the interviews. These issues were replicated in a number of other communities where experience of the Conflict was severe:

"[The Conflict] had a very traumatic impact and the psychological trauma on families was never addressed."

"There are hundreds of families here and in other communities who are voiceless - the voiceless of the Conflict - they don't get involved or speak out publicly. There are huge amounts of pain there and they are highly traumatised. The children of the Conflict seen their parents medicated with tranquillisers - they never told their story or had their pain recognised."

There was a belief that families who had "buried" their pain were beginning to acknowledge its impact, and that children had inherited the trauma of their parents. Some community representatives spoke

of "the secrecy" that had contextualised family life in Northern Ireland, including "an acceptable level of violence" which often started in the home:

> "There is an undercurrent of acceptance of violence in our communities [and] … hidden levels of domestic violence in many communities … young people are still dealing with these issues in silence."

> "It [domestic violence] still happens, far more than people will say or admit. It's part of the culture, part of a way of life."

Representatives across several communities expressed concern about "aggressive parenting". Some related this to parental stress, while others felt that young parents were often inhibited by the trauma, bereavement and depression suffered by *their* parents:

> "The issues are things people are afraid to say – nurturing and loving children. Low self-esteem is bred into children in these communities. It is forceful personalities that survive. Teachers feel it is not their role to nurture and love children. Parents don't learn how to, because they have not had it. So it's endemic."

Whether related to poverty, to the Conflict, or a combination of both, representatives in three communities reported high levels of alcoholism, parental depression and dependency on prescription drugs. They noted how this impacted on parents' ability to adequately parent and on children's emotional well-being:

> "If parents are depressed or have low self-esteem their ability to deal with their child is restricted. Thus, children are not getting support from their own family and they cannot access services."

> "Mental health is a big problem. There are mothers of children in the school with depression and this rubs off on children … There is no resilience, no bounce-back among people living here. Parents can't work through it and then this affects the children."

There was an understanding of the context of the problems experienced by families in all communities, although some recognised the impacts of poverty and the legacy of the Conflict more fully than others. In one community, the predominant view was that "parents don't care", that "parental discipline, control and support is lacking", that there were "poor parenting skills" and that services were used as "a babysitting service". In contrast, discussions in another community focused on parents' difficulties in coping and the need for adequate family support. The child and family support services offered in the first community were statutory, while the latter community had an established history of community/voluntary based child and family support services. This demonstrates the frustrations and difficulties faced by workers in communities where community-based statutory services are relatively recent and where parents are resistant to help (or perceived interference) in the private domain of their homes, particularly if this is considered to be based on a deficit model.

Children and young people's experiences of home life

The following experiences elaborate the points made by community representatives regarding the impacts of parental alcoholism and violence on the lives of some young people. While not illustrative of all children and young people in these communities, the issues raised are

more widespread than is often assumed, and demonstrate, from young people's perspectives, the impact on their lives.

Danny: violence in the home

During a focus group involving young men whom he had known for many years and trusted implicitly, Danny recounted the violence he had experienced while growing up and his violent response. Danny began by talking about his own violence towards his father and discussed how this was a response to his father's controlling and violent behaviour:

> Danny: "I was violent with me Da, I was always violent with me Da. I really didn't like me Da, I was always violent with him. I just couldn't stand him."
> R: "Was he violent with you?"
> Danny: "Yes."
> R: "Did you feel that the violence you showed him was because you'd been getting it from him?"
> Danny: "Yeah, say on like a Saturday night or somethin', he'd want me in at nine o'clock and you'd land in at five past nine, he'd go mad. You know just small things, he'd go mad on ye, shoutin' at ye. Ye'd get hit, ye'd get grounded and all that there ... I just let it all bottle up and bottle up, and one day I just snapped and lost the plot, like, I just went mad ... Started wreckin' the house, started throwin' hammers at him. I was goin' mad, got all my stuff and just threw it outta the door, put it in a taxi and that was the end of it."
> R: "How did you feel after that?"
> Danny: "In a way you feel relieved, like, that you let it out cos ye let it bottle up and bottle up and it has to come out some way, like."

Danny was enrolled on a training course and had aspirations to become a youth worker. He was one of a small group of young men with whom a trusted, local youth worker was undertaking an intensive personal development programme. As part of this, they had completed an exercise in which they reflected on their lives, identifying a point when things had begun to change. This enabled Danny to understand the context of and need to manage, his anger. In the extract, Danny recognised and admitted his violence towards his father but it was when the issue was explored further that he acknowledged its context. Young people often do not identify the context of their behaviour, particularly when it is behaviour that is individualised and pathologised. Without this understanding, self-blame damages their mental health.

Danny talked candidly about how he was aware that this anger was a recurrent issue, that he had "a short wire" and "anything at all and I just kick off straight away". Yet through the support of his youth worker, and his involvement as a young leader, he was developing self-control and establishing new opportunities.

Sadie: alcoholism in the home

Sadie was 21 at the time of interview. She worked part-time and lived with her boyfriend and three year old daughter. She talked openly about her difficult childhood and, from a young age, her violence, sexual relations, drug and alcohol use. She was committed to making a different life for her daughter. Involved with social services from the age of five due to her mother's alcoholism, she took primary care responsibility for herself, her mother and her younger sister. She felt that she had missed out on her childhood:

"I was only 13 and I had troubles like an adult on me shoulders, you know, lookin' after me Mammy. And at the same time I didn't have a childhood, I wasn't allowed to be a wean. I wasn't allowed to be a wee girl, to do what a wee girl has to do … I had to grow up very quick."

Sadie spoke of her anger - directed towards everyone, including those who tried to help. She had struggled to understand: "I had a wile, wile temper, I mean it was outrageous … I was a really angry wee girl. Just angry and I didn't know what I was angry for". Yet every aspect of her life was difficult and, to an extent, out of control:

"School was wile bad and then in the house too. And even in the community, when I was runnin' about with people, I would have been sexually active or I would have been lettin' anyone walk over the top of me. Just fights and different things. *Every* part of me life was all sort of difficult things." (her emphasis)

After moving out and returning to the family home on several occasions, at 16 Sadie went to sheltered accommodation in an attempt to relieve the pressures from home and "to see if it would calm me down". She suffered a miscarriage and "went on the drink", returning to some of the behaviours that she had struggled so hard to abandon. She moved from sheltered accommodation, living with her boyfriend between friends' houses. During this time she had a frightening experience with drugs, which continued to impact on her but also was the catalyst to change:

"That's when I had me bad experience and I couldn't trust anybody around me and I felt all weird and panicky. It was

just all the time … I was grand for the first while and then the next day and that I could just see myself gettin' sliced. Blood, oh Jesus, it was bad. I dream about it. I have nightmares, wakin' up sweatin' in the middle of the night and all. I still get it like, not as bad, but I still get it … and I always say after, 'It was a flashback, oh please'. Because I really do think that somethin' did happen to me and I'm not lettin' it come out, and I don't know why I'm not lettin' it come out."

Sadie continued to suffer from anxiety as a result of this experience. Becoming pregnant, and the support of staff at an NGO, were crucial to sustaining her efforts to change her situation. This particular organisation had been central several times throughout her life. When she was younger, she had attended their residential centre which "was a wee bit 'a respite … I could be a wean down there, I could carry on, have a laugh". She also identified her relationship with a key worker as more positive than that with her social worker. Without this organisation's support she considered she would have been placed in care:

"You don't know how to thank them, do you know what I mean? You don't know how to say to them 'Really, you were there for me when I was goin' through all this bad crap, like'."

Sadie's hope for the future was to ensure that her daughter had the childhood she had missed:

"I just want her to have a normal baby childhood to say, 'Oh I remember when I was six and me Mammy took me here'. I can't say nothin' like that. All I can say

is I saw me own Mammy lyin' blocked with a bottle of vodka in her hand."

Mikey: housing options

Mikey was 21 at the time of interview and reticent to share the full details about his family life. He identified a critical moment in his childhood: "the Brits comin' up to the house and wreckin' it", and he recalled being in "children's homes". At 16, Mikey moved from the family home into sheltered accommodation. After six months he was 'thrown out' for fighting and had no option but to return to his mother's house. His account reveals the lack of options available for young people and how limited involvement in decision-making can affect their experiences:

> *Mikey*: "I moved into [sheltered accommodation] when I was 16 … I only stayed there about six months. I went back to me mother's, then I went to prison and then back out to [same sheltered accommodation] and now I'm back in the house again."
>
> *R*: "Sixteen is young to be livin' on your own. How did you find it?"
>
> *Mikey*: "It was alright like. It's not as if it was hard livin' on me own but [pause] just I got threw outta [sheltered accommodation] for fightin' with the security guard. He's a wile cheeky man, so both times he said the right thing and I got threw out twice."
>
> *R*: "And were you given a chance to explain? Is there a warning system or anything?"
>
> *Mikey*: "No, you're just out."
>
> *R*: "And where did you go from there, then?"
>
> *Mikey*: "I just had to go back home … There's boys who got threw outta there, they're livin' on the streets. They can't go back home. There's no other place in

[the area], no other hostel … so there's not many places to go."

Mikey recalled the difficulties, after prison, in finding a job or even a suitable training course and going "on the dole". At the time of the interview, he was on a work placement in a supermarket through New Deal and hoped he would be given a job. He had received little support following release from prison - "I was just left to get on with it" - but identified the value of his relationship with a worker with whom he had maintained contact through earlier links with an NGO. The worker had since left that organisation, but continued to meet Mikey weekly. Mikey considered that this voluntary involvement showed the commitment, care and respect of his former key worker towards him.

Common experiences

The experiences of Danny, Sadie and Mikey are typical illustrations of the daily realities for children and young people growing up in difficult family circumstances. Their shared experiences included living through chaotic periods as a consequence of family situations, early housing transitions and limited housing options. Each internalised their feelings, manifested externally in violence and/or risky sexual behaviours. They continued to struggle with anger, anxiety and/or depression, yet still emphasised positive aspects of their lives and hopes for the future. But they were aware that some of their friends continued to struggle. As another care-experienced young woman stated:

> "I would have more than enough friends who've been through stuff, maybe the exact same as me, but have turned out to be alcoholics or drug users, standin' on

the street corners - nowhere to live, no friends, or turn out the *worst* people on earth whenever they're not bad people." (Mel, aged 22, her emphasis)

She understood her friends' behaviour because she recognised their circumstances as similar to her own.

Danny, Sadie and Mikey had each developed strong relationships with significant, respected and trusted adults who had compensated for what several community representatives defined as the "poverty of relationships" within some families. Other children and young people interviewed, even those who felt ignored or unfairly treated at home, thought they were respected by their families. Younger children were more likely to 'have a say' in family decisions, particularly regarding holidays, family outings and activities. Many noted, however, that "sometimes" adults did not listen, unless concerned about homework, school or the child's safety:

> "They ask, 'Where are you going? What are you doin'? Who are you with? Phone me, text me'." (Co. Derry, aged 13)

Some appreciated parental concern about their safety, while others resented this:

> "I don't want them to ask me, it's nosey." (Co. Down, aged 9-10)

Contrary to some community representatives' comments that "parents don't care", children and young people reported that parents were likely to discipline and control them. Some were particularly critical of what they perceived as their parents' lack of trust:

> YP: "They [parents] always think we're lookin' to do stuff we shouldn't be doin'."
> R: "Do you think they want you around

the house?"
> YP: "They never want you out of the house, they want you *in* the house so they know what you're doin'."
> R: "And you want to be out of the house?"
> YP: "Yeah, out bein' the numpty, spreadin' sexually transmitted diseases! That's what they think we're doin', but we're not. We just go and play football and chill with the lads." (Co. Derry, aged 16-17: his emphasis)

Many young people did not feel trusted by their parents and consequently did not talk openly with them:

> YP1: "I wouldn't tell them [parents] anythin'. They don't even like me, don't listen and they wouldn't understand. More like they wouldn't even try to understand."
> YP2: "That's right. Some of us will tell our friends stuff rather than our parents because we have more trust between us than we do with our parents."
> YP1: "Yeah, I'd never trust my parents. I'd trust them with nothin'. (Co. Fermanagh, aged 16-21)

Although the home was where children and young people reported significant interaction, as they grew up their participation in family decisions often decreased and their experiences of control and suspicion increased.

While children and young people were not interviewed directly about intimate relations within their families the discussions quoted above, together with the specific examples, provide evidence of the significance of personal relationships in their daily lives. 'Respect' was a theme running through all interviews and focus groups, particularly respect from family

members and other 'significant' adults. It was presented, however, as a two-way process. If respect was not shown by adults, it would not be returned. Adults who gave support to those children and young people who felt disrespected in their families, or who lacked parental support, frequently became mentors and important sources of support.

Key Issues

- *Children, more than young people, felt that adults were likely to listen to and respect their views.*

- *In their families and communities young people often felt pre-judged by adults, without having the opportunity to have their views or accounts taken into consideration.*

- *Children felt it was important to be consulted to ensure their safety. Young people believed they should be consulted because their views were as valid as those of adults.*

- *When children and young people were consulted and included in decision-making processes they felt respected, cared for and positive about themselves. Lack of consultation led to feelings of disrespect, exclusion, sadness and anger.*

- *Young people often explained negative or anti-social behaviour by some young people as a response to feelings of exclusion and rejection within their communities. This view was shared by a number of community representatives.*

- *Children and young people regularly identified an individual community or youth worker with whom they shared mutual respect. 'Trust', 'care' and 'understanding' were central to these relationships.*

- *Difficult circumstances experienced during childhood often led to individuals displaying violent and/or risky behaviours. For these young people, developing strong relationships with respected and trusted adults compensated for lack of family support.*

- *Community representatives noted the dual impact of poverty and the legacy of the Conflict on families. 'Transgenerational trauma', low incomes and 'multi-generational poverty', poor health and well-being each impacted on parents' ability to cope and form positive relationships with their children.*

- *It was not unusual for support services to work with adults whose parents they had supported previously, illustrating the significance of transgenerational trauma and multi-generational poverty.*

EDUCATION AND EMPLOYMENT

Poverty, aspirations and experiences

The impact of poverty and the legacy of the Conflict featured prominently in community representatives' discussions about the education and employment opportunities and aspirations of children and young people. In three communities the view was that particular schools were "bad" and "failing children". Others considered that local schools faced difficult circumstances and that many factors impacted on attainment levels, including: lack of funding, large class sizes and significant numbers of children with statements of Special Educational Need. In comparison to secondary schools, primary education was considered to be under-resourced in terms of ability to respond to the needs of all children.

The majority of community representatives interviewed considered the 11-plus system divisive and stressful for children, impacting negatively on child-parent relationships and children's self worth. They cited examples of effects including bed-wetting, sleep-walking and parent-child conflict. One community representative stated:

> "70 per cent [of children] are told that they're failures at 11, so why are we surprised when they feel failures at 17?"

The significance of poverty on educational attainment and the aspirations of children and young people was also raised as an important issue:

> "The most stark impact of poverty on children is on their educational attainment – there are huge variations in GCSE and A Level attainment across communities. There are underlying issues on ability to learn and upon

aspirations. These include social issues and the political situation."

Inhibitions on attainment included: lack of appropriate resources - "a lot of parents here couldn't afford a computer and the internet"; the low value placed on education in some families and communities; poor quality vocational education/training; limited job opportunities. While noting the impact of poverty on education, Horgan (2007) recently highlighted the family and community as key factors that shape children's educational experiences and aspirations.

Community representatives considered deficiencies in parental support for education to be a 'cultural' issue. Consequently, it was perceived that schools "worked in a vacuum", with the school curriculum unsupported in the home. However, some community representatives recognised that parents themselves may experience low literacy and numeracy skills and a profound lack of confidence. The following responses regarding the influence of the family and community on educational aspirations were typical:

> "Some [parents] are better off on benefits than working. Even if they don't want to sit in the house and want to be out at work they have no choice as they would loose too much in benefits if they worked. The result is two-fold: poverty leads to health issues and young people have it in their heads 'Why bother, as my parents never bothered?'"

> "Young people spend a lot of time in their own community and surrounding estates. They live here, go to school here, spend their free time here. Young people feel that it is ok to give up, they feel they

won't achieve as no-one around them has achieved."

The under-valuing of education was considered by some to be a reflection of embedded working class (male) culture, which has historically placed physical strength before academic achievement. As explained by one community representative:

"Education was never greatly valued in this community. Young men left school at 15 and it was strength rather than brains that got them a job. There is a legacy of this around job opportunities now, where young men aspire to informal work in building sites or taxis."

Linked to family and community background are the employment aspirations and outcomes of children and young people. It was noted across all communities that:

"Those in jobs are often in the lower bracket of earnings as they think this is all there is and all that they can achieve."

Young people with limited qualifications have few options in a youth labour market that revolves around "low paid shift work in the service community". In rural communities, options were generally even more restricted, and employment outside the local area brought additional problems:

"To work outside the area, public transport and buying a car are expensive – it's not worth their while [working], especially if they're on the minimum wage."

Small rural villages heavily affected by the Conflict had experienced a reduction in public services and the loss of many jobs. Despite some investment, full economic recovery had not happened. In many of the communities, young people attended schemes and courses with limited employment prospects:

"A lot of local women have now achieved a certain standard [of education] and are going to work in care homes or the VG supermarket."

Given that many children and young people struggle with formal education, and consider it irrelevant to their future prospects, many community representatives suggested that schools should adapt the curriculum. This would include greater accessibility and relevance beyond the narrow focus on academic qualifications. It was suggested that young people in school should be supported to identify skills that might open up job opportunities rather than "leaving school at 15/16 to a life of schemes".

Struggles with school: school culture, teaching methods and aspirations

Approximately half of those interviewed "hated" school, did not attend regularly and/or considered school "irrelevant". Their rejection focused primarily on school culture, teaching methods and the perceived lack of significance of their studies. A young man who 'self-excluded' stated that it was, "the whole place, I hate everythin' about school: teachers, subjects, rules, everythin'." (Co. Antrim, aged 15-20). Another left school prematurely for low-paid employment because any job was preferable to school. For him and his friends, formal education was unnecessary for the jobs to which they aspired and which were available:

"I went to [school] and it was a pure hole ... I left in fourth year and never went back ... I already had a job so didn't need to go back." (Co. Antrim, aged 18-20)

Within the context of many young people's lives, formal education was stifling and irrelevant. There were few job opportunities and their desire to leave school for any form of paid employment was inevitable. They did not accept that 'staying on' to gain qualifications would necessarily improve their employment options. Many simply maintained that school did not prepare them for their future lives or the jobs to which they aspired. As one young woman indicated, they had a clear understanding of their 'place' in wider society:

"For certain people that want to go to university, that want big jobs, big high paid big jobs, they probably need school. But a person like me, who doesn't want all that, doesn't need school ... You see people that want to be high class, I call them pushy ones. See the ones that wanna do somethin' with their lives, let them have the school if they want the pressure. See the ones that don't want pressure, leave them alone." (Co. Derry, aged 21)

Such views and beliefs have been informed and internalised over generations within marginalised communities. Beyond the issue of an acceptance of a specific class position, young people showed a clear understanding of the local labour market: "There's nothing here, just work in the shop or the pub" (Co. Armagh, aged 9-15). Aspirations beyond what was available meant leaving their community. One group noted that many young people within their community moved from school to work in a local factory. At the time of the

research, jobs were available irrespective of qualifications. This secured an income and enabled young people to live locally:

"A lot take the easy way out and just go to [the factory]. It's the easy way out, nearly anyone could get a job there." (Co. Antrim, aged 19-20)

While economic inequality and relative deprivation have been the long-term reality within these communities, they have also embedded low aspirations. The issue of educational relevance has been important in consolidating inequalities - many young people complained that school was too focused on writing, listening, exams and the regurgitation of information:

"Everybody hates school. It's boring, all you ever do is write and listen." (Co. Derry, aged 13)

"They just give you work and mark it, that's it." (Co. Armagh, aged 9-15)

Interactive classes, taught through exercises and discussions, were considered more relevant:

"If you're playin' games and things like that, and talkin' about different things instead of all written, they're all about learnin'. But ye see when you're writin' all the time, you can't actually learn nothin'. I've found that if you're writin' all the time you don't learn nothin'." (Co. Derry, aged 15-19)

School as preparation for life?

Many young people reflected on how little they had learned in school that prepared them for further education, employment or their personal development:

"I left school with nothin', nothin' ... I had no interest and I ended up comin' out of school with nothin' ... I've got

all my results since I've left school, 'cos there was nothin' at school for me." (Co. Derry, aged 22)

"Advice and information. How are we expected to handle ourselves and take decisions an' all if we don't have information? We get nothing like that from schools, nothing that matters to our lives." (Co. Fermanagh, aged 16-21)

Information provision, even within the same community, varied between schools. Discussing careers advice, for example, a group of young women stated:

"… it was good. It was all about how to get a job and you talk to a careers officer. They also give you information on other training schemes that they might not do in college." (Co. Antrim, aged 19-20)

Yet a group of young men who had attended a different school within the same community considered their advice "a disgrace" - "it told you nothin'". The group agreed with one young man who commented, "I had no idea what I was going to do when I left [school]" (Co. Antrim, aged 18-20).

In one focus group, a range of provision was described. Some attended weekly career classes with careers advisors and other external contributors, or yearly blocks of lessons about 'Preparation for Employment' or 'Learning for Life and Work'. Others received one-off sessions early on in school or in their fifth year. A few described how their school surveyed students' interests using a 'traffic light system' (red - minimal knowledge of career aspirations; green – considerable knowledge). Despite their different experiences, all agreed that work experience was valuable and recommended

more opportunities for this throughout their time at school:

YP1: "That's another way that young people are gettin' treated unfairly - they're tellin' us that we need to choose our career path at such a young age but they don't give us *any* help. They're just throwin' ye in at the deep end, like." (YP's emphasis)

YP3: "Work experience in our school's not until seventh year … you already have your choices made by then, so what if ye go and don't like your work experience? It should be done in fifth year."

YP7: "And what about those that leave in fifth year, they don't get no experience?"

YP3: "Exactly, they're just thrown out to the Tech to do a trade." (Co. Tyrone, aged 14-25)

Young people also noted a lack of consistency and appropriate information regarding sex and sexuality education. Many stated that sex education was confined to the first or second year at secondary school. It was delivered by a teacher, often a science teacher. Young women in particular were critical that the teacher was often male, the class was not engaged and sex education in mixed groups was embarrassing:

"I would have been more comfortable if it was a female teacher for girls and a male teacher for boys." (Co. Antrim, aged 19-20)

Sex education delivered by a science teacher, or within biology classes, "was too scientific" – "you get it in chapter 7 Biology [book]" (Co. Tyrone, aged 14-25). It was suggested that classes should be delivered by external specialists. For many,

restricting sex education to the early years of post-primary education was insufficient:

> "It talked about pregnancy and contraception, and sure you never even think of pregnancy at that age. I didn't even understand half the stuff they were talking about - different contraceptions and that. I still don't." (Co. Antrim, aged 19-20).

The consensus was that sex education should be taught throughout school, recognising different developmental stages and responding to young people becoming sexually active at different times. As one group said:

> "You need it at our age too, cos they're all at it like rabbits. It's true like, it's all the craze." (Co. Tyrone, aged 14-25)

Others considered that the information they had received about sex was inadequate:

> "Aye you done all that, like [sex education in school]. But the most I was taught about it, ye heard it on the street … I read about it first, read about what I was doin', what can happen to you. That's how I learned about sex." (Co. Derry, aged 21)

> "You would of known it well before [it was covered in school] anyway." (Co. Fermanagh, aged 13-15)

While there is value in young people learning from peers, there are obviously issues of accuracy and adequacy concerning this information.

A minority of those interviewed had covered mental health, emotions and feelings in school lessons. Most considered these classes particularly important because "there's a wile lot of people depressed and sad" (Co. Derry, aged 14). Others

were critical of such lessons because those delivering the classes failed to engage with young people or to relate the issues to young people's lives. They considered a peer education approach to be potentially more effective:

> "It's like adults runnin' somethin' that they don't know nothin' about. If it was peer tutorin', like somebody your own age come in, it might make more sense. At least you can say 'Oh you understand more about it cos you're the same age'. But adults just assume everythin's the way they think it is, the way it was whenever they were the same age as us." (Co. Tyrone, aged 14-25)

Teachers

Teachers regularly bare the brunt of school students' and parents' frustrations, sometimes concerning matters over which they have little personal control – the curriculum, the school ethos and the school culture. They work under difficult circumstances, often with children and young people who experience multiple problems and pressures. Children were considerably more favourable about their relationships with teachers than young people. Most reported that teachers listened to and respected children. Young people considered that most teachers did not listen to or respect their students. Although children complained that teachers asked too many questions and sometimes failed to listen, they felt that their teachers would listen and were approachable if the issue was serious:

> "Teachers listen when you tell them about bullying. They put the person in detention." (Co. Antrim, aged 7-10)

Some discussed the value of a 'worry box'. Of concern, however, was the suggestion

that what children posted was occasionally ignored:

> "Sometimes you put your name in but it never comes out and you never hear about it again. I put a note in but [name of pastoral care teacher] hasn't spoken to me about it yet and that was two months ago." (Co. Down, aged 9-10)

The power imbalance between teachers and pupils, and its impact on daily school life, was the site of most complaints. Fundamentally, adults have institutional power in schools. Several groups reported that "teachers are always right" and, consequently, it was pointless to challenge their authority:

> "Teachers always have to be right, no matter what. If you try and prove them wrong, you keep yourself barred." (Co. Derry, aged 15-19)

This also connects to the power of punishment, either formally or informally. Staying away from school (in the form of "keeping yourself barred") amounted to exclusion by feeling unwelcome. There was a common belief that teachers had the authority to make decisions in schools without acknowledging the potentially valuable input of children and young people. A young woman stated:

> "... 'Do this. Do that'. It's boring ... Like in PE, the class could pick a different thing every week instead of the teacher saying, 'You're doing this, you're doing that' ... teachers telling you what to do all the time." (Co. Derry, aged 13)

Many primary school children reported that teachers consulted them about decisions, often in relation to suggestions for school trips or play activities. This was not the case in post-primary schools where many young people considered some teachers to be patronising, condescending and disrespectful:

> "... whenever you went into the older school you're still treated like ... a child." (Co. Derry, aged 22)

> "They [teachers] think they're better than us." (Co. Derry, aged 16-17)

> "... she [class teacher] wouldn't speak to ye in the corridor if she seen ye ... They'd stick their nose up and walk on. It's like 'Who do ye think ye are?' ... It's just they look down on young people." (Co. Tyrone, aged 14-25)

Many believed that teachers were uninterested, did not care about pupils' welfare and were "only in it for the job":

> "They don't care about young people. They think 'Get the job done and get them out'." (Co. Armagh, aged 12-21)

A small but significant number of young people discussed how teachers used their power to embarrass, humiliate, threaten and/or put pupils down. They provided examples of individual young people being sworn at, called names and threatened by teachers. Generally, it was teachers' power to embarrass, often through flippant asides, that young people found memorable:

> *YP5:* "You see our teacher that was takin' us for careers, he said somethin' to my friend and she went all red and he said 'Aw look at ye, I made ya all red haven't I?' and everyone started laughin' at her and she was wile embarrassed."
> *YP3:* "Like, it's hateful."
> *YP6:* "Embarrassin'."
> *YP2:* "It's disrespectful."
> (Co. Tyrone, aged 14-25)

A further example of embarrassment and humiliation related to being publicly compared with peers:

> *YP*: "… you're threw into a class and there's times you're gettin' results and you're at the bottom and you're gettin' pulled for bein' at the bottom of the class. And they're sayin' 'If you bothered…', which knocks ye. It knocks ye further back than what ye were … and they're sittin' maybe in *a full class*, fulla people readin' out the results and you're goin' like, 'There's 26 other people in here and you just told them what everybody has got'. And then maybe the ones with the lower mark would be thinkin' 'Oh jeez, I did bad'. But ye make a joke of it and get by and it's a bit of craic anyway. But when you go home and actually sit and think about it, then you're not great …"
>
> *R*: "What impact does that have on young people?"
>
> *YP*: "With me it would make me worse, I would tend to do nothin' then. What's the point in tryin' whenever they've already knocked ye down in front of 26 other people? So there's no point in you sittin' gonna try much more than what you already were to just get the same result and know what you're goin' to get. So it lowers your confidence because then you're put in the *lower class*. And you always know which class is the *lower class*, which I don't think is fair neither …" (Co. Derry, aged 22: her emphasis)

This example includes a number of key issues. First, was the embarrassment of experiencing public humiliation in front of a class. Instead of showing this embarrassment, thus making herself more vulnerable, the young woman laughed it off until she was alone. Her outward response to such humiliation gave the appearance of not caring but, as many examples in the focus groups demonstrated, this was a defence mechanism against public shaming. Second, was the negative impact on a young person who was already struggling, who either continues in silence or gives up completely. Finally, was the damage to her self-esteem, school experience and educational achievements. An all-male group stated that they stopped attending school because of their negative treatment by teachers. One young man stated: "Just don't go to school, then you don't get blamed on nothin'. I never go to school" (Co. Derry, aged 15-19).

The groups did, however, often identify teachers who were different. Some of those who reported particularly difficult home lives identified a supportive teacher or principal. Many identified one teacher who they could approach. One group considered that newly appointed teachers were more approachable:

> "Some of the new teachers now, you know the ones comin' outta Uni an' all, they're gettin' a bit better 'cos they know what it is like, so they do. There was one there in the [school] before I left … she'd talk away to ye. Ye'd come in after the weekend and she's like, 'What's the craic?' It's teachers like that there that really make ye feel better about going to school, like." (Co. Tyrone, aged 14-25)

'Good teachers' were identified in the following ways:

> "You feel comfortable talking to them."

> "Someone who's always kind to ye."

> "They don't look down on ye."

> "They talk to you on your own level."

"Ye can have a bit 'a craic with them."

"Having respect for ye and bein' there for ye."

"They care about ye."

"Give ye praise."

"They're nice to ye."

"Understand ye."

'Good teachers' were those who listened to and cared for their pupils. 'Trust' and 'understanding' were particularly significant, and 'respect' was central to positive pupil-teacher relations.

Support in schools: counsellors and pastoral care

While children in primary schools had no knowledge of school counsellors, many felt there was someone they could approach when they had a worry or concern. Some schools utilised 'Worry Boxes', others had a named teacher with responsibility for child protection or pastoral care. Most identified their class teacher as the person with whom they would talk if they had concerns. This was in marked contrast to secondary schools, where young people were hesitant about talking to a school counsellor or a designated teacher for pastoral care because they felt that confidentiality would be breached:

"Teachers would take your stuff [business] into school … Teachers talk about you to other teachers." (Co. Armagh, aged 13-24)

"Everythin' you tell them, you hear the next day in class. They tell ye that ye can trust them, but ye can't." (Co. Armagh, aged 12-21)

"One teacher would be sayin', then another teacher would know, and it just gets about. So you don't bother sayin' to nobody in school, cos no matter what you say it'll get passed around, like." (Co. Derry, aged 15-19)

While young people trusted school counsellors more than teachers, they remained doubtful about confidentiality. Many retold stories concerning friends who had been to the school counsellor and had their confidentiality compromised:

YP1: "I wouldn't trust a counsellor in case they told."
YP2: "My friend went to them. It was between her and her Da and they told her Ma an' all, and they put her on to a wee scheme an' all."
YP3: "It was the same with my friend. She told them 'cos she didn't want the teacher to know. But they told the teacher."
R: "How does that impact on other people in the school who might want to go to the counsellor?"
YP2: "You don't wanna go in case they talk to someone else about it." (Co. Derry, aged 8-14)

While there are issues that counsellors cannot keep confidential and have a duty to report, disclosure should be fully discussed with pupils. Although breaches of confidence may not be as extensive as young people reported, the assumption that confidentiality would be breached means that most would not discuss problems with their school-based counsellor:

"… they're touts … Like, we have a school nurse who's meant to be our school counsellor and they tout about everythin'. Like, we have sick beds, an' I was lyin' one time and she thought I

was sleepin' and you could hear them talkin' about, 'Oh that there wee girl, oh my God that happened, aye'. And you're like, oh my God they talk about everythin'. Then I told everybody and now nobody talks to them anymore." (Co. Tyrone, aged 14-25)

Some young people were concerned that the decision to talk with school counsellors was not voluntary. Several reported being sent to the counsellor because it was felt there was 'something wrong'. Others considered that attending a counselling session had become a form of punishment:

> "If you get detention in our school, the school actually *forces* you to go to a counsellor." (Co. Armagh, aged 12-21: their emphasis)

Not all views about counsellors were negative. A few young people believed that school counsellors were important. While others agreed in principle, they would need reassurance that their confidentiality would not be compromised before accessing such a service.

Locating children and young people's voices in schools

While primary school children had no knowledge about school councils, they were more likely than those in secondary schools to state that they participated in school decisions, albeit limited to decisions concerning play and school trips. Many in secondary schools confirmed that their schools had councils. One group noted:

> "We have one in our school but no-one knows. It's just there." (Co. Tyrone, aged 14-25)

Views and experiences of school councils were mixed. A few young people reported various consultations and subsequent changes as a consequence of the school council, including: benches in the playground; decisions about school trips; changes to the uniform. The value of having their voices heard through this mechanism, and the positive impact of consultation, is illustrated in the following example:

> "We got new toilets – mirrors in our toilets. We asked if we could design them ourselves and we got to do it then. It's better when you design it yourself, you'd keep it cleaner." (Co. Derry, aged 8-14)

Despite identifying some positives, the majority of young people considered that school councils had little power and, therefore, minimal impact - although offering some student representation, there was no guarantee that decisions would be followed through. Young people reported repeatedly raising issues and not receiving a response:

> "It wasn't mentioned again when we mentioned it about three times." (Co. Fermanagh, aged 13-15)

> "The teachers wouldn't really listen anyway." (Co. Tyrone, aged 14-25)

> "They say they'll listen to whatever you say, but they don't." (Co. Armagh, aged 15-24)

While it may be difficult for schools to respond to all the issues and suggestions raised by pupils, those interviewed complained that there was minimal feedback and no explanation about rejected suggestions. They felt ignored, which led to a rejection of the process as tokenistic. In theory, young people were 'given a voice', but in practice they had no influence regarding decisions. One young man was

convinced that the school council in his school was a public relations exercise:

> "School council, that's good! It's only for the image of the school, like in all their leaflets: 'We have a student council, they do everything that the students tell them'. It's just for the image of the school." (Co. Tyrone, aged 14-25)

Pupils from three different schools participated in this focus group and all were negative about their school council. A young man from another community noted the selectivity of topics discussed:

> "… when you were talkin' about the behaviour and all it wasn't really taken serious. If you brought up activities and that, they would do somethin' about it. But see when it came to talkin' about this year group doin' what wrong, you couldn't defend it, they wouldn't listen to ye. It was like nine of them onto one of you, so you couldn't really fight your cause." (Co. Derry, aged 15-19)

While positive about the idea of school councils, he felt that their powers were limited and their ability to deal with key issues was restricted.

A further complaint focused on the unrepresentative membership of school councils: "… it would be better if they asked the whole class 'cos them people [council representatives] could be wantin' somethin' what we don't want" (Co. Antrim, aged 10-13). An older group agreed that:

> "… you need to get the whole school involved, go round and get everybody's point of view." (Co. Antrim, aged 19-20)

Some young people believed that 'representatives' had been selected by teachers: "It's always the popular people

and the smart people" (Co. Armagh, aged 13-24). Those in another group felt that some young people used the council as a means of furthering their academic prospects, with little real interest in the issues raised by their peers:

> "The girls who are on the student council, they look brilliant on their UCAS forms for college. It's the only reason they're on it - they're not on it to help anybody." (Co. Tyrone, aged 14-25)

Most young people supported the principle of school councils, but found them ineffective and limited. Ultimately, decisions remained with teachers while councils were used to present the image that consultation and participation were part of school life. Few young people felt their views were adequately represented or taken into account by their school council.

Post-16 opportunities and experiences

While some of the children interviewed had higher education aspirations, relatively few of the young people had considered university as an option. Those who had left school were in paid employment, involved in training programmes or undertaking vocational courses. Training or further education were considered more interesting, engaging and relaxed than school. Tutors were more respectful, the teaching methods and college environment were more accommodating and inspired greater self-confidence. A young woman commented:

> "You've got more respect, you've more … it's not even attention, it's you've more advice. You can ask for advice easier than what ye can [in school], even though there's still the same amount

of people in the class. Ye can still ask for advice without feelin' ... 'Oh I'm not fit for this class, I need to be in the rompers' class'." (Co. Derry, aged 22)

Again, this demonstrates how the school experience can damage young people's self-esteem, learning potential and, consequently, their future options.

Several young people identified lack of post-16 opportunities and minimal options – few jobs and inadequate local training or educational courses - as an issue in their lives:

> "Our lives are far from sorted an' we're lookin' for something to do. Like trainin' for jobs - for good jobs, not crap jobs. A training centre - there's nothing to do around this area." (Co. Fermanagh, aged 16-21)

Some had been unable to access courses in which they were interested and had to settle for whatever was available. Consequently, they had little motivation. One young man stated:

> "I went on to do mechanics. After a couple of weeks they were supposed to get me a placement. But they couldn't get one, so I had to give the mechanics up and sign on the dole." (Co. Derry, aged 21)

Eventually he was given a New Deal placement working in a supermarket. While he hoped the placement would lead to a job, his preference was to train as a bricklayer and he feared unemployment. A young woman from the same community noted the paucity of available training:

> "If the course you wanna do is finished, or taken up, or it's not runnin', then you're threw into IT or somethin' that you've *no* interest in ... I know there's

nothin'. If you don't work, there's not a lot of opportunities out there. You're stuck with goin' to ... a certain buildin' that has maybe courses that ye don't want to do. Or else you're left sittin' with *nothin'* to do seven days a week." (Co. Derry, aged 22: her emphasis)

Both examples reveal the reality of 'choice' available to many young people – to undertake *any* training/educational course or be unemployed. Marginalised, they are moved between courses and schemes, with no effective identification of their skills or options before leaving school. Their 'failure' becomes individualised. It is the young people who have been in care, who have criminal records, whose family cannot offer financial support, or who lack academic qualifications, that are most in need of appropriate and relevant post-16 training and education. As Ken Robert's (1995) research indicates, their experience amounts to a form of 'warehousing', in which young people are 'kept occupied' - invisible in unemployment statistics until they enter the labour market.

Those interviewed rejected and resented portrayal of their situation as one of 'choosing' to be unemployed. Many had taken jobs, or enrolled on schemes, that involved hard work for low wages. For those who were unemployed, their experience of lack of money, boredom and low self-esteem were demoralising. The meaning and value attached to work was clearly evident in their discussions of training and employment, which gave them a purpose, a status and a sense of emotional well-being:

> "I wasn't workin' there for a while and I went back into ma depression, because I would get wile depressed really easily. It [working] brings my self esteem back up ..." (Co. Derry, aged 21)

Despite their efforts to progress employment opportunities, the reality for many was moving from scheme to scheme, or course to course, with diminishing prospects of gaining desirable or interesting work. They accepted the limited possibilities of what was available, but would prefer more extensive and rewarding opportunities. Given these experiences it is difficult to be optimistic regarding positive long-term employment opportunities for young people at a time of growing economic recession. As this chapter has shown, the formal education system has failed many of those from economically disadvantaged communities. Even during economic growth, job opportunities were limited, short-term and poorly paid. As demonstrated in the interviews and focus groups, this process of marginalisation undermines aspiration and diminishes self-worth.

Key Issues

- *Family and community were identified as key factors in shaping children's educational experiences and aspirations.*

- *Identified inhibitions on attainment included: lack of appropriate resources; the low value placed on education in some families and communities; poor quality vocational education/training; limited job opportunities within local areas.*

- *Approximately half of the children and young people interviewed disliked school or considered it irrelevant. Their 'rejection' of school focused on school culture, teaching methods and the perceived lack of relavance of subjects studied.*

- *Many felt that school did not adequately prepare them for adult life. They were particularly critical of careers advice, sex and relationships education, lack of opportunities to explore emotions and feelings in a safe and trusting environment.*

- *Children were considerably more positive about their relationships with teachers than young people.*

- *Young people often felt powerless in school, believing that they were silenced, judged and misunderstood by teachers.*

- *Many young people had experience of school councils, but recorded a range of limitations, including: minimal influence and impact; tokenism; poor feedback about decisions; some issues being defined as 'off-limits'; teachers having the 'final say'; selective representation of pupils.*

- *Despite the presence of school counsellors or pastoral care teams, many young people were reticent to share information with these staff because they believed their confidentiality would be compromised.*

- *On completion of compulsory education, many young people attended schemes and courses with limited employment prospects. Employment opportunities were more restricted in rural communities.*

- *Employment aspirations and outcomes were generally low and related to whatever jobs were available in local communities. Formal education was not considered necessary for most locally available work opportunities.*

CHAPTER 6

COMMUNITY AND POLICING

Communities in transition

Each community was affected significantly by the Conflict, although in different ways depending on its location. The communities included relocation housing for families exiled from their homes, residential locations for police or security forces and recruitment sites for paramilitary groups. Some had experienced disproportionate numbers of deaths and injuries, and the threat of violence was so persistent that several were gated at night. The volume of bombings, shootings and other attacks during the height of the Conflict had constantly disrupted everyday life. For example, in one area it was reported that a bombing or shooting had occurred every week. Another had experienced regular battles between the army, police and paramilitaries on its streets. A third reported "eight bombs on one night ... the whole town was on fire at one point."

Some of the communities had been heavily fortified, with large police or army bases centrally located and security forces a permanent feature on their streets. Many reported experiences of regular house raids, daily intrusions into their privacy and constant harassment by the security forces as they walked the streets of their neighbourhoods. A high level of resentment remained evident in the interviews in these communities, which were frequently described by community representatives as "closed" and suspicious of outsiders. In Republican/ Nationalist areas particularly, alienation from the police and security forces was so strong, "we felt the IRA were here to protect us, they were on our side as the police were not".

Consequently, some areas had become isolated and introspective. With public services withdrawn or reduced, they

developed an ethos of community support. The community was policed from within and, for safety, a culture of secrecy emerged: "you keep your mouth shut". The deficit in State policing meant that offending and offensive behaviour was regulated and punished locally. Within these communities, young people learned to fear punishment, distrust the police and have pride in their cultural identity. The community representatives interviewed considered that the Peace Agreements had failed to recognise these key elements. They felt that the assumption of 'change' - in beliefs, behaviours and expectations - was sudden and unrealistic for communities "at the coal-face of the Conflict". Frustrations across all the communities were palpable:

"With the likes of the *Good Friday Agreement*, nobody looked at what needed to be put in place in the long-term to support communities through this time of transition – the focus was always about getting the Assembly going ..." (Co. Armagh, Republican/ Nationalist)

"On the streets in the community, you don't see any benefits from the peace process at all. Despair is still there ..." (Co. Derry, Republican/ Nationalist)

"There have been changes in Government but not on the ground, they don't care what's happening on the ground ... you can't clear up the conflict in a few years." (Co. Antrim, Loyalist/ Unionist)

"The peace process has made no difference. In fact, it hasn't helped." (Co. Fermanagh, Loyalist/ Unionist)

All communities involved in the research, to varying degrees, considered there had been little progress. In fact, regression was

noted by some. A comment made in one meeting was repeated in all:

> "[The area] has improved in some ways but has deteriorated in others. There is more violence post-conflict, people don't feel safe in this community when they always did in the past."

There were increasing concerns about the behaviour of children and young people in all areas and a shared belief that young people were "disconnected from the community". This was contextualised and understood in some communities better than others. Many considered that young people, and young men in particular, experienced confusion as a consequence of the transition from conflict. They had been brought up with a strong cultural identity - to fight for and defend that identity, sometimes through playing a part in the Conflict. Yet, past expectations had been reversed:

> "There are confusing messages for young people. Now adults are saying don't do that [support 'the cause'], when in the past they were told to do it."

> "Now young people aged 20-21 are in a vacuum. They were told in the past that it was OK to do certain things and now they are told it isn't."

For working class young men with an unambiguous, strong cultural and community identity, there was a collective sense of loss – there were no jobs, education was not valued and there was no alternative. A view echoed across the communities was that:

> "It was always in the heads of these young men, 'We're tough, we're from [name of area]'. They had an image, now they're not allowed that. It has been

taken away and nothing has replaced it. They were something in the past and now they're not."

Joining the paramilitaries was no longer a readily available option. Young men's identity and place within their communities were no longer unambiguous. It was felt that they were "disillusioned and alienated from community life", and that some responded to this dramatic change through violence - asserting their masculinity and sectarianism to defend a culture they felt was under threat. In some communities, powerful adults fuelled such fears:

> "… to some young adults there is no hope. They believe the system isn't working for them – 'Fuck the peace process, it hasn't done anything for us' – and they are attracted to the dissidents." (Republican/ Nationalist)

> "It's hard to keep them not wanting to join the paramilitaries … The paramilitaries have created something that just can't go away, it's going to be so hard to take it away." (Loyalist/ Unionist)

A more visible presence of young people on the streets had emerged, causing concern in all communities. Their physical presence, often combined with heavy drinking, occasionally spilled over into violent behaviour. The general view was that the communities were no longer safe places. There was nostalgia for a somewhat idyllic past, when parents controlled their children and paramilitaries "policed, for the most part, with compassion". The reality, however, was that in the past many children and young people did not leave their homes because they feared for their

safety and paramilitaries were often far from compassionate.

All communities expressed concern that there were no longer effective controls on young people, that there was a 'policing vacuum' and that the 'protectors' of the community had 'retired'. The police were either unwilling to intervene or unwelcome. Whether or not the behaviour of children and young people was as extreme as some believed, the key issue was that community representatives felt communities had been left without support. Typical comments regarding the behaviour of young people and experience of a 'policing vacuum' included:

> "The police are not there and the paramilitaries will do nothin' about it. Young people have no fear so they behave as they like."

> "If something happens now, you feel you have nowhere to go."

> "From when the paramilitaries moved on it is like a free for all here ... the days of running to someone and getting it sorted are gone."

Among some, there was a level of resentment towards the past 'protectors' of the community whom many held responsible for a situation in which previous control within the community (accompanied by active discouragement from working alongside the police) had been withdrawn.

In Republican/ Nationalist communities there was a continuing reticence to report the 'anti-social behaviour' of young people to dissident paramilitaries as it was felt that they punished too heavily. Yet a lack of trust in the police remained. As such, a "policing void" had consolidated:

> "There is much confusion among people in these communities – they can't trust the police and they can't trust the men in their own communities. So they are left in a no-man's land."

Former 'protectors' were no longer visibly active in Loyalist/ Unionist communities. There was a reticence to involve the police for fear of reprisals and it was felt that the police did not have the powers necessary to deal with young people. This, some suggested, was because children had been "given" too many rights:

> "Human rights has taken over. The police regulated in the past but can't do it now, they can't break up a group of lads [standing on the street]."

> "The police can't do anything. They have no powers."

Fears about young people's 'anti-social' and 'criminal' behaviour had spiralled, often amplified by sensationalist newspaper reporting. Many community representatives had an understanding of the difficulties faced by children and young people - that drugs, alcohol, violence and suicide were constituent elements of their marginalisation. As one community representative noted:

> "... everyone washes their hands of these young people – there is a paralysis in dealing with young people."

While it was noted that children and young people needed to be "better connected to community life", there were few examples of efforts to ensure that this happened. In fact, community development work often did not include children and young people.

Analysis of the often contradictory views of community representatives regarding

the position of children and young people within the six communities revealed a generation excluded from, and neglected by, the Peace Process. A generation with little explained to them but much expected of them, pulled in opposing directions by politicians and 'hardliners' in their communities. A generation struggling to retain or reclaim an identity now feared and shunned by many in their own neighbourhoods:

> "Nothing was ever explained to young people - policing was never explained, change was never explained."

Locating children and young people's voices in the community

Despite children and young people feeling distrusted, disrespected and disliked within their communities, most community representatives were aware of the need to be inclusive. Yet no resident or community forums included young people's representatives, and their involvement in community projects tended to be limited to one-off events or programmes and services. The assumption and expectation was that specific youth programmes/ services were provided where young people were located in the community. Little thought was given to including young people in wider, more general community-based programmes and decision-making. Although many young people made a significant, vibrant and defining contribution to specific local youth projects, the progressive ethos of these projects was not reflected more broadly in their communities. This was clearly articulated by those interviewed across all age groups and in all areas. Some gave instances of consultation in decisions about community events, but only one

group had experience of consultation about community facilities. One gave examples of recent changes within its community about which opinions had not been sought.

In one community planning exercise, a young man and a young woman sat on the Neighbourhood Renewal Committee established to develop new play and leisure facilities. This was considered to have been worthwhile, especially as it resulted in the provision of good facilities. However, once that part of the initiative was completed they were no longer invited to the Committee, despite expressing an interest in future developments. Such Committees and meetings are not generally young-people friendly, and young people often lack the confidence or skills to participate fully and effectively.

Two other groups discussed consultations about play facilities. They considered that their views had no impact and they did not receive feedback:

> "They asked us what did we want and we said, 'Monkey swings an' all', and they said 'Yeah we'll get that' and we're still waitin' on it. I think they were just sayin' that to us ..." (Co. Armagh, aged 9-15)

Most children and young people had never been consulted, nor did they expect to be. Adults showed no interest in, or respect for, their views:

> "They think they know what's best for us, so they just do it." (Co. Derry, aged 16-17)

> "Most of them just aren't interested in what young people want or think. They never ask." (Co. Antrim, aged 19-20)

> "If one of us went in, they wouldn't respect our views. But if we sent an

older person in, then they'd respect them." (Co. Fermanagh, aged 13-15)

The consequence of exclusion from decision-making was inevitable. Within one community a new centre opened yet few of those interviewed were aware of its purpose:

> "We're not goin' to want to go, we're not goin' to want to get involved. So they're goin' to lose out on the young people comin' into it … they put that [centre] up there, like … it's been there two years and I've never been in it." (Co. Derry, aged 16-17)

Yet this group, and others, emphasised the need for community facilities that appealed to young people. Most significantly, their exclusion extended to community and residents' forums - no children and young people interviewed had been invited to participate in such forums. While one residents' group argued that young people were apathetic and showed no interest, the group's most recent leaflet (delivered to households throughout the area) invited residents aged "over 18" to its meetings - the message was unambiguous! Children and young people in four communities voiced annoyance about their exclusion from meetings, particularly when people from outside the community (such as councillors and police officers) attended. They felt that they were the main topic of discussion, but that their views were not sought or heard. One group had listened at the door of a meeting, and wanted to make their case, but to have entered would have fuelled negative opinions about them. Exclusion and secrecy were significant in young people's accounts:

> YP1: "They talk about the young ones but you don't get to give your side."

> YP2: "It's not fair - they have meetings about us, but we're not allowed to be there to defend ourselves."
> R: "How do you feel about that?"
> YP1: "Powerless."
> YP2: "They have a say, we don't." (Co. Derry, aged 15-19)

> YP1: "It's ok for them. Adults speak for themselves and can speak for themselves. They have their community meetings and we're left out."
> YP2: "Yeah, how can you get a word in if they have private meetings?"
> R: "How do you feel when that happens?"
> YP1: "You're made to feel excluded. Younger ones need to be given a chance." (Co. Fermanagh, aged 16-21)

To young people, this was a clear indication that their views were inconsequential, that adults were unwilling to listen to their concerns or explanations, and that they were not viewed as important. Their frustrations surfaced when they stated that they were unwanted in a community that was 'theirs':

> "People aren't bothered with us. They just want us out of their area. But it's our area as well. It's not their place, we've been reared here too … We should have more say. Most of the things they complain about we complain about as well. You know, like dog poo and the state of the estate. And there's nothing for us." (Co. Fermanagh, aged 16-21)

While tensions and contradictions emerged from these competing accounts, there was an undercurrent of agreement – that children and young people did not feel fully included or integrated within their own communities.

Attitudes towards the police

Those interviewed across all communities were disillusioned with the police. Many felt that the police were unwilling, unable or ill-equipped to deal with an increase in crime and anti-social behaviour. Police tactics had failed to gain the trust of the communities. In one area, where there had been recent problems with stone-throwing, a community group had invited the police to a local meeting. The police reacted the following night by sending three or four police landrovers into the neighbourhood. A community representative stated, "the police just fuelled the problem by this response".

Some Republican/ Nationalist communities, until recently heavily policed, were concerned that a 'policing void' had emerged. Community representatives stated that local police stations were under-resourced and that the police were unwilling to become involved in community issues. In one community, they complained that the police had failed to respond to a recent spate of joyriding. Local people believed that the consequences were obvious:

> "[It] legitimises people's view of the police based on past experience. If it had of been an IRA man in [the area], the place would have been swarming with police. The message this gives now [is that] people feel the police are ignoring community problems."

Among community representatives in Republican/ Nationalist and Loyalist/ Unionist areas, there was no rejection of the PSNI *per se*, but a shared assumption that the communities were not policed effectively. They also believed that there was a reluctance to report crime to the police, either for fear of reprisals or because people assumed that the police would not respond. Consequently, crime figures were falsely low and this led to continued under-resourcing.

Children's and young people's responses were similar to those of adults. While their attitudes were informed by adults, they also reflected personal experiences. Within some communities, historical resistance to the police, past experience of discriminatory policing and heavy-handed tactics, had been passed down. None of the young people interviewed in Republican/ Nationalist communities trusted the police. A community representative stated:

> "As teenagers we hated the police and some families had more reason to hate them than others because of what happened to them. This history has followed through to young people today … [it is] an ongoing legacy of the Conflict. It has been handed down and young people know the stories of the past."

While young people across all the communities were negative about the police, this view was not universally shared by the children interviewed. Those in predominately Loyalist/ Unionist communities expressed a relatively positive view, particularly regarding safety:

> "I don't feel safe when there is no police" (Co. Antrim, aged 7-10)

In predominantly Republican/ Nationalist communities, however, of all 9 to 11 year-olds interviewed, only one child equated the police with feelings of safety: "You are safe because police come up at the weekend" (Co. Down, aged 10). All others associated the police with rioting. Those interviewed in one area recounted recent

instances when the police had entered the community at weekends because young people were drinking on the streets. This had resulted in conflict in which the police were attacked with bricks and left without resolving the situation. The children in this area did not feel safe when the police arrived:

> "There's sofas on the roads and all … yeah burnin' them on the middle of the road so the police can't get past … it's like a road block."

> "They [young people] brick them [the police] and they always drive away again." (Co. Down, aged 10-11)

In this community, the initial police response had led to a pattern each weekend: young people congregated on the streets, the police arrived to move them, the police were 'bricked', young people were chased and the police left. This interchange had become a form of entertainment, providing interest and excitement on otherwise drab evenings when little else happened. A ten-year-old girl commented that one of the 'good things' about living in the area was the police presence. Asked if it made her feel safe, she replied: "the police always come up and they always get hit with stones and you get a chase."

In several communities, the presence of the police had become synonymous with rioting. A young woman described the situation as follows:

> R: "Would there be many police in the area?"
> YP: "Loads, they start from about 8.00 at night."
> R: "Is there ever any trouble?"
> YP: "Aye, a wile lot of riots."
> R: "So how do these riots start?"

> YP: "As soon as they hear, they start throwing stones as the police come up."
> R: "So if the police weren't to come up, would it be quiet enough or would there be fighting anyway because people are drinking?"
> YP: "No, it would be quiet enough if the police weren't there." (Co. Derry, aged 14)

Likewise, another group commented:

> "They [the police] are the problem. It's them that leads to people petrol bombin' and all that, and then they just destroy the place." (Co. Armagh, aged 12-21)

Such views do not simply reflect culturally reproduced, negative attitudes towards the police within these communities, but are derived in events witnessed and/or experienced by children and young people in their communities. Responding to a questions about trusting the police, the overwhelming response was negative. Across the age ranges the following comments were typical:

> "The police don't do anything when they come up. They don't sort out the problems." (Co. Down, aged 9-10)

> "The response to the police 'round here is no-one will phone them as they don't do anything. They're not very helpful in this area." (Co. Derry, aged 19)

In some communities, a culture of secrecy persisted among young people who feared reprisals:

> R: "If something happened, would you contact the police?"
> YP1: "Yeah, if somethin' happened to ya, if someone hurt ya."
> YP2: "No you wouldn't! You'd just move to a different country and not come back." (Co. Armagh, aged 12-21)

Young people understood and expressed the view that rioting and their relations with the police were embedded within the social, cultural and political context of their lives. They grew up in families and communities that never trusted the police and had directly experienced abuse or intimidation by police officers. These deep-seated memories and experiences had not been erased by a change in the name, badge or training of the police force. As a young woman stated:

> "The younger ones is just bargin' the police 'cos they don't know what's right and what's wrong. They just see the police as bad because we're never taught any different." (Co. Derry, aged 22)

Community representatives within Republican/ Nationalist communities considered that communities had not been prepared for the emerging police presence.

Negative attitudes towards the police were not restricted to children and young people. There was evidence that in some communities powerful and influential adults encouraged violence towards the police. "Armchair paramilitaries", as they were defined in one community, used young people to initiate violence. Yet they accepted no responsibility, stating publicly that they were no longer 'active'.

Young people from different community backgrounds had negative views of the police. Some living in Loyalist/ Unionist areas considered they were policed more heavily than their Republican/ Nationalist counterparts and vice-versa. Those in Republican/ Nationalist areas expressed difficulties in respecting a 'new' force after years of inherent hostility. While some young people in Loyalist/ Unionist areas believed that changes in policing were

necessary, in the transition towards peace, others felt that Catholics had benefited and that the Protestant community had been 'sold out':

> "… these people in politics they tell ye 'Aw, trust the police - they do this, they do that'. But it's like strangers comin' into your area and invadin' *your* space" (Co. Derry, aged 22: her emphasis)

> YP5: "Sure look at [Catholic area] they have their flags up all year and we're not allowed any."
> R: "How does it make you feel when one area is allowed that and yours isn't?"
> YP1: "Hatred to the police."
> All: "Favourin'. Bias."
> YP1: "Sinn Féin win everythin'."
> (Co. Fermanagh, aged 13-15)

Experiencing the police

Most young people did not feel respected by the police. While they accepted that the behaviour of some young people was offensive and required a police response, they believed there was a tendency to view all young people as 'problems'. On the streets, young people were constantly 'moved on', although they had done nothing wrong:

> "… you can't really walk anywhere without them [the police] saying something. They're like, 'Move on, move on!'. You just can't stand about anywhere in the town without them tellin' ye to move." (Co. Derry, aged 15-19)

> "When we were kickin' the ball at the bottom of the street, he [police officer] pulls up and is like, 'Here, wouldn't ye take that there ball away or you're gonna lose it' … Sure we don't even have no football pitch to play on, so where

do they expect us to play like?" (Co. Fermanagh, aged 13-15)

Such interactions diminished young people's respect towards the police. They felt that, compared to adults, the police viewed and treated children and young people differently. It was also stated that, even when young people attempted to positively engage with the police, they were treated disrespectfully and with suspicion:

> "If they do come in and the young ones talk to them, they tell them to go away." (Co. Derry, aged 19)

In one community, all groups interviewed stated that the police regularly threatened young people with Anti-social Behaviour Orders (ASBOs). While no ASBOs had been issued, some children and young people had received warning letters for behaviour they did not consider to be anti-social. ASBOs, they argued, were used to threaten young people, based on the assumption that 'hanging about' was a precursor to anti-social behaviour:

> "Police hate the sight of you. We're told we'll get an ASBO." (Co. Armagh, aged 13-24)

> "You don't feel respected by the police ... they say 'I'm going to put an Order on you wee girl, wee boy." (Co. Armagh, aged 9-15)

In the experience of these young people, ASBOs had become another tool to regulate and control their behaviour - behaviour that involved merely standing or sitting in groups within their own neighbourhoods. On many occasions they were moved under the threat of an ASBO. Yet there were no safe, local alternatives.

Young people considered the threatened use of ASBOs to be further evidence that

the police had pre-determined ideas about young people:

> "... they don't care what you say, they don't listen to what you say." (Co. Derry, aged 9-11)

> "The police never changed. They *always* pick on the young ones, always" (Co. Derry, 15-19: his emphasis)

These views were compounded for some by their direct experience of police responses:

> "If you hit the police [with a stone] and they catch you, they always hit you with their baton." (Co. Down, aged 10-11)

> "I've seen it, some wee wean of seven years old down [name of road] - they were hittin' him with a baton. Alright he had a paint bomb, like. But they still hit him with a baton and he was about seven." (Co. Derry, aged 16-17)

Although the behaviour of children involved in stone-throwing and paint-bombing is unacceptable, it is not without context. The police responses as described are unlawful. They also confer legitimacy on the use of violence and confirm the negative reputation of the police. Intimidation, harassment and violence were themes which arose in five focus groups and were alluded to by others. One group noted:

> "They think they're lethal, they actually do, bringin' out their batons to us. They'd say and all to ye, 'We would never lift our hands to young ones, we never do this, we're not allowed to' - but when there's no cameras around they kick the shite out of ye." (Co. Derry, 16-17)

Young people in two groups recounted personal experiences of police beatings

or described how their friends had been assaulted. They stated that the police deliberately goaded young people, knowing they would react:

> "Beepin' the horns at ye when you're just sittin' there."

> "And they come in your face and just keep talkin' to ye. Ye don't wanna take them on, you don't talk to them. And they're still in your ears. Then they make ye roar at them and tell them to get outta your face. And then they threaten you." (Co. Derry, aged 16-17)

Goading invariably ended in violent confrontation:

> "Well, if the police are always fuckin' annoyin' ya you're gonna be bad and you're gonna hate the law." (Co. Fermanagh, aged 13-15)

> "They wind you up because they know you're gonna retaliate, you're just gonna start throwin' stuff or start riotin' or start somethin'." (Co. Derry, aged 15-19)

This group recalled similar experiences when they had been 'lifted' [arrested]:

> YP1: "They come up to your street and start doin' hand signals and all, like 'Come on, come on'. So we go over to them ones and it all starts."
> YP2: "They shout abuse at ye, they egg you on. Then you get mad. Then you do somethin'. Then they lift ye. Then they put the blame on you. Then it goes on record."
> R: "Have any of you been lifted in that way?"
> YP2: "I have."
> R: "How many times?"
> YP2: "Twice."
> R: "Anyone else?"
> YP3: "Aye."

> R: "And what was that about?"
> YP3: "The same, they try to egg ya with your name and all."
> R: "And how do you respond to that?"
> YP3: "I threw a brick at them." (Co. Derry, aged 15-19)

This young man stated that he was then hit by the police: "I got hit right there [pointed to his side] with a baton". His friend was also 'lifted' and beaten inside the police land rover. Young people in several of the focus groups gave similar accounts.

Overall, young people considered they were an 'easy target' for the police, who used their powers to discriminate against them. From the interviews it appeared that they considered age discrimination was a more serious issue than discrimination on religious grounds. Two groups living in a Loyalist/ Unionist community also experienced constant police harassment, often for little more than playing football on the streets or gathering on the street. One group stated that some officers "think they're Robocop":

> YP1: "... this boy, didn't he think he was the commando? Come up with his wee goatee and his skinhead. And he was all, like, he was wild like. He was real mustard. He come up and he said ..."
> YP8: "'Well girls'."
> YP1: "'Well girls' and not one woman there!"
> R: "What happens when someone does that? What's your attitude?"
> YP3: "Fuck 'em!"
> YP1: "If you're gonna get arrested for disorderly behaviour, so be it."
> YP3: "He just kept on with that shite. He made us line up across the fence and give our names and addresses." (Co. Fermanagh, aged 13-15)

Across the groups interviewed, many children and young people gave examples of being treated disrespectfully by the police. They felt demeaned and humiliated, which sustained a climate of mistrust and confrontation. Instructively, some of the strongest criticisms came from a group involved in a police youth project. While their experiences with police officers involved in the project were positive, the actions of other officers undermined the progressive community work of their colleagues.

The future of policing?

Asked about the potential for change in police-community relations, the groups believed that the police would continue to discriminate against young people. Community representatives and a few young people, however, made suggestions for progress. Across the communities there was an identified need to build positive relationships between the police and the community. While the majority of those interviewed considered this the responsibility of the police, young people also considered that they had a role to play and put forward suggestions for progressing relations.

Community representatives in one area raised the issue of the high turnover of community police officers - within a month, three different community police officers had worked in the area which undermined the possibility of building positive relationships and trust. A consistent and sustained approach was called for, alongside appropriate training for police officers in how to communicate effectively with young people. Young people considered that this was possible. For example, a fun day held in one community had involved adults, children,

young people and the police. This day had encouraged direct and positive engagement, in which all of those involved in the community had an opportunity to mix.

In a community without accessible or safe provision for young people a programme had been facilitated by a small number of police officers and volunteers. Described as "a diversionary scheme put in place due to local concerns about the behaviour of young people in the area and the fact that 'normal policing' was not working", its aims were to build more positive relationships between young people and the police and to decrease anti-social behaviour. The programme was novel, but short-term and under-funded. Yet it operated one evening a week and on occasional weekends, engaging primarily boys and young men identified as a 'problem group' within the community. Over time strong relationships, based on mutual trust and respect, had developed and were sustained. Initially the programme focused on soccer. Emerging from the initiative of the participants, the programme developed other elements including cross-community soccer matches; exploration of their culture; visits to cultural sites outside the area; negotiations to remove flags from the area; consultations with formal bodies and agencies.

It was a demanding programme for facilitators with no background or training in this type of work, and the police officers involved had to overcome much scepticism of those involved. Yet they showed a commitment to the programme and had undertaken a number of training courses over time. The programme developed respectful relationships, although several barriers and difficulties remained. Funding was precarious and there were no local initiatives into which young

people could progress. The attitudes and responses of police officers not involved in the programme towards young people could potentially undermine the positive relationships developed. The sense was that such officers did not value the programme. Further, 'balancing' roles, particularly police officers working as quasi-youth workers, was a challenge. Asked if there was anything they would change about the programme, the workers suggested greater recognition for the young people involved:

> "Young people are not getting the credit they deserve for the things they've done. They've come a long way. It's hard for them to work with the police or with the boys across the town."

While such examples have the potential for establishing better police-community relations, different communities are at different stages in their acceptance of the police. Yet, within neighbourhoods which have traditionally been hostile to the police, some of those interviewed felt that the police should gradually build relations. One young woman suggested that the police, like the fire service and health professionals, should organise sessions within schools explaining their role and what constitutes anti-social or disorderly behaviour. Community representatives considered it important for the police to have a more positive presence - not coming into communities only in response to problems. There was a keen awareness of the difficulties faced by the police, particularly in Republican/ Nationalist areas, but a belief that these would be overcome in time:

> "There is no foot patrol in the area. Politically this is not possible – if people know they are going to be there, they will target the police. But it could be

developed gradually to build confidence – ten to fifteen minutes a day in different parts of the estate."

Although young people within Republican/ Nationalist communities were less convinced, there was no evidence of an outright rejection of the police.

In two communities, young people suggested that people from the local community should join the police as they understood local issues:

> "There should be local police and customs - the lads that knows what's goin' on, rather than the lads that couldn't care less." (Co. Armagh, aged 12-21)

This group wanted a more visible police presence in their community because they felt unprotected. They could not turn to the PSNI for fear of reprisals, nor to former paramilitaries as often they were involved in intimidation. They felt that another form of policing – neutral and trusted – would potentially help the situation:

> "There'd be no lads on the streets that would stop ye and stuff. There should be local police patrollin' the streets more often, 'cos if somethin' happens to ye now ye have to handle it yourself. Like, who are ye goin' to ring?" (Co. Armagh, aged 12-21)

Increased recruitment to the PSNI from these communities, however, was not considered likely to happen in the near future:

> "Sure there was a Catholic one joined the cops and he got shot … the more Catholics that do join the more rights we're probably goin' to get. I think there should be more Catholic cops. But I can't see many joining." (Co. Derry,

Across all communities, the issue of police respect for the community and for children and young people was paramount. Despite more neighbourhood policing, it was agreed that that the police do not have appropriate or effective training concerning working with young people and fail to communicate effectively. The focus groups and interviews indicated that, while they did not consider the police were 'doing a good job' in their communities, adults were more accepting than young people of the police. Young people reported being moved on, verbally abused, scrutinised and targeted far more frequently than adults. The shared view among children and young people was that differential policing towards them continued.

Key Issues

- *Many community representatives and young people expressed frustration that the Peace Agreements had not brought significant change. They believed that the impact and legacy of the Conflict had been ignored, and that communities have been left without necessary economic and social support.*

- *It was recognised by young people and community representatives that many young people were confused about their cultural identities and did not understand the implications of transition from conflict.*

- *For working class young men with an unambiguous, strong cultural and community identity, there was a collective sense of loss — formal education was not valued, local work opportunities were declining with few alternatives, and their cultural identities were felt to be under-valued.*

- *Some young men responded to these dramatic changes in employment and*

social opportunities, and their lack of status, through violence. They asserted their sectarian identity to defend a culture they believed was under threat.

- *Children and young people believed they were purposefully excluded and marginalised in their communities. They were not invited to community forums or meetings and were not consulted in decision-making processes.*

- *Young people expressed frustration about feeling 'unwanted' in 'their' communities.*

- *Community representatives believed there was a 'policing vacuum', particularly regarding the challenging behaviour of some young people.*

- *Community representatives and young people expressed disillusionment with the police, who were considered unwilling, unable or ill-equipped to deal with community concerns.*

- *Police tactics had done little to generate trust or respect. Young people reported being 'moved on', 'goaded', 'threatened' and 'harassed' - sustaining a climate of mistrust and confrontation.*

- *Young people across all six communities were united in the view that they were policed differentially and unfairly because of their age.*

PLACE AND IDENTITY

Meanings and perceptions of place: positives, negatives and suggestions for change

'Place' and 'space' are key elements of people's lives, central to a sense of belonging and personal/community identity. While noting the potentially limiting aspect of communities, Henderson (2007: 129) states that they constitute 'an important source of social recognition for individuals, providing a tangible sense of connection and identity: knowing who you are and where you belong'. Given the politicisation of space, residential segregation and religious/national divisions in Northern Ireland, it is important to consider how local, internal divisions impact on the lives of children and young people. Many assumptions are made about specific, identifiable communities from the outside. The meaning of place, for those living within communities, is often markedly different to external perceptions. Community members have intimate experience, knowledge and understanding of local history and current tensions. Depending on how long they have lived in a place, they are 'insiders'.

Many children and young people interviewed were aware of the often negative perceptions of their communities. While perhaps not fully understanding the consequences, such as impacts on service provision, they demonstrated how perceptions of their communities affected their lives. In areas with a long history of political violence, for example, concerns over safety placed limitations on friendships and movement. Communities labelled 'problem areas' were stigmatised, with people 'badged by the spaces they occupy' (Byrne 1999: 21). This has consequences for self esteem, social interaction and patterns of movement. Many of those interviewed also labelled other areas negatively - as 'problem areas' with assumed high levels of crime and violence. These were 'no-go areas' demarcated by walls, gates and symbols.

While not agreeing with negative assumptions about their communities, children and young people discussed the problems associated with where they lived. There was consistency in the issues raised across the six communities, but discernable differences across age ranges. The main issues/concerns in their communities for children and young people were, in order of priority: the nature of play/leisure facilities; street fighting/violence; alcohol use; the general state of the area.

While all age groups raised the lack or inadequate state of play and leisure facilities as a major deficit in their communities, children under 13 tended to focus on the poor condition of available play facilities:

> "Our playgrounds get wrecked." (Co. Down, aged 10-11)

> "The parks are all broken up." (Co. Derry, aged 9-11)

> "See [the] park, people broke the swings off and everything." (Co. Antrim, aged 10-13)

Older age groups focused on lack of appropriate leisure facilities in their communities. They identified potential sites for provision but believed that politicians and policy-makers failed to recognise the value of such investment. One group that played football on the streets because of a lack of alternative sites stated:

> "Like, there's loads of fields around us - if the Government bought them and put a couple of things in ... They think that

if they put somethin' in we'll probably vandalise it." (Co. Fermanagh, aged 13-15)

Many groups commented that nothing was available:

"There's nothin' to do ... for adults there's six pubs and what's there for us? Sweet FA!" (Co. Armagh, aged 13-24)

"It's [the area] a shitehole, there's fuck all to do." (Co. Antrim, aged 15-20)

Lack of leisure facilities for young people was an issue across all the research areas, but it was particularly pertinent in rural areas - intensified by limited access to local alternatives:

"... we always have to travel to other towns to do these things." (Co. Tyrone, aged 12-15)

"If we go anywhere we need to get a lift ... buses go only at certain times." (Co. Armagh, aged 9-15)

Further concerns within their communities for children and young people were perceived high levels of alcohol use, street fighting and violence. While young people viewed these issues as intricately linked, children considered them separately. Children focused on the nuisance caused by noise at night-time or weekends. They were frightened and intimidated by "drunk people". Under-13s also identified "fighting" as a regular event within their communities. This caused considerable concern, primarily because of its regularity rather than out of fear that they would be harmed, although children within two communities recognised the potential of becoming unintended victims of physical violence:

"Most time they [people in the area] fight and then you're scared you're gonna get hit when they're fighting." (Co. Antrim, aged 10-13)

"There's lots of fights ... when you're not vandalisin' and just walkin' round you could get hit or hurt." (Co. Derry, aged 8-14)

Children did not relate alcohol and violence specifically to young people's behaviour. Several emphasised that adults were responsible for drunkenness and violence, contributing to a climate of intimidation in their communities.

Young people, on the other hand, made a direct connection between high levels of alcohol use and violence. They were more likely than children to view themselves as potential victims of violence. They were regularly on the streets at night and at weekends when there was more reported violence. They consumed alcohol and had witnessed or experienced violence as a consequence. Unlike children, young people viewed alcohol and violence specifically as a 'youth problem' rather than as a 'community problem'. Many made a direct link between the three main issues they identified as impacting on their lives – lack of youth facilities, violence and alcohol use. "Nothing to do" and "nowhere to go", they suggested, led to boredom, which led to alcohol use, which led to the potential for violence:

"The best night's when you're out with your friends, and [then] ye get slapped on the back of the head. Say people's drinkin' around ye, you'd be afraid somebody's gonna turn on ye and you'd get a wile beatin'." (Co. Derry, aged 16-17)

What was reported as high levels of violence, fighting and alcohol use impacted on young people's safety. Consequently, they regulated their movements and employed specific techniques to maximise their safety while on their neighbourhood's streets. For example, children avoided parks at certain times and often remained close to their own streets. Young people would remain in groups, vigilant and prepared, rarely letting their guard down.

The general environment or state of the neighbourhood was raised by children in discussions about litter and rubbish on the streets, graffiti, dog fouling and the consequent 'smell'. They were concerned that the general appearance of their communities was drab and unkempt. Suggested improvements by one boy were: "flowers to grow" (Co. Antrim, aged 7).

Young people living in rural areas identified lack of privacy and "getting a name for yourself" as issues - because their communities were small and close-knit, "everybody knows your business". This had long-term consequences when a young person misbehaved as it was felt that local employers would not give jobs to those with negative reputations.

Unsurprisingly, many suggestions for improvements reflected complaints about neighbourhoods. Children focused on the need for reconstruction, maintenance and security of parks (which they felt should be locked at night and supervised throughout the day). Those who complained about the local environment wanted "poo bins", "more public bins" and to "get the estate cleaned up and stop the vandalism". Young people desired more facilities, improved choice and diversity, with youth clubs open in the evenings and at weekends. Some of the older age groups recommended more opportunities for participation in activities outside their communities.

In making recommendations, few mentioned violence and alcohol use, despite these being major concerns. "Less violence" and "less drunk people" were suggested by five groups, all aged under 13. Possibly, for young people in particular, alcohol use and violence have been 'normalised' – they are an everyday feature of community life. Given that young people made a connection between lack of activities, alcohol use and violence, however, their primary suggestion of more leisure facilities and opportunities reflected what they identified as the root cause of other concerns - more age-appropriate, better resourced leisure facilities and opportunities would lead to a decline in alcohol use and reduce violence.

The upside of community life

All children interviewed had positive experiences of their communities and some had no criticisms. Many young people felt they lived in "a good community". Across all age groups, five positives emerged: local recreation facilities; friends; familiarity with the people and place; the area being safe and quiet; local shops. Overwhelmingly, children noted local recreation facilities as a positive aspect of their communities. Rather than focus on child or youth facilities as a whole, they focused on specific facilities such as local parks or football pitches. Young people who identified local facilities as a positive aspect tended to refer to a specific youth club or programme they were attending. One group stated that such a club was the only "good thing" in their community:

> "This place is made for old people ... We have the club every Wednesday for

one hour but there's nothing else to do." (Co. Armagh, aged 9-15)

Proximity of friends was raised as a positive aspect of their community by all age groups:

> "You get lots of children to play with and lots of friends." (Co. Down, aged 9-10)

> "It's good craic and you can socialise with your friends." (Co. Derry, aged 12-15)

> "All my mates live here." (Co. Antrim, aged 15-20)

Some of the older groups, particularly those living in rural areas, noted that the "only thing we like about the community is young people and the craic" (Co. Armagh, aged 13-24). Familiarity with the community and its people was also noted as positive. For children this was limited to recognition of "friendly people". Older groups linked knowing people and being known with feeling "comfortable" in the community and a sense of belonging:

> "I don't know, just I was from [the area] … My mum lived [in the area] when I was born, then we moved to [another area], then we moved back … when I lived in [the other area] I didn't feel as secure and safe as I did when we lived in [the first area]. It's that thing inside your heart. Just, your home is where your heart is." (Co. Derry, aged 21)

Others liked their community because they had lived there all their lives, with family and friends close by. Even though often critical of their communities, they wanted to remain because it was familiar and they knew people: "I was brought up here … you get used to it, so it's ok." (Co. Antrim, aged 15-20)

A small yet significant number of young people were concerned that they would be compelled to leave their community due to rising house prices and minimal availability of social housing. Some communities where there had previously been a housing surplus (with houses boarded-up or derelict), now had long waiting lists. In one area there was a waiting list of approximately 700 families. Despite recent regeneration, there was a downside, as one young woman explained:

> "A couple of years ago there would have been loads of houses 'cos of the bad name of the place. But they knocked them all down, which was a waste really 'cos they were good houses. Now you can't get one." (Co. Antrim, aged 18-20)

With such changes occurring, the long-established closeness of extended family trends within these communities may well diminish. This would have consequences for young people, particularly those living in poverty, as practical support such as child-care by extended family members could be lost.

'Safety' as a positive aspect of their community was raised primarily by younger age groups:

> "It's quiet, you are safe." (Co. Down, aged 10-11)

> "It's safe living here. It's quiet, there's no break-ins." (Co. Armagh, aged 9-15)

A few children discussed the importance of having local shops within walking distance of their homes. In one group of older young people, a new shopping centre on the estate was noted as the "only good thing" about the community because this provided local job opportunities and goods at competitive prices.

Overall, the focus group discussions clearly demonstrated children and young people's attachment to their communities, based on familiarity and relationships which had been established and maintained over time. Contrary to the views of some adult community representatives, children and young people showed a definite attachment to, and care for, their communities and a desire to improve facilities for all residents.

The meaning of community: local identity and internal divisions

The children and young people interviewed tended to stay within their communities. They lived there, played there and went to school there. While the latter was particularly true of primary school children, many in secondary education also attended schools within their community. Those from rural areas considered that the bus journey to school offered a change of scenery and place.

Where children and young people spent their free time and used facilities defined what they considered to be 'their community' and their identity. Knowledge of the local area, and perceptions about places or spaces within the area, impacted on their sense of self, their feelings of safety and their movements.

While there has been debate in Northern Ireland about the politicisation of space and divisions *between* places as a consequence of residential segregation, 'peace lines' and other symbolic markers of inclusion/ exclusion, minimal consideration has been given to local divisions *within* places and their impact on everyday life and identity.

Internal divisions: history and impact

Five of the six communities involved in the research were single-identity areas. Yet, internal divisions occurred in most: divisions between two sides of a single-identity estate or between particular streets (intra-community); between a small single-identity rural community and similar, local areas; between small, adjacent neighbourhoods within the same area. There were also internal divisions based on religion/ national identity within the 'mixed community'.

Children and young people commented on, but were unable to explain, divisions within their communities. Community representatives in two communities stated that some houses in their community had been provided for families exiled from their homes elsewhere. It was assumed that these families were politically affiliated. Further, they were not local and were considered "outsiders". Resentment was expressed about "blow ins" who came to the area, occupied housing built for local people and "acted as if they owned the place".

A third community experienced similar but different divisions. Community representatives suggested there were "different moralities" and cultures in different parts of the estate. They referred to a Republican and Sinn Féin ethos that impacted on the organisation of, and attendance at, particular programmes or events in one part of the estate. It was considered that this area had "more social disruption and dysfunction". Certainly it was under-resourced in comparison with other areas within the estate.

Representatives in two rural communities noted divisions between adjacent, same-identity communities. They interpreted this as 'parochialism', with each community having strong local bonds and identities. Often defined as "football territories", divisions were created as a result of allegiances to particular Gaelic football clubs. Community representatives explained:

> "Football has done a lot for this [parochialism], everyone is a bit sticking with their own. There is a lot of rivalry between clubs and this has stopped young people from mixing. They don't tend to go to other areas and this is another barrier to service use."

> "There is no religious divide but a Gaelic football divide. Community relations is about more than Catholic or Protestant … There are territorial issues in [the area]. People won't go to other areas. Young people are separated after school. This is about identity issues not based on religion … Young people from small rural areas will often never meet because of football rivalries."

Age-related housing segregation was also discussed. Reflecting a concentration of older residents living in particular parts of an estate, this was believed to "breed isolation, insulation and a lack of tolerance". As a consequence, older people felt threatened by young people.

There was also evidence of serious levels of division within what was viewed as a 'mixed community'. Internal divisions within the community were based on religious/national divisions. Those interviewed considered this was a direct consequence of the Conflict - prior to civil unrest in the 1970s, the different cultural traditions had mixed. Since then housing policy and population movement had resulted in residential segregation, with one side of the area defined as Catholic and the other as Protestant. Shops and bars were locally defined as belonging to one community or the other. Most children and young people attended the local Catholic or Protestant schools and single-identity youth provision. Within this relatively small community, there were few opportunities to mix. The only mixed youth project - a recent initiative in the area - experienced opposition from parents and constant battles for funding.

Within the communities particular neighbourhoods or clusters of streets had developed distinct identities and reputations. Divisions, therefore, were more often perceptual than physical. Yet this had clearly evident consequences for individual and collective identity. The claiming of different and separate identities in specific neighbourhoods affected the positioning and use of local services. Within some communities, play parks and local shops were only utilised by those from one side of an estate or one part of a neighbourhood. Newer, generic services were positioned carefully to ensure that they were not viewed as belonging to one area. These tended to be located at the centre, between different estates or neighbourhoods on what many termed "neutral ground". Failure to find 'neutral ground', however, led to under-use or under-provision of facilities due to spatial divisions.

Across the communities, because children and young people did not access youth facilities outside their neighbourhoods, mobile services had been established. Alternatively, funding had been received to set up specific programmes in different parts of the community, in recognition

of the fact that only certain people would attend particular clubs because of their history or physical location. In one community, adult community representatives working in separate youth facilities noted that young people who attended their provision did not attend other local provision. Another group of community representatives was acutely aware that their provision had an established reputation based on the local historical context:

> "The centre is associated with the Provisionals ... we had to work hard to get the community to realise we are not linked to paramilitaries."

While the group had attempted to break this link with the past, some young people remained reticent to utilise the service because of its reputation.

These very local, complex and deeply rooted meanings and assumptions attached to space created further difficulties for service providers. For those in rural areas the impact was particularly pronounced. There was generally a lack of local provision and what existed was centralised in particular towns. A widely distributed, sparse population, inadequate public transport and divisions between areas led to "people ... not coming together to share resources". The central positioning of services created resentment and increased feelings of exclusion among young people who considered "they get nothing or no-one cares about their area". Psychological barriers exacerbated physical difficulties and the centralising of resources had exacerbated local perceptions of difference. Young people in areas lacking services and resources believed that they were less important than those living in the nearby town or village where these were located.

Some community representatives suggested that this had resulted in young people's lack of pride in their own community.

Positioning the self: local divisions and the lives of children and young people

While children and young people did not demonstrate a comprehensive understanding of the divisions within their communities, they took clear positions. When asked about 'their community' they frequently asked for clarification. Their responses focused on where they lived - "my street", "around my part of the community". Consciously, they positioned themselves according to known divisions within the community.

While divisions originated in housing policies and population movement at the height of the Conflict, these have remained. In children's and young people's accounts they connected to 'reputation'. These included perceptions about the 'good' and 'bad' side of the estate, the 'rough' and the 'respectable', the 'quiet' and the 'trouble orientated', the 'poor' and the 'more affluent'. Adult community representatives in two different areas stated:

> "There is an invisible divide in the area ... Locally, if you live in [one part of the area] you are seen as posh, if you live in [the other] you are seen as a hood."

> "The areas are all separate and the people living there have graded themselves in social rank. The road acts like a river, like a natural divide. People won't mix."

In communities that had marked (yet not always clearly visible) internal divisions, an identifiable part of the estate was often associated with 'trouble', high levels

of disorder, 'social problems', lack of facilities and services, and a poor physical environment:

> "I'm not trying to say that [the other part of the area] is bad or anythin'. But [where I live] would be tidier than bits of [the other part] and, like, there's not as many bad people in [my part] than what there is in [the other part]". (Co. Antrim, aged 10-13)

However, in the focus groups there was considerable disagreement about local divisions:

> YP1: "I don't like it [Area B]."
> R: "Any reason you don't like it?"
> YP1: "Yeah, it's got nothin' to do."
> YP2: "Sure there's nothing to do in [Area A]."
> YP1: "Play rounders."
> YP2: "Whooo, sure you can do that in [Area B]."
> YP3: "I come from [Area A] and I feel safe there because there's more places to go, it's bigger than [Area B]."
> YP2: "The [Area A] crew!" (giggles sarcastically) (Co. Antrim, aged 10-13)

While this exchange reflects apparently petty differences, it shows a local defensiveness of 'their' place. While the young women whose neighbourhood had been negatively earlier labelled had been critical of it themselves, they were loyal to their community when the criticism came from 'outside' and resisted negative labelling. Defending identity against a negative label is evident in the following:

> R: "What are some of the main issues and problems living here?"
> YP1: "Poverty. It's a white ghetto."
> YP2 "Not poverty! He lives in [name of area], you get stabbed walkin' about the streets. Where I live isn't like a ghetto!"

> YP1: "It looks like a shit hole."
> YP2: "The [one part] doesn't look like a shit hole."
> YP1: "I'm talkin' about up here [the other part]."
> YP2: "Aye well, I don't live up there. I don't care what people say, I'm not livin' in poverty!" (Co. Derry, aged 16-17)

While the first young person showed a deeper understanding of local divisions and the differences they represent, poverty is a negative label resisted by the second young person.

Internal community divisions impact on children and young people in various ways. First, they demonstrate that children and young people within the same locality often have very different experiences. Where they live and play in the neighbourhood affects what they witness and experience at a personal level. For example, when discussing violence in a community, one young person stated: "it just depends what street you'd be in" while others reported high levels of fighting on one side of the estate: "there's more fightin' over there". Those in another community argued that recent "problems" were restricted to one particular neighbourhood. The following brief interchange illustrates differential experience within the same community:

> R: "Is drugs a big issue?"
> YP1: "Aye, around [here] it is."
> YP2: "Aye, it's in the community."
> YP3: "I've never come across drugs around my part of the community."
> YP2: "Well I have." (Co. Derry, aged 16-17)

A second issue related to use of local facilities. Community representatives stated their commitment to setting up facilities in different locations within the

community. Despite these approaches, many children commented that their free-time and play was restricted to the street in which they lived as this was where they felt safe. Reflecting on why she would not use services in a particular community centre, one young woman explained:

> "You wouldn't have went into [the centre] because that was all the boys, the RA and like Sinn Féin and all that there. So you wouldn't have went in there." (Co. Derry, aged 21)

While much has been done to change reputations, progress has been gradual. The physical location of some facilities also connected them to a particular 'type' or group, leaving those from other parts of the community reluctant to use them:

> "… it's like all the one gang that goes to it, which means there's other gangs in [the area] won't go to it … they would have all the kind of tough boys among them which means a lot of the younger, the quieter ones … wouldn't go near it … if ye go into the community centres you would never see one of the people from [one centre] down at [the other centre]." (Co. Derry, aged 22)

Community representatives and young people noted that the location of services and who 'ran them' affected who used them. Subtle and local nuances meant that some young people were excluded from local services. A form of territoriality had consolidated, with facilities located in 'their end of the estate' and run by people living there perceived to be 'safe'. They knew the background of, and trusted, the organisers and many others who attended lived in the same streets or part of the community. Others, however, knew that they "wouldn't fit in" and would be made to "feel like a

weirdo". Similarly, children and young people living in rural communities would not use youth services in nearby villages: "We wouldn't be welcome down there because everyone stays in the one place" (Co. Armagh, aged 9-15).

As particular facilities had become synonymous with particular groups, those 'not belonging' were excluded. They had no sense of ownership. However, the choices that children and young people made about use of existing provision were not necessarily informed. They learned the 'rules' of their area quickly, including 'differences' within their communities and estates, which extended to where they should and should not go. This constituted identity formation at a very local level. As one community representative stated, decisions about attending clubs were "as much about culture as about what programmes are on offer".

Further, the attitudes of those working in clubs and other facilities often compounded established assumptions. Some of those interviewed who were involved in youth provision were negative about counterparts offering alternative provision within the local area. Explicitly or otherwise, such messages were likely to be passed on to the young people with whom they worked. Thus, there was evidence that existing local divisions were perpetuated by some of those working directly with children and young people.

Divisions within communities were not sectarian but based on perceived status differences, rooted in the conflict-related history of Northern Ireland. Such divisions had a number of consequences for children and young people, including negative labelling, development of personal and collective identities, selective use of local

facilities, restricted social movements and concerns about safety. It was clear from the focus groups that children and young people living in parts of a community associated with negative labelling found it difficult to avoid the pressures of local tradition. They considered that entering community facilities where they felt they did not belong placed them in risky situations. Their local understanding of place, invisible and often unspoken divisions, and the meanings attached to specific spaces, enabled them to negotiate their movements and negotiate local space safely. It also emphasised, however, the hidden limitations placed on their movements through the legacy of the Conflict – both outside and within their communities.

Key Issues

- *The problems identified in all six communities centred on lack of adequate play and leisure facilities, street fighting/ violence, alcohol use and the general condition of the local area.*

- *Those in rural areas experienced exclusion from play and leisure services due to remote location and inadequate, affordable transport.*

- *For children, positive aspects of their communities included play facilities, friendships and feeling safe.*

- *For young people, positive aspects of their communities included familiarity with the place and proximity to family and friends.*

- *Older young people expressed concern that they would be forced to leave their communities to find employment, ending the availability of extended family support for those making the transition to independent living.*

- *Over time, housing policies and population movement had given neighbourhoods or clusters of streets distinct identities and reputations. Children and young people positioned themselves according to such known divisions within communities, often drawing distinctions between 'rough' and 'respectable' neighbourhoods or streets.*

- *Those living in the same locality had distinctive and contrasting experiences as a consequence of internal divisions within communities.*

- *The location and management of services, even in communities with a shared cultural identity, affected take-up – leading to experiences of exclusion or marginalisation amongst those who felt that 'their' local area had not been appropriately resourced.*

SEGREGATION AND SECTARIANISM

Segregation and everyday life: physical divisions and social identifiers

Some community representatives expressed concern that young people's social networking sites had become vehicles for sectarianism, glorification of death and the Conflict, and actual threats against 'the other community'. They had difficulty understanding such hostility, given that these young people were supposedly 'the ceasefire generation' who had witnessed or experienced little of the Conflict. Others noted the persistence of division and segregation in everyday life. Most of the children and young people interviewed grew up in single-identity communities, were educated in either Catholic or Protestant schools and socialised primarily with those of the same religion. As discussed in the previous chapter, due to limited finances and fears for their safety, many remained within their communities and there were few opportunities for cross-community contact. They were aware of the connection between religion and national identity. While they could wear what they wanted and, to a degree, walk freely around their communities, they felt there were restrictions on expressing their identity and on their movements outside their own neighbourhoods.

Children and young people from all the communities considered sectarianism to be an issue that affected their lives. Where they lived, their school, their uniform and sporting activities defined them within their cultural tradition. While children expressed fewer experiences and less knowledge of sectarianism, effectively 'cocooned' (Roche 2008), they expressed views closely related to their cultural identity. In some cases these were sectarian.

Some children living in Republican/ Nationalist communities, for example, spoke negatively about the police and "the Brits", talking about "getting the Brits and the police out" of their communities. Community representatives from different communities relayed stories of very young children "chanting IRA songs" and "singing Loyalist songs on a bus trip".

Young people, through travelling to school and social events, were more aware of segregation, difference and sectarianism. Divisions between communities were more visible than those within communities through demarcation of territory with 'cultural symbols' such as flags, murals and memorials. These signified a community's tradition, who was welcome and unwelcome, and who was 'safe'. One group, in a mixed but highly segregated community, stated:

> "Ye can tell from the old flags hangin' on the posts - wherever that's outside, that's that territory." (Co. Tyrone, aged 14-25)

Young people living in a Loyalist/ Unionist community commented that the flags positioned on the road leading into their estate were an outward expression of their cultural identity. To some adults in the community these flags marked territory - a visual reminder, or threat: "this is our street, no-one is coming down our street". Some likened their use to "dogs peeing up against lampposts".

Children and young people identified religion and sectarianism as central issues in their lives. Those living within a mixed but segregated community, for example, detailed the divisions and how these often generated sectarian clashes or violence. Young people generally attended

single-identity youth provision and adults frequented pubs associated with their own identity in particular parts of the town. Community representatives stated that "entertainment" was divided: "There's no question of young people socialising together". Young people agreed: "the whole town's divided, like, except for here [a cross-community drop-in centre]." They attended the only mixed religion youth provision within the community - provision set up despite local resistance. Given the contribution this project made within the community, its increasing membership, its valuable courses, its late opening at weekends and its participative framework, it was surprising that the initiative had no statutory funding and was under threat of closure at the time that the fieldwork was conducted. The significance of "a neutral programme in a neutral location" was not recognised by local councillors or funding bodies.

Maintaining segregation in this community had reinforced and exacerbated difference, resulting in much unrest. As Shirlow (2001: 67) notes: "separation is the instrument through which animosity and the reproduction of mistrust and division best manifest themselves." Segregated social activities, local facilities and schools were stark reminders of the extent of religious division. Because social contact with 'the other' was so limited, when it happened, it was potentially dangerous:

> R: "Would there be, like, clashes then between Catholics and Protestants, would there be fighting or …?"
> [Laughter among the group]
> YP1: "You're in [name of community]!"
> YP2: "It's like, when they get outta the pubs late at night, they all kinda mix."
> YP3: "It used to be wile bad."
> YP4: "It still is."

> YP5: "Sure they had to change the time of the schools."
> YP6: "They had to change the times that the schools were allowed to leave because they were fightin' in the middle of the town. So one school leaves at, like, ten past …"
> YP7: "Like, the Catholic school's right beside the Protestant part, where they all live, and then when the Catholics would be walkin' round the Protestants would be comin' home from school and it would just be causing fights when they met."
> YP2: "So they get out at different times."

While this community is often defined as mixed, experiences of division and hostility regarding religion and national identity were deep and constant.

Hall et al. (1999: 509) note that "knowing where others are from makes it possible to *place* them" (their emphasis). Being 'placed' as Loyalist or Republican created risk of attack outside community boundaries. Young people, regardless of their acceptance of cultural identity, were clear that there were places they would not visit. For example, young people living in a small Protestant community associated with strong Loyalism described feeling imprisoned. They identified their community as the *only* safe space. It had no youth or recreation facilities and they did not access those nearby because they feared for their safety. They did not use the local football pitch or snooker hall because:

> "… you wouldn't be long in gettin' an auld crutch in the face if you used it … if you walk up yourself then you wouldn't be seen comin' back out." (Co. Fermanagh, aged 13-15)

This was an illustration of how fear of being identified as 'the other' limited the opportunities available to young people. It was an experience shared by young people living in Republican/ Nationalist areas, demonstrating the connection between identity and territory. Those living in the Loyalist community discussed above were emphatic that they would not accept people from other cultures living in their community. Acceptance was granted to "people who move in, good people who think like you, are loyal like you". Those rejected and driven out by force were "not part of your culture" (Co. Fermanagh, aged 16-25). For some young people in Nationalist communities also, those of "the other religion" would not be welcome:

> YP: "I know boys that know Protestants loads, but if they were seen near the Protestant side they'd get hit."
> R: "And what about the other way round?"
> YP: "Aye, if ye seen one [a Protestant] walkin' about here you'd take a swipe at him." (Co. Derry, aged 16-17)

Clear physical divisions and symbolic markers of ownership map territory which is defended against 'the other': "Local turf is controlled and formed as a safe haven for members of the community" (Kuusisto 2001: 59). Thus, cultural identity remains 'clean' and 'uncontaminated', providing long-standing culturally reproduced reasons for local defensiveness of space.

The threat of attack in one community was significantly pronounced. Even in more 'neutral spaces', such as the town centre, young people were often the victims of sectarian abuse or attack and moved around in groups. This had become normalised as "the way it is":

> "When you're off the estate you're always lookin' where the trouble might come from. Always lookin' over your shoulder … you always have to be in numbers. No way would I walk off the estate on my own." (Co. Fermanagh, aged 16-21)

Children and young people were susceptible to attack partly because towns are small, but also because visual cues connect to cultural identity. Most obvious is school uniform, and also football shirts, caps, scarves and jewellery. One young woman from a Republican/ Nationalist community had experienced sectarian abuse the previous day because she wore a Gaelic football jersey:

> "I was called yesterday goin' to a match and had an ice pop thrown at the car, called a Fenian B." (Co. Derry, aged 16-17)

A child who had been playing with friends on the edge of their estate had been "chased by Catholics … we had to run through nettles and all". This had happened "because one of them [the boys in her group] was wearin' a Rangers top" (Co. Antrim, aged 10-13). Children and young people managed or disguised their identities when outside their communities, particularly by altering their dress. When attacks happened, however, the response was usually retaliation by family, friends or community members - leading to 'tit-for-tat' attacks across the religious divide.

Social networking sites have emerged as significant, with sectarianism on Bebo or Facebook pages increasing the potential for conflict:

> "Young people would have always had conflict with the other religion but this was not to the same extent as

today because access to each other was different. Now, with the likes of Bebo sites, abuse and conflict is constant."

Many individual and local band pages display overt sectarianism. While such sites can be closed and accessed only by invited or agreed friends, many young people leave them accessible. Young people within one community identified these sites as leading to easy identification. Even on sites which were not openly sectarian, information and pictures provided clear identifiers (background of football clubs, links to music or videos of marches, commemorative events) as well as photographs of young people:

> "Everyone knows everybody in this town and ye see Bebo, if there's one wee site which says Northern Ireland, you're dead." (Co. Fermanagh, aged 13-15)

Clearly, regulation of sites could be improved and young people better informed about the potential consequences of leaving their pages open. It is unlikely that the possible consequences of the information they post on these sites is fully appreciated or understood.

Given the unambiguous symbols of religious difference in Northern Ireland, most of those interviewed had a clear understanding of their identity in a divided society. Young men, in particular, protected themselves by staying in groups, being vigilant and/or prepared for attack. This extended to adopting a 'hard man' persona, prepared to retaliate. This form of identity management was an open expression and assertion of identity, rather than a disguise.

While all were aware of the pervasiveness of sectarianism, some were personally affected more than others. For a few, it pervaded every aspect of their lives.

Attempts to move young people 'off the streets' within their communities fail to recognise that young people find safety in groups, or that moving them beyond the relative safety of their communities may compromise this and increase the risk of sectarian abuse or attack.

Making sense of sectarianism: culture and tradition

Young people in three communities raised the issue of sectarianism and conflict during focus group discussions. Others, however, focused on clashes not between different religious groups but between members of their community and the police. As one group noted:

> "If the police come into the area there's riots an' all. Boys start throwin' stones at the Brits." (Co. Armagh, aged 9-15)

Many of the young people interviewed considered that sectarianism was derived in religious differences - a historical 'fact' that had become normalised as part of daily life. Perceptions of difference had been formed long before they had been exposed to 'the other religion'. While sectarian views are learnt in subtle ways through social institutions - family, school, community, media - this was not obvious to young people. Many considered sectarianism as self-evident - some people were Catholics, others were Protestants. They had different and mutually hostile cultural traditions. Growing up with this notion of difference, but not being fully aware of its origin, is evident in a Protestant young woman's account of her first meeting with Catholics:

> "Like, see, before you even meet them they're always gonna have a different opinion of, like, what you are … a long time ago, before I met them, I would

think I would hate them an' all and I would always argue with them. But then, when you meet up, they're really dead on and then, like, ye get to know them and then, ye know like, they're just the same as ye." (Co. Antrim, aged 13)

Notions of difference were perpetuated and exacerbated by a lack of inter-community contact. Most communities were relatively isolated, offering few informal opportunities to meet other than through formal cross-community programmes or, eventually, through jobs or further/higher education:

> "Young people from here can grow up, go to school, socialise and have a family in their community and never knowingly meet a Protestant. This is the reality of isolation and polarisation."

Social isolation impacted on the opportunities and aspirations of young people as well as their attitudes and feelings towards others. Limited exposure to those outside their community, and strong beliefs within communities, consolidated negative attitudes about 'the other' that were passed down through the generations. While they expressed loyalty to 'their own', they articulated mistrust and hostility towards 'the other'. As noted by one community representative, and echoed by others across different communities, "there are first, second, third generation attitudes of not trusting the other side yet".

Many young people and adults identified families and communities as the primary influences on their own and the 'other' religion or culture. These were the sites where sectarian attitudes were reproduced. One young man stated: "It comes from your family background, your whole behaviour and your beliefs" (Co.

Derry, aged 15-19). Some also noted the difficulties associated with breaking away from the attitudes of parents and older members of the community:

> "Like, sectarianism, ok it's bad. But it's like the parents are the worst culprits of it because if young people were allowed to do what they wanted, it wouldn't be as bad as it is. It's the older people that are makin' it so bad, like … what ye have passed down, like, it just stays with ye sorta thing." (Co. Tyrone, aged 14-25)

Young people discussed how constant reminders of the past - through stories passed down in families and communities, images in the form of murals and remembrance events - fed sectarianism and perpetuated conflict:

> "At the end of the day, we're goin' by what our grannies and granddads are tellin' us. And they're puttin' it on the news and they're makin' films about it. And what are we supposed to think when they make a film about Bloody Sunday or they make a film about the bombings and what-not? … So of course young one's are goin' to fight back – 'Oh, you did this to my one' – you know, war stories you could say it is." (Co. Derry, aged 21)

A representative from another community stated: "Young people now can't escape it [the Conflict]. They had parents, friends or grandparents who were involved, or who were killed or injured."

While acknowledging how these factors impact on the socialisation of children and young people, it is important to place them in context. These communities were among the worst affected by sustained political violence over three decades, and violence

persists. Many living residents, including young people, had direct experience of relatives and neighbours being imprisoned, injured or killed. They had experienced discrimination and/or disruption to their lives and had lived with the constant threat of violence. Marking events and memorialising the past was important and their intention was not to feed sectarianism.

Some community representatives discussed the significance of 'war stories'. While young people were told the Conflict had ended and that sectarian violence was no longer acceptable, there was a feeling that some former combatants and politicians "glorified the war" and "romanticised the idea of struggle". One community representative commented:

> "Now it is like a glorious thing for young people. It is actively promoted as a glorious war. There is a strategy here to keep this view, as certain people want votes."

The confusion this caused for young people is illustrated in the following comment from a young men's focus group:

> "All those ones that were at the Bloody Sunday [commemorative march] an' all, if you were out riotin' they're all like, 'Wise up, the war's over' … They went through all the wars like, they should know how it feels. But yet they still get onto us for doin' it." (Co. Derry, aged 15-19)

These young people believed they were fighting for reasons similar to their parents and other adults within their communities. They were "sticking up for themselves" and defending their culture.

Within the different communities, concerns were expressed about influential adults who perpetuated and actively encouraged this mentality and the continuation of violence. Fear, mistrust, hostility, inequalities and confusion remained within the communities and susceptible young people were influenced by the sectarian attitudes of significant adults. As one community representative stated:

> "If we are going to say that young people today are very sectarian we need to think about why that is and where they have gotten those messages from. We give it to them, then blame them."

Beliefs about persistent inequalities informed sectarian responses from some young people, particularly in Republican/ Nationalist areas regarding the police. Despite structural changes to the PSNI, many suggested that attitudinal change among police officers was not evident: "For people in this area, it is still the RUC not the PSNI". Negative experiences of the police and security forces affected daily life in some communities and young people gave recent examples of discriminatory and intimidatory policing. While age discrimination by the police was raised across all groups, some Catholics felt that religious discrimination remained evident in differential policing. They recalled instances when, following riots between young people from both cultural traditions, only Catholic young people had been arrested. They gave an example of the police failing to intervene when a Catholic young person was being beaten by a group of Protestants. The feeling among young people living in Catholic communities was that the police offered concessions and protection to the Protestant community: "the cops … take sides" and "Protestants

get all the protection they want, and we get nothing." (Co. Derry, aged 16-17 and 15-19). Regarding Protestant marches, two groups stated that these should be banned from passing close by Catholic communities as the marchers were provocative: "they egg ye on, shoutin' stuff at ye".

Likewise, young people in Loyalist/ Unionist communities considered that Catholics were given preferential treatment by the police. In one community, they had removed flags but were angry and resentful that the Catholic community had retained their flags. This was considered "favourin' and bias", resulting in "hatred for the police". It was "another example" illustrating how "Catholics get everything" (Co. Fermanagh, aged 13-16). The young people felt "embarrassed and stupid", that they had been duped, and resolved not to enter future negotiations about flags or murals. This situation had solidified their view of inequality and favouritism towards Catholics. Their concerns were not restricted to mistrusting the police or defending symbolic expressions of culture. They felt that the 'new' political situation in Northern Ireland had benefited Catholics to the detriment of Protestants:

> "Catholics get everything. Everything that goes up is in a Catholic area and we don't get nothin'. It's not like they be good to be treated to it, all the sprayin', all the burnt out cars there used to be." (Co. Fermanagh, 13-16)

Identifying sectarianism as the most significant element of growing up, groups in this community suggested that the current situation could deteriorate. Resentment, towards the Catholic community and its perceived privileged

position, consolidated sectarianism. Occasionally it resulted in violence.

Rioting and sectarian clashes asserted identity while symbolising resistance towards perceived inequalities. Rioting was not 'recreational' - it was considered by Protestant young people to have a firm political basis, a view shared by Catholic young people:

> "If you're out there riotin' and you're not Republican and all this here, you'd have to think, 'What's the point?' So in a way ye have to be kinda standin' up for it … we're fightin' for our identity." (Co. Derry, aged 15-19)

Sectarian attitudes and violence were closely linked to cultural identity. While many of the children and young people interviewed stated that their culture was not important, others believed it was of paramount importance:

> "Everybody needs culture, everybody needs somethin' to believe in …" (Co. Derry, aged 16-17)

> "Protestant - it's everything, more or less everything - the way you've been brought up, everything you believe in." (Co. Fermanagh, aged 16-21)

There was minimal, informed understanding about 'the other culture'. All Protestants were portrayed as identifying with Britain/ Unionism/ Loyalism. All Catholics were portrayed as identifying with Ireland/ Nationalism/ Republicanism. Fighting to retain cultural identity was about fighting to defeat 'the other':

> "We're not having a united Ireland. I'd be the first away. But that's the way it's goin' and we have to fight for our culture. If the Catholics took over what would you have? Would you want to

live in Ireland? We'd lose everything. Everything we've fought for." (Co. Fermanagh, 16-21)

YP1: "We're fightin' for our identity. It's like they want Londonderry and we want Derry."
YP2: "It's Derry not Londonderry. London's got its own place and Derry's got its own place … There's no London in Derry."
YP3: "If there's any people in Derry want to support the Queen an' all, they can fuck off back to England." (Co. Derry, aged 15-19)

These views focus on the constitutional issue and the ownership of space. They are two mutually exclusive positions and cannot exist together. While neither is fully achieved, some young people felt their communities had "fought for nothing". Movements towards equality, equal representation, power-sharing, and the de-politicisation of shared space through the removal of sectarian symbols, were identified as concessions to one community and punishments to the other. Young Protestants considered marches, flags and bonfires to be significant expressions of their culture. Their curtailment was believed to be a concerted attempt to weaken their culture: "They're trying to rip away our culture". Their elected representatives, who previously had refused to sit with Sinn Féin or negotiate with the Irish Government, were now working with them. They believed that through political concessions their culture was being "stripped away" while the Irish culture was flourishing. This led to suspicion and fear. A community representative commented: "Young people are growing up to see what has been taken away from them". There was a profound feeling that 'reverse discrimination' would challenge their

cultural identity, compounding a sense of insecurity alongside increased resentment towards 'the other side'.

Given that young people interviewed considered their cultural positions as exclusive and hostile, there was no indication of reconciling their differences:

"We'd show some respect to the Catholic culture if they showed it to us. But they just want rid of us, just want a united Ireland – no way." (Co. Fermanagh, aged 16-21)

Changing attitudes? Cross-community and community relations work

Growing up and mixing "with your own" was the main reason why "the mind set [in Northern Ireland] has not changed". Community representatives repeatedly used the phrases "inherited attitudes" and "learned behaviour" as consequences of isolation and segregation. Many discussed the significance of cross-community and community relations programmes as central to change, but children and young people's experiences of their participation often did not reflect this optimism.

Not all children and young people interviewed displayed sectarian attitudes. Some had friends from the 'other' cultural tradition and others had participated in cross-community projects. Regular cross-community interaction, however, was rare and limited. Views were often ill-informed, with no clear understanding of 'difference'. Sports events enabled some interaction, but this did not extend to breaking the barriers of exclusivity. Sometimes cross-community events heightened experiences of difference:

"Boxing is mainly a Catholic sport. I was picked for the team so you meet

different people, them who come to box. I've been to [Catholic boxing club], but they wouldn't come to ours." (Co. Antrim, aged 18-20)

"Last September there I was playin' in the under-16 Northern Ireland International [soccer] team. And there was an under-19 team, and a senior team, and an OAP team. And I was the only Catholic in all four teams." (Co. Derry, aged 16-17)

Many children and young people had some experience of cross-community projects, often through schools, and/or community relations programmes via youth work. Few could recall learning about 'the other culture' within school other than in Religious Education, where the focus was exclusively on Christian religions. Discussion about cross-community projects revealed that, while they provided limited opportunities to meet children and young people from "the other religion" and discover "some of them are ok", these projects could also reinforce negative attitudes and strengthen the view that "nothing will ever change". Young people and community representatives reported instances of 'the other side' not turning up to meetings, or projects being disbanded due to irreconcilable differences. A young leader explained the demise of one project:

"We did cross-community work and the children, and even the leaders, wouldn't interact and would be offensive." (Co. Derry, aged 19)

While children and young people were often critical of cross-community projects, this related particularly to trips, activity-based initiatives, and specific events which had generally been developed with minimal preparatory work, required

little social interaction and had not led to mechanisms for maintaining longer-term contact. Occasionally there was conflict during these activities. According to those interviewed, such projects had limited impact in building links or good relations with 'the other community'. A typical response was:

"I went on a [cross-community project] and like there's no talkin' or nothin' goin' on like. It's just Catholic boys and Protestant boys playin' football." (Co. Tyrone, aged 16-25)

Young men in two other communities described similar experiences and how fighting had broken out during cross-community football events. Involvement in such projects had little impact on their attitudes about, and opinions of, 'the other community':

YP8: "But there are some dead on Catholics."
YP1: "Oh aye, there is like."
YP5: "But there's not a lot like." (Co. Fermanagh, aged 13-15)

Those who had been involved in cross-community trips commented that there had been no "mixing" and no opportunities to learn about each other's cultures:

"If ye went anywhere ye sat beside your own friends." (Co. Tyrone, aged 16-25)

"They take ye on a wee trip, just to make sure you get on ok, but we didn't learn anything about different cultures." (Co. Antrim, aged 19-20)

After one-off events or short-term projects there was no discernible change in communities. Some who had participated in cross-community projects were criticised by their friends and there was no follow-up work to challenge negative attitudes.

Nor were there opportunities to learn about cultural differences and similarities. Another group of young men who had also been involved in cross-community football stated:

> "Aye, they'll meet and they'll chat and the next weekend, then, they'll just be fightin' again. It's never goin' to be resolved." (Co. Derry, aged 15-19)

Consequently, they believed that cross-community projects were a "waste of time" and that community differences were, and will remain, irreconcilable. A small, but significant, number of children and young people had experienced sectarian abuse and violence while involved in cross-community projects, which obviously challenged their commitment to this type of activity:

> *R*: "So you all think cross-community work is a good idea?"
>
> *YP1*: "I don't! I disagree with it. This is why I disagree. We were on the bus and they chucked stuff at us and one hit me up the face with a ball. It was a boy - so he chucked it at me and it hit me up the face. Just because we were Protestants. So I went down and I grabbed the ball and I smashed it over him."
>
> *YP2*: "One year group always went on a trip, like, every month or so with a different school … the people in the different school were, like, callin' people at our school, like, names and, like, made people in our class cry an' all. They didn't tell the teacher until they got off the bus and we were comin' home. And then they used to like throw stuff at us an' all." (Co. Antrim, aged 10-13)

Others, however, criticised the lack of cross-community projects and were keen to participate:

> "We don't do cross-community trips. It would be class to do cross-community trips." (Co. Armagh, aged 9-15)

Where it did exist, cross-community provision was piecemeal and young people criticised unfair selection criteria based on perceptions about 'respectability': "People puttin' their name down have an acceptance of each other already, so there's not gonna be any hard lads or that" (Co. Tyrone, aged 16-25). Some considered that school-based cross-community work was limited to one-off events, separate to the curriculum, and failed to challenge or inform negative attitudes.

More positively, a few young people had experienced community relations programmes through youth provision. The focus in these programmes was to learn about 'the other culture', challenging negative attitudes and stereotypes in a safe environment. Cross-community events and meetings continued beyond initial groundwork. Community relations work was central to these programmes and the experience of involvement in them was different from school-based events:

> "There was more focus on religion and culture, where you looked at what each reflects. Stuff around symbols and flags and that. Some ones did like a big wall mural with flags and all different things they reflect. It was good." (Co. Antrim, aged 19-20)

These programmes, however, were not without difficulties. One cross-border programme entailed working with each community separately around issues of culture and identity, before bringing them together for activities and sports. A trip was arranged for the full group to visit a European city. Close to the time, "due to

peer pressure, a number of the young men dropped out". The trip went ahead and it was reported that the group "bonded when taken out of the atmosphere and influences around them". Yet, "when they came back, they went back into their own territory" and "fighting between both sides of the community continued".

Cross-community work operates in a climate of discord and dissent, with young people divided in every aspect of their lives. Outside the defining influences of their environment there is potential for positive interaction, but this is difficult to sustain. As McGrellis (2004: 22) notes: "young people [in Northern Ireland] are themselves aware that the influence of their community is stronger than what can often amount to no more than a short-lived contact experience". The cross-community youth forum and drop-in centre discussed earlier demonstrated that youth provision, without the 'cross-community' label, was the priority. Young people 'dropped in' because this youth-centred provision met their needs, not because it was cross-community provision. Located in 'neutral space', it was a place where young people in a bitterly divided town met and interacted on their terms – as young people, not as Catholics or Protestants. While the starting point for many cross-community projects was difference, this cross-community youth provision focused on the common experiences of *young people*, regardless of their cultural tradition.

The fragility of 'peace'

Few community representatives believed there was 'peace' in their communities, or that the Conflict had ended. This was echoed in young people's accounts, particularly when discussing entrenched sectarian attitudes and continuing

street clashes. Young people from all communities expressed anger towards politicians who proclaimed peace but knew little about the reality of their communities:

> "… sometimes I'd be sittin' watchin' the TV and I'd be standin' up goin', 'You see, you bastards, you don't even know what it's like *livin'* on the streets. Youse are all just sittin' in your wee offices, all just conductin' all this shite. Live on the streets, know what it's like before ye say all this stuff.' They don't know nothin' … sure they're still doin' paramilitary beatings … They're still doin' it, they're never goin' to stop." (Co. Derry, aged 21: her emphasis)

Regarding elimination of sectarianism, the situation was considered bleak. While there was disagreement within groups, the general view was that there were few signs that the Conflict had ended because there was not "an acceptance of each other" (Co. Tyrone, aged 14-25). Some felt this might change through initiatives such as integrated education, youth provision and positive community relations work. Others remained unconvinced:

> "There's not a hope because nobody's goin' to change their views on what they think." (Co. Derry, aged 16-17)

This reflected the entrenchment of sectarian attitudes, the maintenance of divisions and prevalent messages about 'the other community'. It was the reason for a shared belief that "nothin' is goin' to change":

> "It's just a general dislike for each other … even if you try to change it, it'll always be passed down to the young people." (Co. Derry, aged 15-19)

It was also closely connected to fears about one side gaining advantage over the other; of giving the 'other community' an opportunity to assert their culture and beliefs. According to one group, this fear exposed the fragility of the peace process:

> "Sectarianism is the major issue. It will always be there, never go away … Some of what you see now is only the beginning. Catholics down here get everything and that's not right … They say the conflict's over. It's not and it'd be back tomorrow, full on." (Co. Fermanagh, aged 16-21)

A common 'other'

Alongside existing divisions within and between communities in Northern Ireland, a new 'other' has emerged. The recent arrival of foreign nationals has had a significant impact on population distribution. Children and young people raised this issue in four communities, as did community representatives in all areas. When discussing the negative aspects of community life and who was perceived as an 'insider' or 'outsider' (particularly regarding culture and rights) a common 'other' emerged. Children and young people across the religious divide were united in negative views about, and attitudes towards, foreign nationals. A community representative stated: "The tables have turned from it being about clashes with the other religion to clashes with ethnic minorities". The implicit and explicit racism expressed, however, was connected to existing sectarian divisions, historical fear and mistrust.

The groups most often identified by children and young people were Polish and Lithuanian foreign nationals, extending to a range of others including Chinese,

Japanese or just simply "foreigners". Children talked of "foreigners", depicting difference as "us and them". A common misconception concerned the volume of foreign nationals in Northern Ireland, the local town or neighbourhood. One young man claimed that, in his community, there were "no Northern Irish people". Another stated: "Ireland, you should rename it Poland 'cos it's all Polish in Ireland" (Co. Derry, aged 15-19). An image of foreign nationals and 'alien' cultures 'invading' or 'taking over' was commonplace and not confined to children and young people.

Foreign nationals were portrayed as dangerous, threatening community safety. This led to fear and suspicion, justified on the basis that "they talk different languages". Consistent with other circumstances in which children have no direct experience of a particular group or situation, cultural myths and stereotypes were recounted as fact, and exceptional incidents were used to define an entire ethnic group, instilling fear and contempt:

> "I want all the foreign people to get out because they kill people – one time in [this community] they killed someone. They broke into their car and they buried the body under the back seat." (Co. Antrim, aged 9-11)

Such stories spread quickly throughout communities, establishing a caricature of the unknown, unwelcome and dangerous 'other'. Many blamed increases in crime, particularly violent crime and drugs in their towns and neighbourhoods, on "outsiders movin' in".

Jobs, welfare and housing were also issues. Yet among children and young people there was less agreement. While some stated bluntly: "they take our jobs" (Co.

Derry, aged 12-15), or: "they're givin' the Lithuanians benefits and everythin' and givin' them lots of jobs" (Co. Armagh, aged 12-21), others commented that foreign nationals did poorly paid jobs which local people had refused. Some drew parallels with Irish emigrants, who historically had been viewed and treated as foreign nationals. For young people, the issue focused on lack of available jobs for them in their communities and the prevalence of a low wage economy. The availability of foreign nationals, some argued, allowed employers to pay low wages as they could fill jobs without reviewing rates of pay. Thus, young people were squeezed out of an already shrinking labour market:

> "They're takin' our jobs. It's hard enough to get a job without them here. There are too many of them." (Co. Fermanagh, aged 16-21)

Others believed that "locals should come first" (Co. Armagh, aged 12-21). They stated that this was an economic issue and was not about racism:

> R: "Where do you draw the line between feeling pissed off and angry [about foreign nationals getting jobs] and racism?"
> YP1: "Oh no, we're not racist. It's just they're comin' over here and stealin' the jobs and workin' for less. So all the young people now lookin' for jobs aren't goin' to get one."
> YP2: "It's not racist, it's about money. They'll work for £2.00 an hour and we'll work for £4.50." (Co. Derry, aged 15-19)

These views reflected fear among a group already disadvantaged in the labour market due to poor qualifications, skills and opportunities. The futures of young people interviewed were uncertain and some considered they would be forced to leave their communities due to inadequate, social housing. Yet they witnessed "outsiders" arriving, who had no attachment to the community and no shared history or culture. There was a belief that foreign nationals received preferential treatment and to raise the issue would bring accusations of racism.

Within the Republican/ Nationalist communities, some children and young people stated that the police excused foreign nationals' 'criminal' or 'anti-social' behaviour. In the Loyalist/ Unionists communities it was considered unfair that foreign nationals could express their culture openly when they themselves experienced restrictions. This reinforced the belief that their culture was being eroded as a consequence of political change. Such perceptions led to resentment among some young people and deepening levels of racism. One group stated:

> "You're not allowed to express your culture. Well, see those bag heads, you know those black people, they're allowed to have those things [turbans]." (Co. Fermanagh, aged 13-15)

Community representatives considered foreign nationals to be isolated: "They live in the community but are not part of it. It is difficult coming into an area when it is close-knit". Many children and young people interviewed did not want foreign nationals living in their communities. One group suggested, "We should build a Lithuanian town so they stop comin' here, a separate town" (Co. Armagh, aged 12-21). Thus, the 'natural order' of divided space should be extended to 'new groups'. This illustrates the deep roots of exclusive identity regarding space, offered as a response to fears about 'the other'.

Territoriality and ownership of space was pushed beyond the religious divide. Some commented that anyone from a different culture would be unwelcome, susceptible to attack and "wouldn't be long of stayin'" (Co. Fermanagh, aged 13-15). This was reinforced in interviews with community representatives who noted the targeting of foreign nationals, and their exiling from local communities.

Loyalist/ Unionist communities were concerned about Polish immigrants and this reflected their religion: "At the end of the day they are Roman Catholics" (Co. Fermanagh, aged 13-15). There was a sense of double inequality: not only were foreign nationals perceived as limiting job opportunities but, as Catholics, 'one side' was gaining privilege. A community representative explained:

> "Employment is 50-50 now between Catholics and Protestants but with many Polish people being Catholic it appears more than 50% now. It seems unequal, the balance is going."

This comment also shows how the views of children and young people are influenced and shaped within communities by adults. 'Tipping the balance' of long-standing structural and cultural divisions exacerbated fears about the potential dilution of cultural identity within communities. Those groups most overtly committed to their cultural identity were most resistant to the cultural identity of others. When discussing the victimisation of minority ethnic families, a community representative stated that people wanted to "keep [this community] the place to be, the Loyalist place to be".

Key Issues

- *Children and young people from all six communities considered sectarianism to be a significant issue affecting their lives.*

- *Children and young people were 'badged' by the places they occupied; often feeling 'imprisoned' within their communities.*

- *Fear of being identified as 'the other' limited opportunities (freedom of movement, opportunities for play and leisure, social relations) and impacted on children's/ young people's feelings of safety.*

- *Perceptions about 'the other community' were formed long before children and young people met someone of 'the other religion'.*

- *Limited exposure to those outside their community, and strong sectarian beliefs within communities, consolidated negative attitudes about 'the other community'.*

- *Rioting and sectarian clashes symbolised a means of asserting cultural identity and were described as responses to perceived inequalities.*

- *'Concessions' to one community were viewed as 'punishments' to the other. This created a sense of unfairness, insecurity and increased resentment towards 'the other community'.*

- *Children and young people were critical of cross-community projects based on minimal social interaction and no long-term plans for maintaining contact. Projects with a starting point of commonality, rather than difference, were better received and involvement in such projects was felt to have been beneficial.*

- *Children and young people across the religious divide shared negative views towards foreign nationals.*

- *Territorialism, uncertainty and insecurity at a time of transition for established populations exacerbated the difficulties faced by foreign nationals residing in small close-knit communities.*

VIOLENCE IN THE CONTEXT OF CONFLICT AND MARGINALISATION

The legacy of violence

As discussed previously, few of those interviewed for the research considered that Northern Ireland had achieved 'peace'. Their accounts described communities neither at war nor in peace - places of uncertainty and unease. Although some considered that communities were in transition towards 'peace', others believed it to be an unattainable goal while sectarian divisions and violence remained powerful illustrations of the legacy of the Conflict. 'Transition' is not an unproblematic concept as it implies a definitive, albeit complex, move from a conflicted to a peaceful society. A further, key issue is that the emphasis on peace has disguised the threat, legacy and ongoing reality of violence. As a young person stated, the message of peace acts as a form of social control while not delivering change:

> "There'll never be peace, they're just sayin' that. They're sayin' that to make everybody feel safe and happy to go about their business. But everybody in the back of their brain knows that there'll never be peace in Northern Ireland. Never." (Co. Derry, aged 21)

Many of those interviewed, particularly those aged over 16, had been exposed to political violence. While levels of violence had diminished, many young people had experienced or witnessed sectarian fights and confrontations, rioting with the police and paramilitary-style threats, beatings or shootings. Most understood how their community had been affected by, and involved in, political violence. The previous chapter considered how segregation maintained divisions between communities, ensuring generational transmission of sectarianism and violent

conflict. In this, the impacts and legacy of political violence is particularly significant.

Paramilitarism: past and present

Illustrating the continuation of paramilitary violence, and the persistent threat to the right to life, 113 casualties were recorded as a result of paramilitary-style attacks and five people were killed as a consequence of the security situation during the course of this research (PSNI 2009). Some of the communities involved in the research feature in these statistics, contributing to experiences of death, injury, fear and intimidation. Community representatives and young people reported increasing levels of threat from dissident groups. Young people in one of the Republican/ Nationalist communities had been recent targets of dissident Republicans. In one of the Loyalist/Unionist communities, a well established Catholic family had recently been intimidated out of their home. Within another Loyalist/Unionist community, resentment and tension regarding what was considered to be a political "sell-out" were high. A community representative stated that the paramilitaries "could start up [the Conflict] again tomorrow"; there were "elements of Loyalist paramilitaries in the area who can do something about it" and "they will get a lot of support".

Adult community representatives in all communities involved in the research raised the issue of the continued presence, or activity, of paramilitaries. While some reported continuing low-level recruitment of young people, others considered that this centred on youth wings of both Loyalist and dissident Republican paramilitary groups. Many young people reported an underlying fear in what they portrayed as insular and closed communities. The

quiet knowledge, or silent presence, of paramilitaries informed a common belief that violence remained a real threat. Representatives in one community stated there was "no freedom of speech". Those in another commented: "certain individuals control certain areas". In a third community the representatives agreed that paramilitaries were "still a real threat".

Children and young people in four communities discussed paramilitaries. They were aware of past and current paramilitary activities, expressing their support or rejection, and of the continued recruitment of young people. Some had recent direct contact with paramilitary or dissident groups. One young woman stated that all her friends had been summoned to discuss their behaviour:

> "We woulda had a meetin' with them and it woulda been maybe four of them and only you sittin' there and like 'Jesus, I'm gonna get killed now' … we were threatened."

At the time of data collection, warnings had been posted throughout one community about young people's behaviour - particularly regarding drugs. Included in the warning, the name of an individual who had been 'put out' or exiled from the community had been scored off the list. This direct threat to young people impacted on the whole community. A 13 year old boy stated he wanted paramilitaries out of his community: "Everybody's scared". Others considered they were targets solely because of adverse publicity about 'anti-social' behaviour. Recent examples of young people suffering punishments without warning included:

> "[Name] was shot there last week outside his front door. [Another name] was shot in the leg and told to get out."

A young woman gave a personal account of the failure of punishments to stop anti-social behaviour by some young people:

> "[My boyfriend] was done twice by the RA … he was left in hospital with broken hips, broken legs and he still went out and did it [again] and then they come and says, 'Right if you do it again we're goin' to shoot ye in the head'. And he still went and did it."

Among the community representatives and young people interviewed there was an overwhelming rejection of 'paramilitaries'. Distinctions were drawn between past and current paramilitaries, with the latter described as "wannabees", "clingers on", "hard men", "alpha males", "a thug element" and "vigilantes". They were considered to be men who used violence and the name of paramilitarism for personal gain, rather than political principle:

> "The politicians are only interested in the money, like some of the paramilitaries. They cared about the country then, but not now. It's about money."

Community representatives suggested that these 'new paramilitaries' had little connection with politics or 'the struggle', judging them as 'criminals' who use the paramilitary badge to access power and status and to instil fear:

> "It's all about money now. They call themselves paramilitaries, but it's all about money."

> "… [they] were always on the periphery and are trying to get a name for themselves second time round."

Community representatives and young people were concerned that these individuals had persuaded young people to adopt their agenda. They considered that young people were heavily politicised through interpretations of the past, glorification of violence and discussions about how politicians had 'sold out'. Young people in one community were acutely aware of this influence:

> "Some organisations would still try to bring them [children and young people] in to do stuff, like get eight year olds to riot."

Others felt strongly that such individuals had considerable influence over young people, inflaming and inciting sectarianism:

> YP1: "Sectarianism now is mostly all to do with paramilitaries. Like here you have the RA and they would be encouraging you to be Republican and to row with the UDA, an' all that there. And then that's how riots and all that there sectarian stuff starts."
> R: "Do you think the RA is still active around you?"
> YP2: "They've still got a strong hold on young people."
> YP1: "But you see wee young ones runnin' about as well, 'Up the RA' and all this shite. And they don't even know what they're chattin' about, but it's just they're encouraged to do it."

There was considerable resentment about those referred to as "armchair paramilitaries" who politicised young people, steered them towards violence and then stood back free from direct responsibility:

> "There are a small number of Loyalist paramilitaries who would send young

people out to do things but do little themselves."

> "This group of dissidents are politicising young people on the streets by going out and talking to them. They are taking what was a contention between the community and the police and using it to incite violence among young people - passing on and glorifying the stories of the past."

When young people were politicised and 'recruited', they became the 'new recruiters', exerting control and influence on younger children. The children admired their older peers, who had status. The continuing recruitment of children and young people into violent sectarianism, often in the guise of celebrating cultural tradition, is a crucial issue for communities working towards transition from Conflict. Community representatives stated that there had been no political acknowledgement of these ongoing problems faced by their communities. Having detailed the nature and extent of these problems in his community, a community representative concluded: "This is what happens at the local level … you never hear about it unless you are in the community". In discussing why children and young people become involved, several community representatives considered that paramilitaries "preyed" on the young, "feeding" their fears and emphasising their vulnerability. In situations where young people's role and identity were uncertain, they were considered "easy to drag in and give a focus in their lives". A community representative stated:

> "A lot of men have nothing to be proud of because they're unemployed. So they regale kids with stories of the glory days,

as this is where they got their pride, and young men see this as a rite of passage."

There was significantly less criticism of the actions of paramilitaries in the past. A typical comment from a young person was:

> "Paramilitaries were good for communities. They kept the riff-raff out. They'd stop gangs."

Community representatives across all areas stated that, while there was little continuing support for paramilitaries, people harked back to when "you could knock on someone's door and get it sorted". There was general concern about drug and alcohol use, 'anti-social behaviour' and crime involving young people throughout the communities. Fear of contacting the police and being identified a 'tout', lack of trust in the police, and the decline in what were identified as 'legitimate' paramilitaries, had left a policing vacuum. One focus group of young people struggled with the moral dilemma of using extreme physical punishment and its consequences. They discussed the availability and impact of drugs and believed that, previously, paramilitaries had succeeded in preventing the supply of drugs to the area. Given a policing deficit, paramilitaries had effectively filled the void.

Expressions of disillusionment about the peace process were not confined to the feeling that politicians had 'sold out'. Those interviewed felt excluded, that negotiations had been conducted behind closed doors by those in positions of power. There had been no preparation in communities regarding devolution. This experience of disconnection, of feeling alienated from key decisions about Northern Ireland's future, had encouraged some young people to associate with paramilitaries. In three

communities, this association gave young people a clear identity. In one situation, young people had developed strong, personal relationships built on respect and trust of an individual who, while encouraging them to embrace their cultural tradition, directed them to commit acts of violence and intimidation against 'others'.

There was also an understanding and awareness that those who were 'connected' were 'protected', including protection against arrest by the police. Young people discussed unfair administration of punishments: "there are different rules for different people". While, for many interviewed, such power and discretion deepened their disrespect for quasi-paramilitaries, they were aware that some young people sought this 'connection' and 'protection'. As a community representative stated:

> "[They] are protected and get away with crime, so it pays to be involved. Those who aren't supporters and who are involved in crime won't get away with it."

Young people in all communities rejected and resisted what they identified as the injustices of threats and punishments. Some demonstrated their anger and resentment by deliberately causing trouble. To them, civil disorder was a form of resistance and a means of demonstrating that they would not be controlled by paramilitaries or vigilantes. As stated previously, however, other young people considered close association with paramilitaries to be part of asserting their identity.

Violence and everyday life

The violence of the Conflict remains celebrated, glorified and normalised at several levels. Certain murals, commemorations, parades and stories reflect stark images of structural, institutional and direct violence. 'Cultural violence', closely associated with identity, is embedded in the language of opposition politics, the direct experiences of families and communities and the segregation or marking of space.

In the transition from political violence an increase has been reported in what has been termed 'everyday violence', giving rise to discussions about acceptance and 'normalisation' of violence within Northern Ireland. The assumption is that part of the legacy of violent conflict is an unusual toleration of violent responses to settle disputes. Many of the children and young people interviewed identified fighting, bullying or violence as significant parts of their lives. All groups were concerned about violence in different contexts - sectarian violence, violence against the police, violence by the police, youth on youth violence, adult violence - and its impact on their lives and/or communities.

Children and young people did not, however, indicate an 'acceptance' of violence. Regarding safety, free movement and being victimised, the common thread was fear. A few groups noted this with resignation: "It's just life, like" (Co. Derry, aged 13). It was clear from the focus groups that many children and young people regularly continue to experience or witness serious community violence. While the motives behind such violence varied, the impact was felt by all. Some reported that there were "lots of fights" or a "wile lot of riots" (Co. Derry, aged 14)

in their communities, that "violence is bad and it's getting worse" (Co. Fermanagh, aged 16-21). Others commented that it was "kind of up and down" (Co. Antrim, aged 15-20). Clearly, the intensity of violence was dependent on circumstances or the celebration of cultural or commemorative events such as parades, 12th July, St Patrick's Day and significant anniversaries.

Children and young people discussed recent incidents of severe violence in their communities. These included: the sectarian killing of a young person; paramilitary-style punishments; alcohol-related violence ending in the death of a young person; and intra-community feuding resulting in weapons being used on the streets. The latter incident had impacted on the whole community: "They don't just fight, it's like worse than fightin' … it was wile scary and they done it every night … ye get scared at night".

While these events were sporadic, less dramatic acts of violence were constant. Children and young people across all communities experienced fighting and violence at weekends, usually related to alcohol. Despite the disproportionate focus within communities and in the media on young people and violence, many pointed out that adults in their communities were also involved. In one community, a number of groups claimed that "believe it or not, it [is] mostly the adults" (Co. Antrim, aged 19-20) who were responsible. Community representatives stated:

> "The children are growing up in a general environment of criminality. It is mostly the older people involved, but young ones get pulled into it."

While only raised by a few of those interviewed, it was stated that what adults

often perceived as violence between children or young people may be 'play-fighting': "the fighting isn't always real." (Co. Derry, aged 9-11)

Bullying, intimidation and safety

Children's discussions of 'fighting' were often linked to personal experiences of bullying, explained as occurring "because they're bullies" (Co. Antrim, aged 7-10). They considered bullying as violence beyond physical exchanges, including verbal attack, intimidation and exclusion:

> "Fighting would be just calling names." (Co. Armagh, aged 9-15)

> "They say stuff about you when you walk past." (Co. Derry, aged 8-14)

'Fighting' also occurred as a result of games and play. Yet some were thought to fight more than others, including older young people and those from particular streets. Children in a number of communities gave examples of being bullied and intimated by older young people – on the streets, in their play areas, on their way to youth provision:

> "Like, one day we were in [the park]. I was in with me wee cousin and we were on the swings and they [a group of 16 year olds] told all of us to get off 'cos they were playin' football. Like, there's a pitch right beside it and they were playin' football in the park." (Co. Antrim, aged 10-13)

They provided many examples of such intimidation and its impact on children's opportunities for play. Some noted the psychological consequences of being laughed at and talked about:

> "They would laugh and make you paranoid."

> "They might take a hand out of ya, hurt your feelings." (Co. Derry, aged 8-14)

Children felt intimidated and unsafe on the streets, particularly at night, because of comments from young people drinking alcohol. Some would not go out at night or would not visit parks, while others walked to youth clubs in groups:

> "Seein' people smokin' and drinkin' and you don't feel safe an' all. And you wish your Mammy an' Daddy were there." (Co. Derry, aged 9-11)

Children, particularly in one community, related bullying behaviour to alcohol. A typical comment was:

> "I don't like where we live because people drink and start bullying." (Co. Down, aged 10-11)

Within communities it was clear that young people exerted power over children. Yet young people also experienced regulation and control from adults, including use of threats and force by paramilitaries or vigilantes. As the accounts above illustrate, emotional and physical violence within communities was often explained as bullying but was considered to be part of everyday life. Children provided an holistic understanding of violence and its consequences, including negotiation of movement within their communities. Apart from the threat and reality of physical attack, their self-esteem and personal worth were also undermined.

Alcohol and violence

In discussions of violence and fighting, seven of the focus groups emphasised the relationship between alcohol use and violent assault. A further eight groups drew a link between boredom, alcohol use and violence. Fighting and violence in their

communities was particularly marked at weekends:

> "Hitting people – there's lots of fighting around here because of drinking on weekends." (Co. Down, aged 9-10)

> "… at the weekend, when the boys are tanked up." (Co. Antrim, aged 18-20)

While some noted that violence was not restricted to young people, others stated there was a clear connection between alcohol and boredom among young people. Alcohol use did not always result in violence, but there was always the potential for trouble given that consumption regularly occurred among groups in public places. Those living in rural communities with few youth or recreation facilities stated that they drank alcohol to relieve boredom:

> "What else are we meant to do? You drink. It's something to talk about. But when we do it, we get in trouble." (Co. Armagh, aged 9-15)

Others noted that youth facilities were closed at weekends. The alternative was to hang out on the streets drinking alcohol. This often led to violence:

> R: "Why do you think they are fighting?"
> YP: "The influence of drink … they're bored, there's nothin' for them to do. The club opens on a Friday night and it's Saturday when it happens." (Co. Derry, aged 8-14)

Many felt that the effects of alcohol caused violence: "When the drink's in, the wit's out!" (Co. Derry, aged 21):

> YP1: "Usually on a Saturday night and stuff they go round the estate fightin'."
> R: "Why's that?"
> YP2: "Cos they argue."

> YP1: "Cos they're all drunk and they just start rows and that, and then start to fight."
> YP2: "Cos they get drunk and don't really know what they're doin'." (Co. Antrim, aged 10-13)

Being on the streets or other public places drinking alcohol was not without risk. Young people recognised the risk of 'trouble' – from the police, the community, paramilitaries and/or as a result of losing control of their behaviour. Some noted the potential for violence:

> "They drink and they turn into Rambo … all somebody's got to do is turn on ye." (Derry, aged 16-17)

Young people reported that much of their time spent on the streets involved little more than meeting with friends and passing the time. Alcohol was not always involved - considerable time was spent playing football, walking about or just chatting. Yet it was during such 'routine activities' that young people experienced 'crime' as victims, perpetrators and witnesses. From the interviews it was clear that fighting was often a consequence of hanging around drinking alcohol. Within some communities, particularly but not exclusively in rural areas, alcohol consumption among young people was marked.

Many community representatives, children and young people stated that drinking alcohol started at a young age (ie. 10 or 11 years). This was supported by a survey of pupils in one school. As previously noted, most of those interviewed connected alcohol to boredom:

> "We've nothing else to do but drink." (Co. Armagh, aged 12-21)

"You only go drinkin' because you're bored." (Co. Derry, aged 15-19)

Drinking alcohol was identified as a legitimate pasttime for young people; developed through peer groups and, more generally, within the wider community. One group stated that young people's drinking was 'normal' and others suggested that it was culturally acceptable. Drinking was endemic in some communities:

"It's everywhere … it's easy to get." (Co. Tyrone, aged 14-25)

"Alcohol is just the thing round there … it's just that we're Irish and we're made to drink." (Co. Armagh, aged 12-21)

In rural communities, alcohol was easily accessible. Young people stated that local pubs had no qualms about serving those known to be underage. In addition to relieving boredom, alcohol provided camaraderie with peers and the wider community. Alcohol use was part of growing up for all young people interviewed, but within communities experiencing poverty and poor facilities it provided "something to do". In communities with few leisure opportunities, where access to activities outside the area was expensive, alcohol use provided the cheapest form of leisure available. For some, it was also part of their local identity. Some suggested that, particularly for young men, alcohol use was linked with "acting tough" and "being hard" - it was significant in young male identity formation, in achieving and asserting male status.

Young people discussed use of alcohol as an escape from the boredom of everyday life and the difficulties they faced. Often, however, it brought more risks and additional stress:

YP1: "You get blocked [drunk] and you just don't care what you do."
R: "You see, when you get blocked, does that worry you?"
YP1: "Only when you get real blocked and you don't care what happens to you. You regret it in the mornin' – it does your head in."
YP2: "You wake up the next morning and think 'Oh God, what did I do last night? What have I done? I coulda done somethin' stupid' – or somethin' like that." (Co. Derry, aged 15-19)

Rather than seeking support at particularly stressful times, some young people turned to alcohol. Discussing how a close group dealt with a friend taking his own life, one young man stated: "Well, we were all shocked about it … we more or less went drinkin'." (Co. Derry, aged 21). Ironically, while alcohol was used as a coping mechanism and a means of forgetting about problems, it also perpetuated emotional distress and could be used as a form of violence against the self.

Violence: a legitimate response?

In discussions about violence within their communities, young people repeated that they felt neither valued nor respected. This was illustrated by: inadequate recreation and leisure facilities; negative perceptions and representations of young people; exclusion from discussions and consultations about the future of communities; openly hostile, disrespectful and aggressive responses towards them. In these circumstances, their reactions were predictable:

"People get drunk and wreck the place because of the way they've been treated." (Co. Armagh, aged 13-24)

R: "If somebody asked you to move along, what's the response to that?"
YP: "It depends on what way they ask ye. Some of them would be like, 'Lads, come on, please move on'. The boys just walk away. Some of them that come out and shout, you're just gonna take the hand outta them." (Co. Derry, aged 21)

Young people's hostile reaction to aggressive adults was an issue also raised by representatives across the communities:

"There is an undercurrent of acceptance of violence in our communities – this starts in the home and young people feel there is an acceptable level of violence for them when they are young. All this moves on with age."

"We have had 25 years of violence and it has been passed down from generation to generation that violence is acceptable. Parents are violent towards children in the home – they get a good thump – and the young people learn that violence is the right way to go, it's the answer."

"There is a violent nature to the culture [in this area]. There is a mindset that violence is alright – shout to be heard, fight to get by. Status is achieved through violence."

On a number of occasions, children and young people commented that acting violently was what was expected of them by their peers, friendship groups and, more widely, the community. Questioned about why young people 'fight', some responded: "they just react" or "because their friends fight". Reacting violently to "someone slaggin' ya", was considered a legitimate response. Standing up for personal reputation, for family, friends and community was part of local culture and learned through experience. Previous

research reported that young men in Northern Ireland identified violence as a defence of themselves and their communities. They considered their behaviour to be "unnecessarily violent" (YouthNet 1999: 3). As discussed earlier, violence was also justified in specific circumstances - when someone from the 'other community' entered the area or attacked friends.

While some of the young women interviewed were involved in 'fighting', 'rioting' and aggressive behaviour, violence was an activity *most often* associated with young men. It was clearly linked to masculine identity. In their consultations with 135 young men aged between 14-25 years, YouthAction (2001a: 1) concluded that "violence is seen as natural within young male culture. It is considered inescapable, normal and often acceptable". The 'hard man' image was significant - as illustrative of dominance, 'toughness' and 'maleness', and as a means of gaining control, status and respect. It asserted identity and secured protection: "Standin' up for yourself" and "takin' no lip" was about facing others down and maintaining respect. Fighting for identity brought respect. Some community representatives felt that violence achieved more respect from peers than other factors, including educational achievement.

The relationship between masculinity and violence is particularly significant in Northern Ireland where violence, specifically paramilitary and sectarian violence, has been a defining reality for many young men in working class communities. It has been closely associated with male identity; used to maintain difference and assert both masculine and national identity. At a time of political and economic change, when the identity

and position of working class young men is uncertain, violence as part of identity is a complex issue. Masculine identity, often associated with employment, is difficult to attain in a shrinking youth labour market during a time of rising unemployment. Further, masculine identity acquired by young men with strong links to their culture is less certain when many believe that their culture is being eroded. In this context, "violence is often an expression of young men's hopelessness, frustration, isolation, boredom and energy" (YouthAction 2001b: 13). Within communities, links between violence, boredom, frustration, lack of power and respect - together with a precarious material position at a time of economic, political and cultural uncertainty - are part of the complex mix underpinning violent behaviour.

Violence is a significant issue in divided communities with a divided government. It is experienced disproportionately within communities which endure the dual impacts of poverty and the legacy of the Conflict. As illustrated throughout this chapter, and those that have gone before, it is part of everyday life - in families, schools, relationships - between and within communities. Such conflict exists in other western democratic states, yet the recent history of violence in Northern Ireland, the current situation of 'no peace - no war' and political as well as economic uncertainty, add significant dimensions. The children and young people interviewed experienced sectarian divisions alongside class divisions, and an ever-present threat of sectarian violence. Fear and mistrust were compounded by the emergence of new forms of 'paramilitarism' involving individuals prepared to control and punish,

as well as politicise and recruit, young people.

The reality of life within these communities often remains hidden. Official discourse focuses on 'peace' and a 'post-conflict' society, resulting in denial of continued fear, violence and conflict. Thus, heightening tensions have not been recognised or acknowledged. These tensions arise from concerns within communities where people feel excluded from the Peace Process, unprepared and under-resourced for change. They believe they have been ignored, blamed and left to deal with complex intra-community, as well as inter-community, conflict. In discussing underlying tensions in his town, and echoing the fears of others, a community representative stated: "Something will ignite it, like a killing, and it will erupt". Since this comment was made, several attacks (some with fatal consequences) in a range of Northern Ireland communities have borne out his fears.

Key Issues

- *Many children and young people were exposed to community violence, sectarian violence, rioting against the police, paramilitary-style threats and punishments.*

- *The perceived anti-social behaviour of young people made them targets for those who continued to ascribe themselves paramilitary status.*

- *While children and young people felt threatened and intimidated by violence in their communities, they were resigned to its presence.*

- *As a by-product of being on the streets at night and weekends when (reportedly) there*

was more 'fighting', young people regularly experienced or witnessed violence.

- *Violence impacted on children's and young people's feelings of safety, their freedom of movement, opportunities for play and levels of victimisation.*

- *A connection was made by children, young people and community representatives between boredom, alcohol use and violence. Alcohol use was a concern in rural areas and in communities where few facilities for young people existed.*

- *Alcohol was often used by young people as an escape from boredom and the difficulties of life. Yet its use often increased the likelihood of experiencing violence and emotional distress.*

- *Some young people exerted power over children, threatening and intimidating them. This was consistent with young people's experiences of adult power.*

- *Violence was deemed by some young people to be a legitimate response in defending cultural identity.*

SERVICES AND SUPPORT

Play and leisure

Children and young people in all communities complained about the poor maintenance of local parks. They were concerned that damaged facilities were left unrepaired:

> YP1: "The parks aren't working, they're not cleaned, there's glass all over the place. The swings and slide were broken and taken away."
> YP3: "They took the slide away too and said they were bringin' somethin' to replace it but they never did." (Co. Derry, aged 8-14)

Apart from the physical dangers of broken equipment and glass, children felt intimidated by young people who congregated in local parks (often drinking alcohol).

Across the communities there was no consistency in the quality of play and leisure provision. It ranged from large, bright buildings with computer suites, art rooms, hairdressing rooms, space for activities and games rooms, to dilapidated, cold, damp buildings and church halls. Despite poor facilities that did not meet their needs, young people attended the clubs and programmes provided. A young woman stated:

> "There woulda been maybe 30 people, 30 weans in there and one pool table and one tennis table. Two people to a table and that's it, the rest left sittin' tryin' to find somethin' to do. It never give a lot of us a wile lot ... so it was *there*, but ..." (Co. Derry, aged 22: her emphasis)

Girls and young women interviewed stated that what was available was "all for boys". This was particularly the case in youth clubs and in rural areas where most provision was sports-based: "Boys are ok but the girls don't have anything" (Co. Armagh, aged 9-15). Clearly, young women were disadvantaged and a 'boys club' ethos remained. In one community, lack of provision for girls was explained as follows: "There are no real girl trouble makers".

There was general agreement that young people beyond 15 'outgrew' provision: "I went to the youth club when I was really young but stopped. It's mostly kids" (Co. Antrim, aged 18-20). A young woman stated: "There being a lot in an area doesn't matter if people don't want to use it" (Co. Derry, aged 21). Many commented that there was "nowhere to go and nothing to do", particularly when facilities closed early and did not open at weekends or during school holidays. Without provision young people stated they would "just hang about the streets", "do nothin'" or "get up to no good".

Play, leisure and youth provision often relied on volunteers, with minimal grant-aid. One group received £300 to run a full summer scheme. Another activities-based youth centre annually received £300 statutory funding as the emphasis was on "utilising the building and its facilities". This was one of the better resourced centres, yet resourcing issues-based work was difficult. In another project, some staff worked without pay as they awaited the outcome of funding applications. Many youth and community workers worked beyond their contracted hours on limited budgets. One area had not had a full-time statutory youth worker for a prolonged period due to under-funding. The feeling among those working with children and young people was that the statutory sector was dependent on the voluntary and

community sectors to provide services, but there was no statutory investment in essential provision - the value of their work was not recognised. One youth worker stated: "It gets to the stage where you feel it is a reflection on how your work is perceived."

Five recurrent needs emerged from the focus groups with children and young people: better maintained parks; improved youth provision; provision during evenings and weekends; more opportunities for trips away; appropriate provision for older young people. As one young man stated: "Everyone is just bored of their own estate" (Co. Antrim, aged 15-20). Among young people some desired more structured activities and programmes, others wanted a place to relax, talk with friends and play pool. They wanted provision separate from children. In rural areas, free or subsidised transport was a priority. Those within a 'mixed' community requested more 'mixed' youth provision and suggested a 'one-stop shop' providing: sports and activity-based projects, structured courses and programmes, a drop-in, an activities room and a counselling service. Poor play and leisure provision was identified as a clear indicator of the low value placed on children and young people. Consequently, children and young people were forced into unsafe play spaces where the risk of causing and experiencing trouble was increased, giving rise to allegations of nuisance and anti-social behaviour.

Across all communities, particular clubs and projects were popular because: staff were respectful; they provided a place to meet with friends and new people; there was 'something to do'; they provided opportunities, developed social skills and gave information. Some noted that projects kept them "off the streets" while for others:

"It gets you out of the house, I would just be sitting around if I didn't come here" (Co. Antrim, aged 19-20). While often being "the only option", going to the club or a project was "something to look forward to" and "something different" - even when provision was restricted to a few hours one evening a week. Several community representatives emphasised the importance of youth provision for those excluded from community life and/or experiencing difficulties at home:

> "For those living in families where there are obvious difficulties the youth club is a haven – it is a place to escape to, where staff show some level of care."

Activity-based provision also provided a place to develop skills in play, teamwork, communication and social interaction. Those who understood the benefits of youth programmes for personal and social development were committed to structured, programme-based work. Often they were older teenagers and young adults who had a personal understanding of the positive impacts of such provision. For them, building confidence, self worth, self-awareness and developing social skills were priorities. Residentials were particularly significant:

> YP1: "Comin' to this place too, you begin to respect yourself as well."
> YP2: "You build your confidence for yourself and respect yourself more."
> YP3: "You learn how to talk to other people through residentials and the work we do."(Co. Derry, aged 16-17)

In accessing services young people appreciated opportunities for frank and open discussion in situations where they were shown respect by workers. Youth and community workers were identified

by young people as those most likely to facilitate such interactions. Young people described how youth workers conducted consultations that were not tokenistic but based on interest and respect. They felt "listened to" and their opinions mattered: "We get a choice for what to do ... when you're asked you feel class" (Co. Armagh, aged 13-24). Junior leaders and youth committees provided a voice for some young people, who reported back to leaders/ service providers and ensured that those who did not have the confidence to talk directly to workers had their views represented. Reflecting on their youth committee, three young people stated:

> YP2: "It's all like *our* opinion." [their emphasis]
> YP3: "We represent different areas, like, and we bring our information to our area and we bring the information back."
> YP1: "... there's how many of us? – 12, and then each one of us represents a place round this area and we have a meetin' every other Wednesday. And if there's anything that our friends have said they wanna do, if we can get the numbers then we bring it to [the youth workers] and they sort it out." (Co. Tyrone, aged 14-25)

In four communities, youth workers consulted with young people on the streets to provide information about provision and to establish the most appropriate provision. In one community adults requested a meeting with young people to conduct a needs assessment, which drew a positive response. In another community a proposed project for girls was accepted because:

> "It was stuff we wanted to do ... We were asked what we wanted to do ... we

got to do what we wanted to do outta our choice, so we didn't have to sit and watch everybody else [boys] because there was no money [for the girls]." (Co. Derry, aged 22)

Emotional and mental well-being

Children and young people talked about issues that created stress in their lives. These included: school work and exam pressure; lack of jobs; concerns about the future; parenting; family problems; witnessing and experiencing violence; appearance and feeling excluded; lack of identity and place; adults' negative responses towards young people. The two issues most frequently raised in these discussions were depression and suicide, particularly related to those aged 16 and above. Young teenagers in one community felt that many of their friends and acquaintances, especially young adults, suffered depression: "There's a wile lot of people depressed and sad" (Co. Derry, aged 14). Many felt that issues relating to mental health, or "emotions and feelings", should have been discussed in schools.

Developing self-awareness and an understanding about what constituted good and poor mental health was not generally explored in forums attended by young people, other than in sessions concerning drugs and alcohol. While members of one focus group, who attended three different schools, had covered mental health in class, none considered it informative.

Many raised the issue of suicide. Within four groups, one or more individual revealed that a friend or someone they had known had taken their own life. Not discussing feelings and emotions was considered a significant issue:

"We had a friend who committed suicide two years ago … young people just really close-up and don't really want to talk about things." (Co. Antrim, aged 19-20)

For young men in particular, and for some young women, not talking allowed pressure to build without any release. This was perceived to manifest itself outwardly in anger or violence towards others, or inwardly through abuse of alcohol and/ or drugs, self-harm or suicide. Young people felt that some of their peers did not recognise the 'problems' they were enduring or, when they did, were silenced by embarrassment. A young woman stated:

"In the years there's a lot of my mates have lost themselves, you know, lost their lives over maybe drugs, drink - hangin' themselves. It's because they don't speak. A lot of them's wee boys, they don't speak … When my friend killed himself last year the girls were all taken out to talk about it but the wee boys were left, and I've seen three or four of them changed. One of them has faded away to nothin', he won't come outta the house or nothin'." (Co. Derry, aged 22)

While many drew a direct correlation between alcohol or drug use, depression and suicide, other reasons were also given. One group discussed recent cases in which young people had taken their own lives following persistent bullying. Others discussed the pressures on young people to conform: "fittin' in", "lookin' good", being sexually active. Appearance was a particular issue for young women, who considered bullying and abuse to be sexualised and often focused on the body: "They say, 'Look how fat she is, look at her boobs'" (Co. Armagh, aged 9-15 years).

Some believed that being undermined, viewed and treated negatively, damaged young people's self worth:

"It just gets to you all the time, undermines you. It's feelings of insecurity that leads to suicide." (Co. Fermanagh, aged 16-21)

Lack of self worth was made worse by having little to do, feeling bored and experiencing difficulties in finding paid employment. Unemployment was also a key issue:

"I'm workin' now. I wasn't workin' there for a while and I went back into depression because I would get wile depressed really easily. It brings my self esteem back up, you know doin' maself up and lookin' in the mirror and goin', 'You know I am a good girl, I'm not bad anymore.' … I come in here [to work] to have a *life* of me own outside me family home, outside of me wean, 'cos ye need it. See if you're a Mammy 24/7 too, your head goes away with it and I mean your head does go. You end up fightin' with everyone and then you do get angry and frustrated." (Co. Derry, aged 21 – her emphasis)

According to some community representatives, lack of qualifications, low skills and poor employment opportunities brought little hope and low aspirations, leading to depression:

"They may not recognise it, but that's what it is. They have nothing. They stay up half the night because they've nothing to get up in the morning for. They don't look forward to the weekends as they're not working during the week."

In two communities, those interviewed connected suicide among young people

to the recent influx of drugs into their communities. Low self-esteem alongside lack of focus or hope often led to use of alcohol or drugs as coping mechanisms. Many drew a link between boredom, low self-esteem, feeling down and using alcohol or drugs as a means of filling time, increasing confidence or as a form of escape. Some considered this to be a downward spiral:

> "People feel so low they want to just go and take drugs to get rid of all their problems and then they might take a bad trip and then they might be suicidal." (Co, Derry, aged 16-17)

Others gave personal accounts of turning to alcohol or drugs as ways of coping, only to find that they actually reduced their capacity to cope:

> "I had a miscarriage and I went on the drink again and doin' all that stuff again … we were always drinkin … that's when I had me bad experience [with drugs] … I'm on the sick now, since then." (Co. Derry, aged 21)

In the young people's accounts, drinking alcohol or taking drugs to deal with problems (including low self-esteem), rather than seeking support, was connected to anger, violence and/or suicide. This was a view shared by many community representatives who considered that drugs and alcohol were used to increase self-confidence and "kill emotions":

> "Drink changes the young fellas – they feel they're not getting anywhere anyway. They feel angry and hate everyone. Young men rarely express their feelings."

While children and young people were often aware that suicide and depression

were issues within their communities, many lacked an understanding of the wider issues regarding mental health. In five communities, community representatives raised concerns about the mental health of children and young people. They discussed "high suicide rates" among young people in their communities and "pockets of suicide" in the region. They gave examples of children as young as 11 having taken their own life, of young people within one community choosing the same location and of a family in which the father, son and daughter had each taken their life. The impacts of such events on other children and young people within a community are obviously considerable, yet this was rarely recognised or addressed. One community representative stated:

> "The young man was 20 years of age and was well known in the community. When he was younger he was seen as the brightest child in his class and people expected him to go places. On the evening of the wake young people were gathered in the town … you could see it in their faces: 'If it didn't work for him and he had all this, how is it going to work for us?' It was just a feeling that you could sense. It was in their faces."

Some linked the situation to emergence from the Conflict:

> "You don't focus on the Conflict any more, you focus on yourself."

> "For us growing up, our attention and aggression was focused elsewhere. Now there is less to focus upon."

> "When conflict is happening, there is so much else to concentrate on. When it's over, what happens now?"

Many spoke of young men who "grew up to be something but then suddenly had it taken away," whose identity and status was previously linked to the Conflict - whether actively or politically - through Loyalist or Republican identities.

Some young people had lost mothers and fathers during the Conflict, and had experienced and/or witnessed community violence, harassment by the police and security forces. Community representatives suggested that such experiences had been buried and were now emerging: the "hurt and damage done" to parents, relatives and friends "comes to the surface years after the Conflict is over". Many discussed the continuation of violence within their communities. Recounting a punishment beating that had resulted in the death of a young man, a number of community representatives noted profound impacts on young people in the local area:

> "… there were three young men with him, what impact must that have had on them? Young people all over [the community] were at the funeral. Think of the trauma something like that causes."

The dual impacts of poverty and the Conflict were paramount in community representatives' discussions about mental health and well-being. Many discussed intergenerational trauma and the despair caused by poverty, bereavement, fear and/or intimidation. Some considered that low self-esteem and lack of confidence were intergenerational.

Those working closely with young people identified "a very bleak outlook", "low expectations" and a profound belief among young people that "nobody cares". These adults understood that young people were often negatively labelled in schools and the community, their behaviour judged as 'anti-social', with little recognition of context. They considered that young people lacked positive feedback, supportive reinforcement, reliable relationships and "someone to ask how they feel". Young people's emotions, and the difficulties they faced, were overlooked:

> "You can tell by looking at them - they're all bravado on the outside, but when they're on their own, you can tell that inside they're hurting."

Support mechanisms and services

Across all age groups, friends were identified as key providers of support. More significant for young people than for children, among some friends were the only support mentioned. While many children and young people could not identify local support services, most named a person or place where they could access help, advice or information. The most frequent response was a youth/support worker or youth provision. Few identified a parent or family member and most who did were in the younger age groups. Parent-child relations were more strained with age, as young people considered there was little trust or understanding between themselves and their parents. Additionally, not all children and young people had access to family support. Many community representatives noted that youth workers were often the only positive adult relationship experienced by young people:

> "Youth workers are like parents to some of the kids in this area, so the kids need them. There is a great need for a significant adult in their lives."

Across all ages, children and young people identified a youth worker or project as their main source of information, help and support. The youth club/project provided a contact point:

> "Some people would go down to [the youth club] – it has signs in it: 'Phone such and such'. Or tell them ones [youth workers] and they'd get someone straight away." (Derry, aged 13)

Others stated that if they were in trouble they would go to the youth club: "They would put you in contact with someone". Personal contact based on trust, respect and caring was considered vital:

> "I'd talk to [the youth worker] about anything. He's just easy to talk to. And it's the same with the kids here, they all love [him] and would talk to him." (Co. Antrim, aged 19-20)

In two communities, youth projects had engaged counsellors to provide individual contact and support for young people. Many projects also ran programmes based on identified need. The issues of significance across the communities included: bullying; community relations; domestic violence; anger management; alcohol and drugs awareness; mental health; and sexual health. In rural communities, youth provision was often the *only* source of help, information and support.

A significant number of children and young people also identified school as a place where they could access information, help and support. While many children viewed this support as 'teachers', young people focused on particular teachers who they could trust. A few identified school counsellors, but others explicitly rejected school-based counsellors. There

were issues that some young people would not discuss with staff because they feared confidentiality would be compromised, they would be too embarrassed or misunderstood: "In my school there's a good man but you couldn't talk to him about girls' stuff" (Co. Armagh, aged 9-15). Approachable teachers were those who respected, cared about, understood and spoke to children on their level.

Strong and reliable relationships with professional workers were predicated on mutual respect. Young people's respect depended on the attitudes and actions of those who provided for them, listened and advocated on their behalf. Youth workers were the most frequently named trusted support providers:

> "[Our youth worker] takes the time to help us ... she understands us." (Co. Armagh, aged 13-24)

> YP: "He does care about us ye know."
> YP: "He knows us."
> YP: "He's done good stuff for us."
> YP: "He stuck up for us." (Co. Fermanagh, aged 13-15)

> "They don't jump to conclusions if we're standin' in the street doin' stuff ... They worked with young people before so they know that not all of us are bad, like, and they enjoy workin' with younger people because when they take us away on residentials they're spendin' the whole weekend with us ... and some of them mightn't even get paid for it." (Co. Derry, aged 16-17)

The closeness of relationships with individual workers generated a willingness to open up:

"They just know whenever there's somethin' wrong with ya." (Co. Armagh, aged 12-21)

There were many examples of young people benefiting from group and one-to-one work. Particularly for those who lacked good, supportive relationships elsewhere, individual youth or support workers were important. A young woman described her relationship with her support worker:

"…you coulda rung her at *any* time of the day like. You coulda rung her at 3 o'clock in the mornin' if somethin' had of happened in the house and she would be there for ye straight away." (Co. Derry, aged 21: her emphasis)

Some described youth and community projects as providing a place to relax, where they could be themselves and talk with peers who had experienced similar concerns. As one group stated: "You come up here and it releases the stress of your day" (Co. Derry, aged 15-19).

Many of the children and young people interviewed had difficulty identifying other services and sources of support they would find useful. Rather, they suggested changes to, or extensions of, what was already available in their communities and schools. Priorities for additional support and services were based on: generic needs for all children and young people; specific needs in communities; individual or personal needs. The two most frequently raised areas for development were expanded youth and community provision, and information and advice available in schools. Improved youth provision centred on drop-in facilities; better opening times; adequate long-term resourcing to ensure the continuation of programmes and projects. Additional funding was also required to provide children and young people with good quality information and advice not available through school or in the home. A young youth leader raised the practical difficulties associated with accessing such provision within youth services:

"Young people need information, more courses - drugs courses, alcohol courses, sex education. We need to pay if we want them in. There are very limited courses for free … It's only when we would get funding to bring them in. If we can't pay them, we can't get them." (Co. Derry, aged 19)

Identified deficiencies in school related to careers advice, sex and relationship education and health issues. Children and young people recommended that provision should be more practical and delivered by those with relevant expertise. In one community, there was no sexual health clinic within reasonable travelling distance. This was an issue of particular concern to young people, given what they considered to be inadequate sex education in schools. However, those living in a rural community felt that if such provision was available locally, they would not access it for fear of being identified. Their local youth project (currently under threat of losing funding) was their means of support and advice, and acted as the main referral point to other services.

In another community, where most education, youth and leisure provision was segregated, cross-community provision was prioritised:

"We need more places like [project currently attending] where we are treated the same, regardless of religion, and where we are given a chance to mix." (Co. Tyrone, aged 12-15)

Young people and workers who had experienced difficulties in accessing appropriate provision for individuals raised the issue of poor mental health services:

> "I would say the last two months I've had an experience of tryin' to get somebody into a mental hospital and they've no beds. And then they say, 'Aww there's plenty of help out there', but there's *not* considerin' the help they need is to be locked up for a while with the counsellin' and whatever. But they can't get it because there's no beds. So they're sent home again. First thing they're goin' to do whenever they get to the house is top [kill] themselves, or do somethin' … you're waitin' on an appointment for maybe a month or two down the line. What's that person supposed to do that's mentally ill for a month or two?" (Co. Derry, aged 22: her emphasis)

Community representatives identified many gaps in support services for children and young people, particularly concerning mental health. In two communities, mothers whose children had taken their own lives had founded support services to meet the deficit in statutory provision. One reported the high incidence of self-harm within her community and lack of a support group or counsellors. Many community representatives noted limited provision of child and adolescent mental health services, inadequate support for parents concerned about their child's mental well-being, long waiting lists for counselling, lack of aftercare for those discharged from hospital and doctors who are inadequately trained to respond to depression and self-harm among children and young people. Reflecting on the relatively high incidence of depression among primary school children in the

community where she worked, a head teacher commented:

> "There is one child who is obsessed with death. He is very withdrawn and clearly depressed. The school is working with his mother to get him some help, but have been unsuccessful to date."

Given concerns about the emotional well-being of children and young people, a number of projects across the communities had attempted to provide support (often at the request of young people). This included: securing funding for community health workers; bringing specialists into youth projects to deliver sessions; commissioning counsellors; running specific programmes; working with young mothers in rural areas. Many noted lack of input from, and the narrow emphasis of, statutory service provision. The main problems were perceived to be "high levels of need" and "an under-resourced service". Consequently, services were reactive and crisis-based, delivered to those considered serious risks. Young people with non-acute mental health problems did not receive necessary services, leaving voluntary and community providers to deal with the deficit.

Barriers to provision of effective services and support for children and families

Assessing, identifying and meeting need

Adapting Hardiker et al.'s (1991) model of prevention in child care, children's services in Northern Ireland are based on four levels of provision:

- level 1: universal services 'for all' children, young people and families at all stages of a child's/young person's life;

- level 2: targeted early intervention programmes for children and families needing extra support, directed at children/young people perceived to be 'vulnerable' or 'at risk' (of abuse, neglect, offending);

- level 3: services and support for children and families needing intensive assistance, directed by one or more agency at children/young people 'in need in the community';

- level 4: specialised services for children and families in crisis who need urgent intervention, focusing on individual children/young people 'in need of rehabilitation' in which services are designed to prevent harm and provide a (usually residential) opportunity for intensive intervention.

Statutory provision targets levels 3 and 4. Early intervention work at levels 1 and 2 is generally provided by the voluntary and community sectors. Community representatives described how research in local communities had produced evidence of need, forming the foundation for successful funding applications and the appointment of workers to develop programmes to respond to identified need. A few noted disparities between how individuals or families defined their needs and how needs were assessed by professionals: "The biggest problem is adults thinking they know what young people want and trying to fit young people into it". According to another community representative:

"There are a lot of services there, but they are not being accessed. They are on parallel tracks - services are thrown at young people, but it isn't based on need. It's like pushing square pegs into round

holes. A more co-ordinated approach to working with families is needed, with services becoming more convergent to reach shared outcomes. There is not enough involvement of service users. Outcomes [that] professionals are aiming for and outcomes [that] young people and families are aiming for are different."

This person also noted difficulties in addressing the needs of young people who do not access, or have been excluded from, community-based services. For them, there is often a "divergence of services" and individuals become "stuck in a professional path" rather than being supported to access community-based provision. There were also disparities between perceived needs and actual services provided. Some described a "referral culture" through which "children and families are told: 'We'll refer you to a, b, and c, and they'll sort you out'." This approach had failed to engage children and families or effectively meet their needs.

Community representatives called for "diligence" when assessing young children's needs, leading to intervention and support at the earliest stage. Once need was identified, a "collective consideration of issues and use of resources" should follow. This should not be restricted by the school curriculum or priorities for health strategies. Decisions about allocation of resources should "protect families from changes in priorities and be sustained, with everyone working to the same ends". They should also be based on informed local knowledge to ensure that services are "designed and delivered in a way that meets the needs of the community". For this to happen, a strong representation of community-based representatives on management committees was required:

"They *know* where needs lie" and can limit "others starting to soften or cushion what could be done".

Some considered that needs were not met because of limited understanding about the lives of families. One example was the removal of children from lists, such as speech and language therapy, if they missed two appointments. This ignored the practical difficulties experienced by many parents in taking their children to appointments and gave the appearance "that need is decreasing when this is not the case". Another example was reluctance to report crime and/or anti-social behaviour due to fear of reprisals. This led to the community lacking support in responding to these issues: "No crime reported, therefore no resources to address the problem".

Adults across the communities reported gaps in specific provision, noting how this exacerbated poverty and disadvantage. Some commented on the difficulties involved in recruiting community-based health professionals such as dentists and GPs, particularly when these could earn higher salaries in the private sector. Others noted the absence of a strategic youth work policy. 15-16 year olds who were not attending school, who were involved in anti-social behaviour, who had difficult relationships with their families or were being threatened by 'paramilitaries' in their communities, were considered by one community representative to be "falling through the net" - statutory services were reluctant to work with these young people as they were not the responsibility of children's services once they reached 16.

Community representatives also discussed the need for provision to promote children's and young people's self-esteem. In one

community, this included introducing a range of programmes within a primary school to raise self-belief, confidence, and expectations. For young people it was considered that this should include provision of safe, non-judgemental spaces in which they could express and explore personal issues or "tell the stories of their lives". All community representatives emphasised relationship building, especially with parents. It was recognised that "the people who need most help don't step forward" because of low self-esteem, lack of confidence and difficulties in admitting that they require help:

> "Projects have to be very attractive and you have to build up relationships of trust, which is not easy. People say 'What are you going to do for me?' In any community there are people ready to move, but beneath that there are layers of people *not* in that state of readiness. You need to reach them incrementally … You can't force people to change – they have to grow into it. Alternatives and opportunities have to be created to enable them to see this is possible."

This representative argued that an "educative process" was necessary "for people to be fully engaged" - "guarantees and accountability can be built in" to this process and "increased responsibility would lead to power to change their lives". Two other community representatives raised the importance of "community knowledge":

> "We need to get back to a process of empowering by giving knowledge to people to change things themselves – trying to create a 'can do' culture."

It was the specified role of some organisations to support communities: "to move towards change and effect

that change themselves" by providing or facilitating access to training, helping them develop policies, supporting completion of funding applications, informing them about rights, advocating on their behalf when statutory duties were neglected.

Community representatives in three areas mentioned involvement in 'cross-community' projects but noted the sensitivity of this work, with one referring to it as "the hidden gem of the community". In one cross-community project it was concluded that "poverty and disadvantage transcend the sectarian divide – the conflict is an added dimension to poverty, not the be all and end all of it". Despite the value of this work, it was not promoted as an example of effective practice as there was often a lack of community support for such work.

As previously noted, structural poverty was identified as the main issue affecting these communities. This was perceived as "embedded … multi-generational … compounded in the area over time [without] help by government agencies", although the historical contexts of poverty and unemployment in each community were different. Across all communities, the transition from conflict had not led to noticeable structural change. At a 'regional' level, disparities in investment had persisted.

Financial, bureaucratic and procedural constraints

Funding constraints had a major impact on programmes and projects. On several occasions, funding had been received for specific programmes but not to pay salaries for the necessary workers. Within youth services, this had resulted in less detached youth work, a reduction in longer-term,

programme-based work and a decrease in one-to-one work with young people:

> "It is ironic that there is a perceived increase in anti-social behaviour among young people and at the same time a reduction in the amount spent on the youth service."

Many reported that programmes were increasingly funding-led, rather than needs-led. Thus, the focus of work shifted to meet changes in funding criteria, and workers attempted to alter the needs of the community/group to meet the demands of a different (and sometimes inappropriate) set of outcomes. Services based on identified need sometimes had to close or change focus. Often, the needs of children and young people were subsumed within an adult-defined funding agenda:

> "The type of work you do is dictated by funding … Now women and children are the focus for funders. Before, it was the elderly."

> "Every community group has anti-social behaviour on its agenda. This comes from the adult perspective."

Dependence on non-statutory funding also meant that much work was focused on 'topical issues' and current 'problems', the context of which was sometimes lost. During the process of transition in Northern Ireland, this increasingly prioritises "making the community ready for the next generation", in which funding is allocated to new groups, new initiatives, or new government programmes - with little reference to, or negotiation with, existing community groups.

The administrative demands of funding bids were considered time-consuming and frustrating:

"As a community worker, my role should be doing research, audits, finding out what the community want. But I spend my time office-based because of the amount of paperwork required by funders."

Information sought by funders often focused inappropriately on the numbers involved and 'hard', easily measurable outcomes rather than the quality of work carried out and 'soft' outcomes which make long-term contributions to people's lives but are less easy to evidence (such as raising self-esteem and confidence): "People become numbers, wards. The focus needs to return to *people*."

Organisations within communities were pushed into competition for scarce resources, endangering partnership working. The ability to pursue long-term strategic work was often compromised:

"Those with responsibility for resources are too caught up in creating and maintaining the pie that has to be shared out. What's needed is long-term, committed investment."

Lack of sustainable funding brought frustration, vulnerability and 'territoriality'. Significant time was spent searching for funding, trying to sustain projects and holding back information and ideas that could be shared:

"... people hide their best ideas as they don't want to lose out to someone else on the funding. There is a feeling that what we have, we hold – out of a scarcity culture."

"There is a lot of work going on in [community], but it all goes on behind closed doors – you don't know what others are doing ... because people

fear losing funding to others providing similar services."

Short-term and insecure funding had severe consequences for workers. Lack of job security and professional development opportunities resulted in declining staff morale and retention. A community representative stated: "Not much value is placed on staff and workers". Others noted the lack of training opportunities for part-time staff and volunteers. The contributions of volunteers required recognition and support to avoid resentment between volunteers and paid workers, who "may be able to attract more resources and training, while others are doing this work for free". Some areas had no full-time, qualified youth worker for substantial periods of time.

It was suggested that regulations concerning child protection, health and safety, and public liability inhibited work with children and families. Community representatives emphasised need for a greater 'balance' in regulations, less bureaucracy and more "space to deliver initiatives". One suggested that "top-heavy" regulations and procedures, unnecessary paperwork, inspections and assessment led to "families ... not being serviced in terms of good quality services". There was considerable disparity in understanding 'child protection'. Several community representatives provided examples about restrictions they perceived were being imposed by child protection guidelines:

"We are not building enough self-sufficiency skills in children. It is all about protection, but children need to take risks too."

While children and young people might be encouraged to act autonomously and

take risks, when they pursue 'self-sufficient' actions they are often demonised or perceived to require greater regulation.

There was also a perception that child protection policies had 'tipped the balance', to protect adults from allegations of abuse or harm rather than accommodating the best interests of children. This had created a climate of fear and self-regulation in adults' interactions with children, which could undermine children's protection:

> "There's no common sense … If a child falls and grazes her knee, you have to get her parents' permission to apply a plaster … if a child gets upset, you have to be careful how you comfort them … Policies are there for good reasons, but they've tipped the balance."

Volunteers also voiced concerns that reflected misconceptions:

> "Child protection has gone overboard … everyone is treated as a paedophile. You're not allowed to do anything … a child needs love but you're frightened to give a hug if a child is crying."

> "I was frightened to tie the shoe-laces of a 5 year old girl."

Sector ethos and partnership working

Among community representatives there was a perception that the statutory sector was dependent on voluntary and community sector provision:

> "[community] is one of the most deprived areas for child poverty out of 556 wards … but still the government and statutory sector are leaving it to the voluntary and community sector to devise means of responding to this. If

they were not there to do it, what would happen?"

Despite statutory sector representation on relevant committees, and audits of the work carried out, there was a reticence by Boards and Trusts to approve initiatives such as *community-based* education welfare provision. Community representatives suggested that the voluntary and community sectors should be more involved in committees making decisions about allocation of funding (currently dominated by the statutory sector).

While some considered the roles of the voluntary and statutory sectors had become increasingly blurred, others stated that the work of the sectors was different in ethos and principles. One community representative noted that voluntary sector organisations were "further down the road in terms of strengths-based models", emphasising a "philosophy of care and nurturing". Smaller voluntary organisations, however, had minimal infrastructural support, which affected workers' knowledge about: the local context, existing services, potential partnerships and sources of funding.

Community sector representatives highlighted the practical difficulties of partnership working between the statutory sector and voluntary/community sectors. Describing the introduction of a Neighbourhood Renewal Strategy, one stated:

> "The statutory bodies don't know what they can put into the pot. All the funding is put into one pot and the community are supposed to decide how to spend it. This is a sound concept. But the statutory sector is wanting to put as little in as they can. They know

how good communities are. There's a dependency on the voluntary and community sector."

Questioning the funding and management of 'extended schools', another community representative suggested a collaborative approach between schools and children's services planning would have been more appropriate: "then schools would have known what the areas of need were and tailored extended schools money accordingly". Another noted that use of different approaches and language by different service providers caused problems for service users.

Within each community, specific issues had consequences for partnership working. In one community, "There are lots of resources in the area, but they are not necessarily mapped or working together." This implied that partnership working was more a theoretical objective than a practical reality. In another community, a representative discussed lack of co-ordination: "Some groups don't talk or meet. They don't come together. There is a fear of losing their identity as a group. This makes it hard to push a partnership approach."

In two communities of the same cultural identity, members from different parts of the community neither trusted each other nor worked together. Thus organisations promoting community development became involved in "a parallel process" - working with each area separately but on the same set of agreed issues. This division resulted in difficulties finding 'neutral territory' for the location of facilities, which would otherwise be used only by people from the area in which they were situated. These divisions impacted on funding

applications, recruitment to programmes and opportunities for partnership working.

In some communities, poor relations between local residents and the police affected development of partnership working. For those involved in a community-based restorative justice scheme with young people in a Republican/Nationalist community, workers struggled to maintain local credibility (particularly since the introduction of guidelines requiring that the police should be passed information regarding criminal offences). Community representatives in a Loyalist/Unionist community considered that difficulties in building trust between the community and the police were exacerbated by: a high turnover of community police officers; ineffective communication by police officers towards young people and minimal involvement in youth activities; perceived lack of interest and action, insufficient resources and limited police powers; slow police response to emergency calls.

Positive links between schools and their local communities were considered vital, particularly in addressing the social and health needs of children and their parents. Suggested possibilities for improving and strengthening links between the community and the school (and thus improving support for families and children) included: a parent worker in each school; a link social worker in schools, where appropriate; location of speech and language therapy in schools; increased access to trained counsellors in schools; increased family support services in schools - accessing adults through their children; workshops for parents about the value of play as a developmental necessity.

Improving services for children and families: suggested ways forward

In communities "beleaguered by unemployment, poverty, depression, domestic violence", the capacity of parents to cope with everyday life as well as meet their children's physical, emotional, social and educational development was under constant pressure. Community-based workers had often worked with parents when they were children. They suggested that interventions should be family-focused, "working on a family basis and advocating for families to sow the seeds of change":

> "Spending time with the whole family to work out what the family need and not working on the deficit model because, in reality, most parents want the best for their children."

They emphasised preventative work rather than "immediate responses to problems". One worker described how "low intensity" programmes over a long period of time (for example, children from the same family attending summer camps) reduced tension within families. Early intervention also provided motivation and support for families to access services. One community representative suggested that organisations should "recognise the blocks they present to people coming through the door", and provide a "lead-in" to services.

The importance of acknowledging changing family structures and children's diverse experiences of family life were also discussed. This included the impacts of parental separation or divorce, parents' involvement with multiple partners and complex extended families. They emphasised promotion of self-esteem and

strengths of parents/carers – reinforcing the development of positive attitudes and aspirations:

> "Too often we start with a deficit model, with the idea that there is something wrong and, if we can get the funding, we can fix it. It is not just about having facilities. It's about facilities in the mind, and changing these."

In some communities, considerable work had been carried out over time with minimal positive impact on people's lives. Poverty levels had remained high, socio-economic differentials had remained constant and "a wider gap between the haves and the have-nots" had consolidated:

> "Huge resources are being poured into the area. But what are people getting for that? It's not impacting on people's lives ... we know it's not making any difference."

In rural areas, resources were not distributed evenly across communities. The "scattering of people", poor public transport, divisions between areas, and "possessiveness", made resource sharing difficult. Across all communities, partnerships between statutory services and voluntary/community projects were identified as vital for resource sharing.

Using resources for capacity-building was raised as a significant issue - to "create relationships with young people that ... aren't evident in other areas of their lives". This would establish the "groundwork before getting into programme-based work". While some considered that quality youth work need not be expensive, others stated that work on relationships was "not a cheap option", since it is "heavy in human resources".

As discussed previously, community representatives (as well as children and young people) commented that adults often viewed young people as a threat:

> "Adults are frightened of young people and frightened to say anything to them. People just stay indoors and hope they go away."

> "There needs to be more work between adults and young people to get rid of the fear and mistrust. It's like a vicious circle, where adults remain fearful of young people and children mistrust adults because of the way they treat them."

> "… everything is blamed on them [young people] and this stops people [adults] taking responsibility, control, moving forward. It's easier to sit back and say, 'We can't do anything'."

One youth worker stated: "the intergenerational gap is getting bigger – there is more fear among older people about young people and older people do not respect young people". Children were "not respected in many areas of their lives – there is a need for mutual respect to bridge the gap".

Efforts to include young people, and programmes provided for them, were not always based on what young people wanted. The focus on 'anti-social behaviour' in some areas had led to adult-defined programme development which started from an assumption that young people were a problem:

> "There is an ethos that identifies young people as a problem, to the extent that we build the euphemism of anti-social behaviour. It is all about punitive

responses and problem-solving – our values are all up the left."

While it was recognised that communities often experienced difficulties 'policing' young people, community representatives reiterated the importance of not solely focusing on behaviour while ignoring its context. It was acknowledged that, "some young people have power that can be harmful", but suggested that:

> "… no child burns out cars, or stabs someone if they're loved or have a connectedness with people or their community".

Despite some scepticism, positive interventions had been established to improve intergenerational relations and youth workers had developed strong relationships based on mutual respect with so-called 'hard to reach' young people. Many recognised the need for further development of intergenerational work, and there was a commitment to working towards greater understanding of, and respect for, young people.

In one Republican/ Nationalist community, the central role of voluntary youth leaders and community activists was acknowledged. These individuals worked with "the 'toughest young people' who don't want to know about statutory provision". As one community representative stated: "There was the pragmatic recognition that if they didn't work with young people and have the skills, charisma and desire to do so, the situation would not get any better". Community activists had also developed a local community initiative which included an Early Years Network and a Community Health Information Programme. They were involved in other initiatives, including: a Healthy Living Centre;

youth clubs; Sure Start; a Trust providing programmes, services, information, education and training to meet identified local needs; neighbourhood partnership; community forum; parent and toddler group; community groups and clubs.

Representatives in a Unionist/ Loyalist community highlighted how a core group of volunteers had worked on various, long-established community projects. With minimal support from within their community or statutory services, they had developed: a residents' association; an environmental action team; an after-school project; a neighbourhood renewal board; a youth centre; a community forum. Many of these individuals were now senior citizens and expressed concern about "getting others involved". They noted the time taken for projects to become established and accepted within communities:

> "When Sure Start first came to the area, residents wouldn't get involved. It has only taken off in the last year and it's been here for five years."

Representatives across the communities emphasised the importance of providing activities which were accessible at times, and in a form, that suited children and young people. Successful projects included a youth centre that opened six days a week, providing detached and programme-based work focused on raising young people's self-esteem and enhancing their personal development, and youth programmes that offered Youth Achievement Awards. Through these awards, young people received recognition for their work without a formal assessment. Other successes included: a late night soccer league; healthy eating classes; issue-based music and drama, leading to performances; film and pizza night; drop-in centres; accredited

educational and 'Citizenship' programmes; summer schemes throughout the holiday period.

Youth and community workers often used a "progressive participation" approach. Initially involving or 'recruiting' young people through detached work, they built teamwork skills through games, activities and sport, and used drama or group work as a starting point for enabling young people to express emotions without having to personalise them. This progressed to personal development work, providing programmes leading to formal qualifications or accreditation. Further programmes opened opportunities for young people to receive leadership/ coaching training or experience of volunteering.

Within the communities there was evidence of intensive, valuable community-based work by non-statutory organisations and individuals committed to community development. This work was consistently undermined by pressures to secure longer-term funding, retain experienced staff and secure professional development. Yet these were essential services delivering significant interventionist work based on sound relationships, especially with children and young people. The evidence presented here affirms the necessity of adequately resourced services that meet the needs of children and young people within communities experiencing the dual impacts of material deprivation and continuing conflict.

Key Issues

- *Children and young people felt that poor play/youth provision was an indication of their low status in communities.*

- Of those adults with whom they had regular contact, children and young people felt most respected by youth workers.

- Community/ youth projects acted as a local support service for children and young people. Individual workers often filled the void for those who lacked positive adult relationships.

- Children and young people considered they could be better supported through expanded community/youth provision, as well as improved quality of information and advice in schools.

- Young people noted the difficulties involved in recognising the signs of depression and poor mental health amongst their peers. Some stated that they were silenced by embarrassment or the stigma associated with poor mental health.

- A significant minority of children and young people had experienced the death of a relative, friend or acquaintance through suicide.

- Young people perceived a connection between boredom, low self-esteem, feeling down and use of alcohol or drugs as a means of filling time, increasing confidence or as a form of escape.

- Some community representatives related the high incidence of young people taking their own lives, self-harm and depression to emergence from conflict and young men lacking identity or status.

- Community and voluntary groups considered that they were expected to meet the deficit in local services.

- Programmes and projects for children/ young people were increasingly funding-led, rather than needs-led. Adult concerns, rather than those of children and young people, dictated funding agendas.

- Opportunities for qualified youth workers to utilise their skills were limited by time spent applying for funding and satisfying administrative demands made by funders.

- Insecure funding forced organisations within communities to compete for scare resources. This inhibited information sharing and partnership working.

- Short-term, insecure funding had many negative implications for organisations aiming to develop services in communities: limited opportunities to develop trust and build positive relationships; loss of foundational work; lack of sustainable, developmental work; sudden rather than gradual withdrawal of services; loss of confidence and difficulties in recruiting for future provision; difficulties recruiting and retaining workers and volunteers.

- Long-term, holistic, preventive programmes based on individual strengths were considered more valuable than 'crisis' or reactive interventions.

- Intergenerational relationships appeared to have worsened. Community representatives prioritised the need to develop mutual respect and understanding between children/young people and adult community members.

THE RIGHTS DEFICIT

Children's definitions of 'rights'

In 2007, the *Young Life and Times* survey of 16 year olds in Northern Ireland questioned their knowledge about children's rights (ARK 2008). Forty-nine per cent knew they had rights but had no knowledge of them, 41 per cent could 'list a few', 6 per cent stated they had no rights and 4 per cent knew 'a great deal about them'. In the focus groups, a few children and young people had "no idea" about children's rights. Others suggested that they had a broad understanding about rights, but could not be specific:

> "I know what rights are, but I don't have a clue what they are." (Co. Derry, aged 21)

> "You have rights alright, you're bound to … freedom of speech and that." (Co. Antrim, aged 15-20)

Some felt that, as children, they had no rights or that their rights were restricted:

> "We have no rights. Parents have the rights." (Co. Tyrone, aged 12-15)

> "Adults will only speak to their [childrens'] parents, not to them." (Co. Derry, aged 19)

They recognised that *adults* make decisions, including on children's behalf. One group concluded: "We don't have enough rights" (Co. Fermanagh, aged 13-15).

A significant number of children and young people living in Republican/ Nationalist communities mentioned "civil rights" without offering definitions. This was a term not used by those living in Loyalist/Unionist communities, reflecting political differences in conceptualising rights. 'Civil rights' were not perceived as relevant to *all* citizens but to those defined, or defining themselves, as oppressed and discriminated against.

Overall, there was a lack of consistency across communities in understanding rights. Only one group defined rights as entitlements. For others, rights expressed permitted actions:

> "Something you're allowed to do." (Co. Down, aged 10-11)

> "What we can do and what we can't do." (Co. Derry, aged 15-19)

> "It's what you've earned." (Co. Tyrone, aged 14-26)

These examples implied that rights were not perceived as universal and that others (adults) decide whether rights can be conferred, based on judgements about whether a child is competent, has behaved appropriately, or 'deserves' to be 'given' a right as a privilege.

Emphasis on rights as a contractual relationship was explicitly recognised by one group: "With rights there are responsibilities though" (Co. Tyrone, aged 12-15). Another group acknowledged the potential for competing rights: "But the person who is tellin' ye to go away when you're playing football, they also have rights to say, like, 'You're disturbin' us'" (Co. Derry, aged 15-19).

Several children defined rights by talking about what they fulfil: "A way of getting what you need"; "If people don't have rights, they don't live" (Co. Tyrone, aged 12-15). Such comments related mainly to survival rights and having basic needs met, which they did not perceive as relevant to *their* lives: "We don't have rights … People in the developing world have rights" (Co. Armagh, aged 9-15).

Others gave examples of specific rights such as unemployment or welfare benefits, the legal age for purchasing cigarettes and the right to have an opinion. One group listed rights that they thought people *should* have, implying that they did not have these rights. These included the right to:

> "Enter an area and feel you can go there."

> "March free anywhere without the PSNI or other people stoppin' ye."

> "Be free and left alone to be in peace." (Co. Derry, aged 8-14)

A few defined rights in terms of annoyance or dissatisfaction with actions perceived to be violations of their rights:

> "We shouldn't be allowed to get searched, no way."

> "I think we should be allowed to wear what we want to school. You're sweatin' in the blazer." (Co. Fermanagh, aged 13-15)

> "Do you mean like, say I was a couple of streets up from my street, someone would say 'You've no right to be running round this street 'cos you're not from here'?" (Co. Derry, aged 13)

This young person connected rights to broader social responsibilities: "Everybody looking out for everybody" (Co. Derry, aged 13).

While some articulated what they thought rights were, young people were conscious of having limited *formal* knowledge about children's rights: "Not sure what children's rights are, as we were never told" (Co. Tyrone, aged 12-15). Demonstrating that children did not learn about their rights because children's rights were ignored

within popular and political debate, one young woman commented:

> "I don't know my rights. I don't know *anything* about my rights … It's not a natural thing to think about. But I do think, if it was said more about – it's always ye hear about *adults'* rights, *civil* rights. That's all I've heard. You never hear nothin' about weans [children]. So why not say we'll give weans their rights and always have them on the news." (Co. Derry, aged 21: her emphases)

When addressed, as one group stated, discussion of children's rights was usually negative:

> "We might have heard of children's rights and the rights of teenagers - mainly because adults are always going on about how we have too many rights - but we know nothin' about any of it. That's the reality." (Co. Fermanagh, aged 16-21)

As illustrated, there was a lack of detailed understanding about the meaning of rights and limited knowledge about what rights children and young people have. Only one group defined rights as entitlements, with most associating them with rewards, responsibilities and restrictions. This illustrates how 'rights' have become defined in popular discourse, and how limited any discussion in schools had been. Only two young people had considered rights in school, through 'Learning for Life and Work'. Given their lack of knowledge, some concluded that 'knowledge about rights' should be a right for children and young people:

> "The right to know your rights." (Co. Derry, aged 22)

"I really think we should be entitled to know our rights, 'cos I don't know nothin', never did." (Co. Derry, aged 21)

In the 2007 *Young Life and Times* survey, 70 per cent of those surveyed had not heard of the *UN Convention on the Rights of the Child* (ARK 2008). It is a government responsibility to ensure that children and adults know about children's rights, the UNCRC and other international standards, yet the overwhelming majority of children and young people interviewed in this research had no knowledge of the Convention. Only 21 out of 136 (15 per cent) had heard of the Convention, usually via 'Learning for Life and Work' or 'Personal Development' lessons in school. Even fewer had heard of the Northern Ireland Commissioner for Children and Young People (NICCY) - only 7 out of 145 (5 per cent). Their knowledge of NICCY came through direct contact, attendance at an award ceremony or during a visit by the Commissioner to their school. This suggests that the children most likely to have their rights violated are those who are least likely to know about their rights.

Participation rights

In their discussions, children and young people felt strongly that their views should be taken into account:

> "Right to talk, express your views." (Co. Derry, aged 9-11)

> "To speak out. To have your say and not be told to be quiet." (Co. Armagh, aged 13-24)

> "The right to *speak*." ... "The right to talk to older people. People don't listen." (Co. Derry, aged 16-17: their emphasis)

One group termed this "freedom of speech", stating: "It is important but sometimes ye don't get it because nobody asks us what we have to say ... because people don't want to listen to ye" (Co. Derry, aged 15-19). Most groups reinforced the importance of being able to articulate views and ideas, *for themselves*. This included expressing an opinion, advocating on their own behalf, describing or explaining their emotions, and being involved in decision-making processes:

> "Right to have your own view." "We want to have our own opinion." (Co. Derry, aged 16-17)

> "The right to speak up, to speak your mind, to express your own opinion." (Co. Derry, aged 22)

> "You have the right to say something.'"

> "Everyone has the right to their own opinions."

> "You've the right to stick up for yourself."

> "To make up your own mind." (Co. Antrim, aged 10-13)

> "Right to let people know how you feel." (Co. Derry, aged 8-14)

> "Be able to make your own decisions." (Co. Down, aged 10-11)

Children and young people also emphasised the need to have their views taken into account: "Right to be listened to" (Co. Tyrone, aged 12-15); "A right to be heard" (Co. Derry, aged 8-14). They gave examples of lack of participation in decision-making in interpersonal relationships, often because their views were given no validity:

> "See, if you say anything to your mother and you're arguing with them, they don't pass any heed. They just tell you

to be quiet. They don't *listen* to your opinion." (Co. Armagh, aged 12-21: their emphasis)

"Whenever I got suspended, my Ma always took the teacher's side." (Co. Armagh, aged 12-21)

"Say if somethin' happened in school, you're tryin' to explain yourself: 'Shut up, shut up'." (Co. Derry, aged 16-17)

They noted that sometimes effort, or skill, were required on the part of adults – to listen, interpret and understand children on *their* terms:

"A right to be understood. Because sometimes people don't understand ye 'cos, like, you know what you're on about but some people don't. But you're tryin' your best to explain but sometimes they don't really be listenin'. So a right to be heard too." (Co. Derry, aged 8-14)

"Allowed to make mistakes and not be judged." (Co. Down, aged 10-11)

"We don't get enough opportunity to explain. Adults don't listen." (Co. Armagh, aged 9-15)

A lack of participation in one sphere of their lives inhibited young people's involvement in other spheres:

"A wile lot of children … can't speak out … they'd be afraid to speak their mind, frightened they'd be roared at … They think adults is just goin' to undermine them 'cos in the house their Ma and Pa tell them off." (Co. Derry, aged 19)

One group mentioned people who made an effort to listen to them. Usually these were adults who took time to understand the child's perspective:

"Responsible adults sometimes listen."

"One teacher understands us. He talks in your own language. He wants to know, to understand what you're saying."

"Sometimes your mum understands you." (Co. Armagh, aged 9-15)

Young people also discussed the importance of their involvement in community life and public decision-making processes: "To be part of your community, to participate in the community" (Co. Armagh, aged 13-24), particularly when decisions centred on allocation of funding:

"We have the right to see what happens in our town before it actually does. A new statue was built, which cost a lot of money, and an arcade opened, and we knew nothing about it. We could think of better things to spend money on." (Co. Tyrone, aged 12-15)

Some young people recognised the significance of having their views represented through voting:

"It doesn't matter about your rights anyway 'cos you can't vote, therefore you can't tell politicians … what you want, or that 'I have a right to do this' 'cos your voice isn't goin' to be heard." (Co. Derry, aged 15-19)

"… everyone should be allowed to vote because maybe the adults want somethin' different to what the children want. And it's their place to live too, it's not just their [adults] place." (Co. Antrim, aged 10-13)

A few suggested that the voting age should be lowered, in line with other social responsibilities:

"The right to vote at 16 'cos that's when you're supposedly an adult." (Co. Derry, aged 16-17)

"We should be able to vote at 16, because you leave school and you're more sensible. We know what's goin' on 'cos we're educated. We can't even vote until we're 18 and in that time we have to put up with all the shit that we don't even want here. And we have to put up with it 'til we're 18, and by the time that happens everyone probably doesn't even give a shit." (Co. Armagh, aged 12-21)

Many of the rights mentioned by children and young people related to civil rights and freedoms. The right to information was raised as an issue in relation to awareness about planned events and current circumstances: "A right to know what's goin' on around ye – information" (Co. Derry, aged 8-14). It was also important in terms of access to information, particularly as the basis for making informed decisions:

"To say what ye have to say and to ask questions and get information." (Co. Derry, aged 22)

"Advice and information. How are we expected to handle ourselves and take decisions an' all that if we don't have information. We get nothing like that from schools, nothing that matters to our lives." (Co. Fermanagh, aged 16-21)

A number of groups mentioned the right to freedom of religion:

"Churches for all religions." (Co. Down, aged 9-10)

This included personal choice:

"The right to stand up for your own religion." (Co. Antrim, aged 10-13)

Reflecting links between religious and cultural identity in Northern Ireland, and the signifiers of these identities, they felt

that children and young people should be able:

"To express your own culture" (Co. Fermanagh, aged 13-15)

"The right to wear your Celtic top without getting' a wile beatin'."(Co. Derry, aged 16-17)

"We should have freedom of speech, especially our religion and culture. You know, flags an' all." (Co. Fermanagh, aged 16-21)

While the freedom to practice their own religion was important for some, they did not necessarily want to spend time only with others who shared their religion: "A right to mix with Protestants" (Co. Derry, aged 8-14).

Freedom of association and peaceful assembly were key civil rights for all age groups:

"Freedom of movement." (Co. Derry, aged 8-14)

"Just people being able to stand about, to socialise and do stuff together." (Co. Fermanagh, aged 16-21)

As discussed earlier, young people on the streets often received verbal harassment:

"We want to go somewhere without bein' bawled at."

"The right to stand on the streets without gettin' gyp or slagged." (Co. Derry, aged 16-17)

Provision rights

Many children (7-13 year olds) across groups believed that children should have their basic needs met - food, water, shelter and clothing. Some groups described the

range of public services that should be available within any community:

> "Petrol stations, buses." (Co. Derry, aged 13)

> "Electricity … Street lights … Toilets … Safe bicycle lanes, next to road … Shops … Public transport." (Co. Down, aged 9-10)

> "Shops … a caravan site for Gypsies … hotel … school." (Co. Antrim, aged 9-11)

This included access to health services: "A Hospital" (Co. Derry, aged 13); "Doctors" (Co. Derry, aged 9-11). Some recognised the importance of mental health and well-being: "Make sure everyone's happy" (Co. Derry, aged 13) and one group recognised that expressing negative emotions could be healthy: "A right to be sad and not always have to hold it in but let it out" (Co. Derry, aged 8-14).

A few children and young people mentioned the right of children to accommodation:

> "Somewhere to go and stay."

> "Houses." (Co. Down, aged 9-10)

> "… somewhere to live." (Co. Antrim, aged 9-11)

> "Better opportunities, especially in work and housing." (Co. Fermanagh, aged 16-21)

Discussions of welfare and living standards generally related to the right of young people to work and receive decent wages. A group of 16-17 year olds considered the difficulties involved in combining education and paid work: "We should have the right to work. Well, you do have a right to work when you're 16. But it's hard to work when

you're 16 'cos you have your GCSEs" (Co. Derry, aged 16-17).

Those interviewed also considered education and school: "Children have the right to an education" (Co. Tyrone, aged 14-26). They recognised that this included a right to education beyond school through colleges and universities. Some focused on the content of education and matching work to ability and interest:

> "Right to learn what we want in school." (Co. Tyrone, aged 12-15)

> "The right to do whatever subject you want at school - I wasn't allowed to do History because I was too stupid." (Co. Armagh, aged 12-21)

> "Be given your own level of work." (Co. Down, aged 10-11)

Education that prepared young people for employment was considered important: "Practical education and proper jobs, full employment" (Co. Fermanagh, aged 16-21).

Restrictions on movement and clothing in school were raised in two groups:

> "Be able to go to the toilet during class."

> "To wear trousers in school."

> "She was suspended because of her hair." (Co. Derry, aged 12-15)

Some young people suggested that teachers were functional in their work. They questioned whether teachers respected confidentiality:

> "[Teachers] wouldn't care. They're just here to teach us."

> "They would tell other teachers. You couldn't trust them." (Co. Armagh, aged 9-15)

When considering what rights children and young people should have, most groups noted the importance of opportunities for relaxation, play and leisure:

> "You've a right to play football and enjoy your childhood." (Co. Derry, aged 15-19)

> "Play – swim, rugby, dance, skip, draw, climb trees, tennis." (Co. Antrim, aged 7-10)

> "To be able to go to places without rows – everyone allowed to go anywhere."

> "After school club and summer scheme."

> "Park, swimming pool, theme park, cinema, discos, beach parties, nightclubs – the right to play and have fun." (Co. Antrim, aged 9-11)

> "Exercise places, gym, swimming, museums, beach." (Co. Derry, aged 9-11)

> "Get activities and a residential place." (Co. Armagh, aged 12-21)

> "We just want somewhere to hang out, to sit and talk." (Co. Armagh, aged 9-15)

However, they noted that *safe* play areas were not always available for children, with play often inhibited by adults or unsafe physical environments:

> "Leisure time."

> "We have the time, but there's nowhere to do it." (Co. Fermanagh, aged 13-15)

> "We're not allowed to play football in the street or in the school." (Co. Derry, aged 9-11)

> "Freedom to walk down the street and sit wherever you want." (Co. Armagh, aged 13-24)

> "Some places aren't safe to go. Some people don't like children playing near where they live."

> "You aren't free to play. Other people stop you playing – teenagers hang around and bully you or say nasty things."

> "There's glass everywhere." (Co. Down, aged 9-10)

Protection rights

The right to protection against all forms of discrimination was raised by children and young people regarding their acceptance as individuals:

> "Right to be ourselves." (Co. Tyrone, aged 12-15)

> "Not to be stereotyped." (Co. Tyrone, aged 14-26)

> "A right to be yourself and not try to be like somebody else." (Co. Derry, aged 8-14)

Many considered that this linked to style, recognising that children, young people and adults often make assumptions about individuals solely based on their appearance:

> "People should be able to dress the way they want."

> "The first impression is what defines you."

> "Don't judge a book by its cover!" (Co. Derry, aged 8-14)

> "Not to be judged by the way you look."

"Wear what clothes you want, not what everyone else wears." (Co. Down, aged 10-11)

"Be your own person - look how you want, wear what you want." (Co. Fermanagh, aged 13-15)

Some groups discussed explicit age discrimination relating to being treated differently, or excluded, because they were young:

"Young people should have the same rights as older people." (Co. Derry, aged 16-17 years)

"The only way we can get old people to understand us is for us to change. And we shouldn't have to change." (Co. Armagh, aged 9-15)

"What we think too. Like, if we're gettin' left out and other people - older people - be heard and all, and you don't." (Co. Derry, aged 8-14)

As one group concluded, children should have the right: "To be included" (Co. Derry, aged 9-11).

One group noted perceived differences in protection provided by the police across communities. When asked whether they thought the Orange Order had a right to march, they responded:

"Not through Catholic areas. It's provokin'."

"Yeah, it's provocative to Catholics."

"They egg ye on as well. They have no right to be marchin' through a Nationalist area."

"And then, when there's a Catholic one [march], the cops appear and they take sides ... Protestants get all

the protection they want, and we get nothin'." (Co. Derry, aged 15-19)

This group accepted the Protestant community's right to express their culture, but considered that this should not compromise their right to safety. They also believed that the Catholic community should be afforded the same rights.

For children, protection rights were described as the right, "to be safe". Strategies for safety included practical suggestions such as: "Free telephones, for safety. So you can always ring your mum and let her know where you are, or call for help if you need it" (Co. Down, aged 9-10). One group perceived children's welfare to be a shared, social responsibility: "Older people to keep you safe - to watch out for you" (Co. Down, aged 9-10).

Children also raised the issue of the "Right to be loved and cared for" (Co. Derry, aged 8-14), and the right to a "Family" (Co. Derry, aged 13). In discussion, one group noted the tensions between protection and autonomy:

"A right to do what ye want to do and not to be so over-protected. Because sometimes your Mammy might treat ye like a wee baby and always want to know where ye are ... tell her that you're a certain age and should be treated differently."

"A right to have your own life too, your own independence." (Co. Derry, aged 8-14)

Discussions about safety concerned protection from violence on the streets, where children and young people should be safe at any time: "To be safe. To walk down the street whenever" (Co. Armagh, aged 13-24), and anywhere: "Space to enjoy

ourselves without being afraid of attacks" (Co. Fermanagh, aged 16-21). As noted in earlier chapters, violence and intimidation could be perpetrated by other young people: "Right to be safe – There'd be no lads on the streets that would stop ye and stuff" (Co. Armagh, aged 12-21). Violence, often alcohol-related, was also committed by adults: "Make sure they're don't be fighting, and drinking, and going mad on the street and fighting each other" (Co. Derry, aged 13).

While one group raised the issue of unwelcome regulation by the police: "Right to walk around town without being hit by thugs or targeted by police" (Co. Tyrone, aged 12-15), one young person suggested that there should be more local policing to reduce the influence of paramilitaries in some communities: "Keep the IRA out. Keep the police in to help people" (Co. Derry, aged 13).

Adults' discussion of children's rights

While community representatives were not asked specific questions relating to children's rights, the issue emerged during discussions. Some considered that children and young people knew about rights in relation to protection or provision entitlements:

> "The kids in here say to me, 'You're not allowed to hit me or I'm ringing Childline on you', so they know about rights and where to get help. They have some idea of what their rights are. They know what age they can smoke and drink at."

Overall, adults' discussion about children's rights was narrow and defensive. One community representative, for example,

commented that the first thing that comes into young people's or professionals' heads when they think of children's rights is "discipline and child protection". Rather than positive interpretations of children's entitlements to be cared for and protected from harm, children's rights were considered to have inhibited positive interaction between children and adults.

Demonstrating the contradiction between adults' beliefs and children's realities, a common element of their discussions was the perception that children 'take advantage' of rights, sometimes using them as a 'threat' (although this was usually in relation to an adult's anger and potential use of violence against the child):

> "They know their rights and would be quick to tell you so if you laid a hand on them."

> "A child said to me, 'You can't touch me or I'll get you done'."

One group of community representatives implied that children's knowledge about their rights underpinned the perceived negative behaviour and attitudes of young people:

> "Children are taught from an early age that children have rights. This is the problem … as soon as they go to Sure Start they see a poster on the wall telling them about their rights and this is how they're brought up today."

In contrast, community representatives in another area suggested that authoritarian attitudes prevailed, arguing that the key issue was adults' lack of respect for young people:

> "Young people are starting to realise they do have rights … But they've been brought up to do what they've been

told or get a smack for it. Respect is the issue. There's a lack of respect for young people – adults have to earn young people's respect."

Overall, there was a lack of informed understanding about children's rights mainly due to a lack of training for those working with, and for, children and young people, and a lack of information for children and young people themselves regarding their rights. There was a tendency among the adults interviewed to equate children's rights with child protection or barriers to effectively working and engaging with children and young people. Rather than using rights in a liberating way arguing that, as duty-bearers, they will only be able to meet their obligations and implement children's rights if they have the appropriate structures and resources to do so, they instead tended to be resistant to the notion, fearing personal implications.

KEY ISSUES

- *Few children and young people were familiar with the UN Convention on the Rights of the Child. Even fewer were aware of the existence of the Northern Ireland Commissioner for Children and Young People.*

- *Very few children and young people had learned about children's rights in school.*

- *Most children and young people considered they should have the right to form an opinion, express their views and have these taken seriously.*

- *Children and young people were generally not encouraged to express their opinions, describe or explain their emotions and behaviour. Nor were they involved in decision-making processes – either as*

individuals or as a social group within their communities.

- *Some young people acknowledged the significance of the right to vote and their exclusion from public decision-making until they reached 18. A few suggested that the voting age should be lowered to 16, consistent with other social responsibilities.*

- *Children and young people emphasised their right to age-appropriate information and its importance in informing decisions about their lives, opportunities and destinies. They felt they were denied access to appropriate information concerning sexual health, relationships and sexualities; mental health and well-being; education, training and employment opportunities; substance use.*

- *The right to practice their own religion and culture was important to many children and young people, especially outside their community.*

- *Many felt they should have the right to freedom of association and peaceful assembly. They did not consider it appropriate that their presence on streets and in other public spaces in their communities was regulated and controlled.*

- *Children considered that basic needs should be met, with a full range of public services available within all communities.*

- *Children and young people considered access to primary, secondary and tertiary education to be a universal right. They felt that the curriculum should be relevant to employment, and matched to interest as well as ability. They noted the negative impact of intransigent rules and tokenistic School Councils, raising the need for effective participation in school decision-making processes.*

- *The right to play, leisure and relaxation was considered important by children and young people of all ages. However, they noted that safe play areas were not always available. Leisure facilities were lacking, particularly for those aged 13 and above, for girls and young women, and for those living in rural areas.*

- *Children and young people felt discriminated against by appearance and age. They considered that they should be able to dress and adopt styles without being judged and stereotyped. They resented being treated differently, or excluded, because they were young.*

- *Children raised the rights to 'be safe' and to 'be loved and cared for'. For young people, discussions about safety concerned protection from violence – particularly on the streets, where they were susceptible to intimidation and violence perpetrated by other young people or adults.*

- *Community representatives generally mentioned children's rights negatively, suggesting that they inhibited interaction between children and adults because children 'used' rights as a 'threat' or because child protection placed restrictions on adults' responses to children.*

FINDINGS AND SUMMARY OF KEY ISSUES

Introduction

This community-based research project was established as a partnership between Queen's University, Save the Children and The Prince's Trust. The aim of the research was to understand and explore the lives of children and young people living in those communities in Northern Ireland enduring the legacy of the Conflict and persistent economic disadvantage. While the advances of the Peace Process, devolution to the Northern Ireland Assembly and the profile of human rights have been heralded internationally as positive indicators of transition from conflict to peace, progress at a political level has not been matched by progress within and between communities. This research project shows that the discourse of 'post' conflict is premature. Claims of 'peace' and 'transition' are not evident within the experiences of those living in marginalised, disadvantaged and under-resourced communities. Further, young people's views, experiences and behaviours have not been sought, understood or contextualised within political and popular debates. In a climate of economic, political and cultural uncertainty, poverty and severely limited opportunities have consequences for all aspects of children's lives. Those areas most affected by the Conflict are also those most economically deprived. The project has produced extensive data, drawn from in-depth qualitative research with children, young people and community representatives. It challenges positive assumptions made in official discourse and media commentaries that Northern Ireland as a 'society in transition' is making significant progress in promoting community development and safeguarding the rights of children and young people.

Chapter summaries and key findings

Images of children and young people

The interviews with children and young people clearly demonstrated their sensitivity to, and understanding of, negative labels ascribed to them. While they accepted that the behaviour of a small minority caused problems in their communities, for them as well as for adults, they carried a deep resentment that the atypical was presented as typifying the behaviour of all children and young people. They felt that children generally were viewed positively and supported within their families and communities. The major shift in how young people were perceived as they moved out of 'childhood', and the expectations placed on them in the home, in school and in the community, alongside a public climate of persistent rejection presented real difficulties in making this transition. Young people were viewed with suspicion, distrust and disrespect. Consequently their self confidence was undermined and often they felt worthless, depressed and even suicidal. Their negative experiences of emotional and physical development, including peer pressure to 'fit in', emphasised personal vulnerability.

Key Issues

- *Children considered that they were respected and supported within their families and communities.*

- *For many young people, rejection and exclusion by adults was a common experience in their families and in their communities.*

- *The expectations and responsibilities placed on young people, in the home, in school*

and in their community, were not matched by appropriate information, advice and support.

- *Young people described the difficulties they faced in the transition from 'childhood' to 'adolescence' – a period when they experienced physical and emotional change but a perceived loss of adult protection and support.*

- *Young people considered the labelling of their behaviour as 'anti-social' or 'criminal' by sections of the media to be an unfair and unfounded misrepresentation. This was deeply resented.*

- *In all focus groups conducted with children and young people, there was evidence of diminished self-esteem impacting on their emotional well-being. While some young people responded through being hostile, angry and volatile – often bolstered by alcohol – others withdrew into themselves.*

- *Well-conceived and adequately resourced intergenerational initiatives challenged negative reputations and stereotypes that prevailed within communities.*

- *Promotion and protection of children's rights is central to development of positive interventions, opportunities to challenge discrimination and stereotyping, secure free association, promote participation and create the conditions for good health and well-being among children and young people.*

Personal life and relationships

Children reported instances in which adults listened to their views and took them seriously. Yet the majority of children and young people noted that this was not the norm. Not being listened to or taken seriously impacted on their feelings of self-worth, safety and belonging. Making time for children and young people and not

judging them unfairly engendered respect and trust. It also provided constructive relationships between children/young people and adults. Mutual respect was key to positive relationships between children/young people and adults.

Key Issues

- *Children, more than young people, felt that adults were likely to listen to and respect their views.*

- *In their families and communities young people often felt pre-judged by adults, without having the opportunity to have their views or accounts taken into consideration.*

- *Children felt it was important to be consulted to ensure their safety. Young people believed they should be consulted because their views were as valid as those of adults.*

- *When children and young people were consulted and included in decision-making processes they felt respected, cared for and positive about themselves. Lack of consultation led to feelings of disrespect, exclusion, sadness and anger.*

- *Young people often explained negative or anti-social behaviour by some young people as a response to feelings of exclusion and rejection within their communities. This view was shared by a number of community representatives.*

- *Children and young people regularly identified an individual community or youth worker with whom they shared mutual respect. 'Trust', 'care' and 'understanding' were central to these relationships.*

- *Difficult circumstances experienced during childhood often led to individuals displaying violent and/or risky behaviours.*

For these young people, developing strong relationships with respected and trusted adults compensated for lack of family support.

- *Community representatives noted the dual impact of poverty and the legacy of the Conflict on families. 'Transgenerational trauma', low incomes and 'multi-generational poverty', poor health and well-being each impacted on parents' ability to cope and form positive relationships with their children.*

- *It was not unusual for support services to work with adults whose parents they had supported previously, illustrating the significance of transgenerational trauma and multi-generational poverty.*

Education and employment

Within the context of many young people's lives, formal education was considered stifling and irrelevant. While there were few job opportunities, the desire to leave school to enter paid employment (regardless of pay, conditions or security) was inevitable. Yet, for many, the only available options were courses, schemes and low-paid employment. Young people had a clear understanding of their 'place' in the economic/employment market and most did not have aspirations beyond the experiences of family members or people within their local communities. For some, school experiences had damaged their self-esteem, capacity to learn and ambition. They reported more satisfactory educational experiences in colleges and informal education settings, where teaching methods and the environment were less formal, more accommodating of individual needs and interests, and inspired greater confidence.

Key Issues

- *Family and community were identified as key factors in shaping children's educational experiences and aspirations.*

- *Identified inhibitions on attainment included: lack of appropriate resources; the low value placed on education in some families and communities; poor quality vocational education/training; limited job opportunities within local areas.*

- *Approximately half of the children and young people interviewed disliked school or considered it irrelevant. Their 'rejection' of school focused on school culture, teaching methods and the perceived lack of significance of subjects studied.*

- *Many felt that school did not adequately prepare them for adult life. They were particularly critical of careers advice, sex and relationships education, lack of opportunities to explore emotions and feelings in a safe and trusting environment.*

- *Children were considerably more positive about their relationships with teachers than young people.*

- *Young people often felt powerless in school, believing that they were silenced, judged and misunderstood by teachers.*

- *Many young people had experience of School Councils, but recorded a range of limitations, including: minimal influence and impact; tokenism; poor feedback about decisions; some issues being defined as 'off-limits'; teachers having the 'final say'; selective representation of pupils.*

- *Despite the presence of school counsellors or pastoral care teams, many young people were reticent to share information with these staff because they believed their confidentiality would be compromised.*

- *On completion of compulsory education, many young people attended schemes and courses with limited employment prospects. Employment opportunities were more restricted in rural communities.*

- *Employment aspirations and outcomes were generally low and related to whatever jobs were available in local communities. Formal education was not considered necessary for most locally available work opportunities.*

Community and policing

The impacts of the Conflict (including death, injury and fear) were recent experiences within the communities. Distrust of the police persisted and the much-publicised benefits of 'peace' were not evident to children, young people or community representatives. Frustration, anger and resentment were directed towards the rhetoric of 'peace' and 'change' as communities attempted to address the legacy of the Conflict without necessary resources. Concern about the perceived 'anti-social' behaviour of young people was considered to have encouraged a climate of demonisation and marginalisation. During a complex period of transition from conflict, segregation and sectarianism between and within communities continued. Those interviewed believed that the police and politicians were out of touch with the views and experiences of their families and communities. Young people, in particular, were resentful about what they considered discriminatory policing as a consequence of their age.

Key Issues

- *Many community representatives and young people expressed frustration that the Peace Agreements had not brought significant change. They believed that the impact and legacy of the Conflict had been*

ignored, and that communities have been left without necessary economic and social support.

- *It was recognised by young people and community representatives that many young people were confused about their cultural identities and did not understand the implications of transition from conflict.*

- *For working class young men with an unambiguous, strong cultural and community identity, there was a collective sense of loss – formal education was not valued, local work opportunities were declining with few alternatives, and their cultural identities were felt to be under-valued.*

- *Some young men responded to these dramatic changes in employment and social opportunities, and their lack of status, through violence. They asserted their sectarian identity to defend a culture they believed was under threat.*

- *Children and young people believed they were purposefully excluded and marginalised in their communities. They were not invited to community forums or meetings and were not consulted in decision-making processes.*

- *Young people expressed frustration about feeling 'unwanted' in 'their' communities.*

- *Community representatives believed there was a 'policing vacuum', particularly regarding the challenging behaviour of some young people.*

- *Community representatives and young people expressed disillusionment with the police, who were considered unwilling, unable or ill-equipped to deal with community concerns.*

- *Police tactics had done little to generate trust or respect. Young people reported being 'moved on', 'goaded', 'threatened' and 'harassed' – sustaining a climate of mistrust and confrontation.*

- *Young people across all six communities were united in the view that they were policed differentially and unfairly because of their age.*

Place and Identity

Despite the media-reported view that children and young people are 'disconnected' from their communities, most displayed a definite attachment to, and care for, the place in which they lived. While recognising problems associated with their community, they emphasised its improvement, rather than abandonment. Personal identity was strongly linked to place. For some this related to particular streets or parts of the community. The local and historical meaning of space created divisions and areas of difference *within* communities. This had consequences for identity and reputation, the use of facilities and services, and for feelings of safety and belonging.

Key Issues

- *The problems identified in all six communities centred on lack of adequate play and leisure facilities, street fighting/ violence, alcohol use and the general condition of the local area.*

- *Those in rural areas experienced exclusion from play and leisure services due to remote location and inadequate, affordable transport.*

- *For children, positive aspects of their communities included play facilities, friendships and feeling safe.*

- *For young people, positive aspects of their communities included familiarity with the place and proximity to family and friends.*

- *Older young people expressed concern that they would be forced to leave their communities to find employment, ending the availability of extended family support for those making the transition to independent living.*

- *Over time, housing policies and population movement had given neighbourhoods or clusters of streets distinct identities and reputations. Children and young people positioned themselves according to such known divisions within communities, often drawing distinctions between 'rough' and 'respectable' neighbourhoods or streets.*

- *Those living in the same locality had distinctive and contrasting experiences as a consequence of internal divisions within communities.*

- *The location and management of services, even in communities with a shared cultural identity, affected take-up – leading to experiences of exclusion or marginalisation amongst those who felt that 'their' local area had not been appropriately resourced.*

Segregation and sectarianism

Every aspect of the lives of children and young people was defined by division – their identities, communities, schools, social networks, sporting activities and use of free-time. Notions of difference were perpetuated by a lack of inter-community contact and understanding. Segregated education and housing remained a significant barrier to ending sectarianism, often actively ensuring its continuation. Territorial 'ownership' of space and the use of violence to assert cultural identity went beyond the religious divide. Resentment

towards 'new cultures' represented a fear that they would dilute the 'host identity' and further restrict employment or housing opportunities for 'local young people'.

Key Issues

- *Children and young people from all six communities considered sectarianism to be a significant issue affecting their lives.*

- *Children and young people were 'badged' by the places they occupied; often feeling 'imprisoned' within their communities.*

- *Fear of being identified as 'the other' limited opportunities (freedom of movement, opportunities for play and leisure, social relations) and impacted on children's/young people's feelings of safety.*

- *Perceptions about 'the other community' were formed long before children and young people met someone of 'the other religion'.*

- *Limited exposure to those outside their community, and strong sectarian beliefs within communities, consolidated negative attitudes about 'the other community'.*

- *Rioting and sectarian clashes symbolised a means of asserting cultural identity and were described as responses to perceived inequalities.*

- *'Concessions' to one community were viewed as 'punishments' to the other. This created a sense of unfairness, insecurity and increased resentment towards 'the other community'.*

- *Children and young people were critical of cross-community projects based on minimal social interaction and no long-term plans for maintaining contact. Projects with a starting point of commonality, rather than difference, were better received and involvement in such projects was felt to have been beneficial.*

- *Children and young people across the religious divide shared negative views towards foreign nationals.*

- *Territorialism, uncertainty and insecurity at a time of transition for established populations exacerbated the difficulties faced by foreign nationals residing in small close-knit communities.*

Violence in the context of conflict and marginalisation

The violent past of Northern Ireland remains celebrated, glorified and 'normalised'. Murals, commemorative events, parades and stories act as reminders of institutional and interpersonal violence. Cultural violence is reproduced in the language of opposition politics, the direct experiences of families and communities, the segregation and marking of space. Violence has remained a part of everyday life for children and young people living in communities defined by uncertainty, unease and the continued presence of paramilitaries or dissidents. These individuals continued to prey on vulnerable young people lacking status, identity, self-worth and a sense of belonging. They incited violence and sectarianism. Links between violence, boredom, frustration, lack of power and respect – together with a precarious material position at a time of economic, political and cultural uncertainty – were part of the complex mix underpinning the violent behaviour of some young people and adults in the six communities.

Key Issues

- *Many children and young people were exposed to community violence, sectarian violence, rioting against the police, paramilitary-style threats and punishments.*

- *The perceived anti-social behaviour of young people made them targets for those who continued to ascribe themselves paramilitary status.*

- *While children and young people felt threatened and intimidated by violence in their communities, they were resigned to its presence.*

- *As a by-product of being on the streets at night and weekends when (reportedly) there was more 'fighting', young people regularly experienced or witnessed violence.*

- *Violence impacted on children's and young people's feelings of safety, their freedom of movement, opportunities for play and levels of victimisation.*

- *A connection was made by children, young people and community representatives between boredom, alcohol use and violence. Alcohol use was a concern in rural areas and in communities where few facilities for young people existed.*

- *Alcohol was often used by young people as an escape from boredom and the difficulties of life. Yet its use often increased the likelihood of experiencing violence and emotional distress.*

- *Some young people exerted power over children, threatening and intimidating them. This was consistent with young people's experiences of adult power.*

- *Violence was deemed by some young people to be a legitimate response in defending cultural identity.*

Services and support

Transition from conflict had not led to noticeable structural change within the six communities. Disparities in investment persisted, with gaps in provision exacerbating poverty and disadvantage. Representatives from the community and voluntary sectors considered that statutory services depended on non-statutory provision to meet identifiable local need – developing essential services based on understanding of the local contexts/issues and respectful relationships with children, young people and their families. Despite the value of this work, non-statutory services were generally: under-funded and unrecognised; insecure and short-term; influenced by funding agendas and heavily bureaucratised. Lack of investment in local services was expressed as evidence of the low value placed on children, young people, community/youth work and communities in need.

Key Issues

- *Children and young people felt that poor play/youth provision was an indication of their low status in communities.*

- *Of those adults with whom they had regular contact, children and young people felt most respected by youth workers.*

- *Community/youth projects acted as a local support service for children and young people. Individual workers often filled the void for those who lacked positive adult relationships.*

- *Children and young people considered they could be better supported through expanded community/youth provision, as well as improved quality of information and advice in schools.*

- *Young people noted the difficulties involved in recognising the signs of depression and poor mental health amongst their peers. Some stated that they were silenced by embarrassment or the stigma associated with poor mental health.*

- *A significant minority of children and young people had experienced the death of a relative, friend or acquaintance through suicide.*

- *Young people perceived a connection between boredom, low self-esteem, feeling down and use of alcohol or drugs as a means of filling time, increasing confidence or as a form of escape.*

- *Some community representatives related the high incidence of young people taking their own lives, self-harm and depression to emergence from conflict and young men lacking identity or status.*

- *Community and voluntary groups considered that they were expected to meet the deficit in local services.*

- *Programmes and projects for children/ young people were increasingly funding-led, rather than needs-led. Adult concerns, rather than those of children and young people, dictated funding agendas.*

- *Opportunities for qualified youth workers to utilise their skills were limited by time spent applying for funding and satisfying administrative demands made by funders.*

- *Insecure funding forced organisations within communities to compete for scare resources. This inhibited information sharing and partnership working.*

- *Short-term, insecure funding had many negative implications for organisations aiming to develop services in communities: limited opportunities to develop trust and build positive relationships; loss of foundational work; lack of sustainable, developmental work; sudden rather than gradual withdrawal of services; loss of confidence and difficulties in recruiting for future provision; difficulties recruiting and retaining workers and volunteers.*

- *Long-term, holistic, preventive programmes based on individual strengths were considered more valuable than 'crisis' or reactive interventions.*

- *Intergenerational relationships appeared to have worsened. Community representatives prioritised the need to develop mutual respect and understanding between children/young people and adult community members.*

The rights deficit

Children and young people lacked understanding about the meaning of rights, and had received limited formal information about children's rights. Many associated rights with privileges, responsibilities and restrictions, illustrating how rights have become defined as transactional in popular discourse. Children and young people clearly articulated rights to which they felt entitled. Yet they provided examples illustrating how their rights were not promoted or protected at home, in schools, and in communities. This revealed a gap between the rhetoric of children's rights contained within policies and political discourses and the reality of their lived experiences. Adults tended to associate children's rights with child protection or barriers to effectively working and engaging with children and young people.

Key Issues

- *Few children and young people were familiar with the UN Convention on the Rights of the Child. Even fewer were aware of the existence of the Northern Ireland Commissioner for Children and Young People.*

- *Very few children and young people had learned about children's rights in school.*

- *Most children and young people considered they should have the right to form an opinion, express their views and have these taken seriously.*

- *Children and young people were generally not encouraged to express their opinions, describe or explain their emotions and behaviour. Nor were they involved in decision-making processes – either as individuals or as a social group within their communities.*

- *Children and young people recognised that effort, time and communication skills were required by adults - to listen, interpret and understand children's views, experiences and actions.*

- *Some young people acknowledged the significance of the right to vote and their exclusion from public decision-making until they reached 18. A few suggested that the voting age should be lowered to 16, consistent with other social responsibilities.*

- *Children and young people emphasised their right to age-appropriate information and its importance in informing decisions about their lives, opportunities and destinies. They felt they were denied access to appropriate information concerning sexual health, relationships and sexualities; mental health and well-being; education, training and employment opportunities; substance use.*

- *The right to practice their own religion and culture was important to many children and young people, especially outside their community.*

- *Many felt they should have the right to freedom of association and peaceful assembly. They did not consider it appropriate that their presence on streets and in other public spaces in their communities was regulated and controlled.*

- *Children considered that basic needs should be met, with a full range of public services available within all communities.*

- *Children and young people considered access to primary, secondary and tertiary education to be a universal right. They felt that the curriculum should be relevant to employment, and matched to interest as well as ability. They noted the negative impact of intransigent rules and tokenistic School Councils, raising the need for effective participation in school decision-making processes.*

- *The right to play, leisure and relaxation was considered important by children and young people of all ages. However, they noted that safe play areas were not always available for children. Leisure facilities were lacking, particularly for those aged 13 and above, for girls and young women, and for those living in rural areas.*

- *Children and young people felt discriminated against by appearance and age. They considered that they should be able to dress and adopt styles without being judged and stereotyped. They resented being treated differently, or excluded, because they were young.*

- *Children raised the rights to 'be safe' and to 'be loved and cared for'. For young people, discussions about safety concerned protection from violence - particularly on the streets, where they were susceptible to intimidation and violence perpetrated by other young people or adults.*

- *Community representatives generally mentioned children's rights negatively, suggesting that they inhibited interaction between children and adults because children 'used' rights as a 'threat' or because child protection placed restrictions on adults' responses to children.*

Cross-cutting themes

The following themes emerged from the research and are evident in a range of chapters:

- How children were perceived and respected by adults - in families, their communities and service provision – significantly affected their responses and behaviour.

- Lack of respect and age discrimination remained prevalent at every level in the lives of children and young people, emphasising and exacerbating negative intergenerational relationships in communities and in institutions.

- Lack of participation in the decisions that affected their lives, interpersonally and institutionally, led to children and young people feeling undermined, unimportant, excluded and resentful.

- Family and community experiences had a significant, often defining, impact on the lives of children and young people in terms of education and employment, culture and identity, opportunities and inhibitions.

- The persistence of separatism generated social isolation. This impacted on the opportunities and aspirations of children and young people and contributed to negative attitudes and responses towards others. Segregated education and housing create insurmountable barriers to ending sectarianism and actively ensure its continuation.

- Relationships between children/young people and significant adults were vital. Mutual respect was considered essential to positive relationships, and was dependant on adults listening to children and young people,

understanding the contexts of their lives, and advocating on their behalf.

- Social injustice and material deprivation were determining, structural contexts that affected the opportunities available to children and young people, inhibiting their potential and aspirations.

- Despite a powerful rhetoric to the contrary, within communities and in service provision children's rights standards were not understood or realised. This resulted in a serious rights deficit in most aspects of children and young people's lives.

- Perceptions about, and the reality of, young people's anti-social behaviour required more thorough understanding. Individualising 'bad' behaviour, pathologising young people and demanding more authoritarian measures, not only failed to consider the structural, cultural and sectarian contexts of violence but also escalated the potential for conflict and confrontation.

Table 1: Sample of Children and Young People

	8-12 yrs	13-17 yrs	18-25 yrs	TOTAL
Co. Antrim	21	8	10	39
Co. Armagh	3	26	4	33
Co. Derry	18	29	6	53
Co. Down	33	–	–	33
Co. Fermanagh	-*	18	1	19*
Co. Tyrone	1	16	2	19*
TOTAL	76	97	23	196

*relatively small numbers reflect the size of communities and the proportion of children and young people living within each

REFERENCES

ARK (2008) *Northern Ireland Young Life and Times Survey 2007* Belfast: ARK (available: www.ark.ac.uk/ylt/2007/Rights).

Blair, T. (2002) 'My vision for Britain' *The Observer,* 10 November.

Byrne, D. (1999) *Social Exclusion* Milton Keynes: Open University Press.

Byrne, J., Conway, M. and Ostermeyer, M. (2005) *Young People's Attitudes and Experiences of Policing, Violence and Community Safety in North Belfast* Belfast: Northern Ireland Policing Board.

Chief Medical Officer (1999) *Health of the public in Northern Ireland: report of the Chief Medical Officer, 1999: Taking care of the next generation* Belfast: DHSSPS.

Chief Medical Officer (2007) *Your Health Matters. The Annual Report of the Chief Medical Officer for Northern Ireland 2006* Belfast: DHSSPS.

Cohen, S. (1972) *Folk Devils and Moral Panics* London: MacGibbon and Kee.

Crawford, A. and Lister, S. (2007) *The use and impact of dispersal orders* Joseph Rowntree Foundation Findings (available: www.jrf.org.uk/sites/files/jrf/2135.pdf).

DENI (Department of Education Northern Ireland) (2008) *Enrolments at schools and in funded pre-school education in Northern Ireland 2007-08* Statistical Press release, DENI, 26 February.

DHSSPS (Department of Health, Social Services and Personal Safety) (2005a) *Number of Admissions of Young People to Adult Wards and Bed Days Occupied across the Region 2003-2005* Belfast: DHSSPS.

DHSSPS (Department of Health, Social Services and Personal Safety) (2005b) *Care At Its Best*, October 2005, Belfast: DHSSPS.

DHSSPS (Department of Health, Social Services and Personal Safety) (2006) *Protect Life. A Shared Vision: the Northern Ireland Suicide Prevention Strategy and Action Plan 2006-2011* Belfast: DHSSPS.

Donoghue, J. (2008) 'Antisocial Behaviour Orders (ASBOs) in Britain: Contextualizing Risk and Reflexive Modernization' *Sociology*, Vol 42, No 2, pp337-355.

Ellison, G. (2001) *Young People, Crime, Policing and Victimisation in Northern Ireland* Belfast: Institute of Criminology and Criminal Justice Queens University.

Ewart, S. & Schubotz, D. (2004) *Voices behind the Statistics: Young People's Views of Sectarianism in Northern Ireland* London: NCB.

Fay, M., Morrissey, M. & Smyth, M. (1998) *Mapping troubles-related deaths in Northern Ireland 1969-1998* Derry/Londonderry: INCORE, (2nd edition).

Fortin, J. (2003) *Children's Rights and the Developing Law* London: LexisNexis, (2nd edition).

France, A. (2007) *Understanding Youth in Late Modernity* Berkshire: Open University Press.

France, A., Bendelow, G. and Williams, S. (2000) 'A 'risky' business: researching the health beliefs of children and young people' in A. Lewis and G. Lindsay (eds.) *Researching Children's Perspectives* Birmingham: Open University Press, pp151-162.

Franklin, B. (2002) 'Children's rights and media wrongs: changing representations of children and the developing rights agenda' in B. Franklin (ed) *The New Handbook of Children's Rights. Comparative Policy and Practice* London and New York: Routledge, pp15-42.

Freeman, M. (2000) 'The future of children's rights' *Children and Society*, Vol 14, No 3, pp.277-293.

Freeman, M. (2007) 'Why it remains important to take children's rights seriously' *International Journal of Children's Rights,* Vol 15, No 1, pp5-23.

Garrett, P. M. (2007) 'Making 'Anti-Social Behaviour': A Fragment on the Evolution of 'ASBOS Politics in Britain'' *British Journal of Social Work,* Vol 37, pp839–856.

Geraghty, T., Bleakey, C. and Keane, T. (1997) *A Sense of Belonging: Young People in Rural Areas in Northern Ireland Speak about their Needs, Hopes and Aspirations* Belfast: YouthAction Northern Ireland.

Gilligan, C. (2006) 'Traumatised by Peace? A Critique of Five Assumptions in the Theory of Conflict-Related Trauma' *Policy and Politics,* Vol 34, No 2, pp325-345.

Gil-Robles, A. (2005) *Report by Mr Alvaro Gil-Robles, Commissioner for Human Rights, on his visit to the United Kingdom 4th – 12th November 2004 for the attention of the Committee of Ministers and the Parliamentary Assembly,* 8 June 2005, Strasbourg: Office of the Commissioner for Human Rights, CommDH(2005)6.

Goldson, B. (2000) 'Wither Diversion? Interventionism and the New Youth Justice' in B. Goldson (ed) *The New Youth Justice* Dorset: Russell House, pp35-57.

Goode, E. and Ben-Yehuda, N. (1994) *Moral Panics: The Social Construction of Deviance* Cambridge USA: Blackwell.

Gray, P. (2007) 'Youth Justice, Social Exclusion and the Demise of Social Justice' *The Howard Journal,* Vol 46, No 4, pp401-416.

Hall, T., Coffey, A. & Williamson, H. (1999) 'Self, Space and Identity: Youth Identities and Citizenship' *British Journal of Sociology of Education,* Vol 20, No 4, pp501-513.

Hamilton, J., Radford, K. and Jarman, N. (2003) *Policing, Accountability and Young People* Belfast: Institute for Conflict Research.

Hansson, U. (2005) *Troubled Youth? Young People, Violence and Disorder in Northern Ireland* Belfast: Institute for Conflict Research.

Hardiker, P., Exton, K. and Barker, M. (1991) *Policies and Practices in Preventive Child Care* Aldershot: Avebury.

Harvey, C. (2003) 'On Law, Politics and Contemporary Constitutionalism' *Fordham International Law Journal,* Vol 26, No 4, pp996-1014.

Haydon, D. (2007) *United Nations Convention on the Rights of the Child. Consultation with Children and Young People* Belfast: OFMDFM.

Haydon, D. (2008) *Northern Ireland NGO Alternative Report: Submission to the United Nations Committee on the Rights of the Child for consideration during the Committee's scrutiny of the UK Government Report (July 2007)* Belfast: Save the Children Northern Ireland and Children's Law Centre Belfast (available: www.childrenslawcentre.org).

Haydon, D. & McAlister, S. (2009) *An Independent Analysis of Responses to the Department of Education's 'Priorities for Youth' Consultation* Belfast: DENI
(available: www.deni.gov.uk/index/19-youth_pg/19-priorities-for-youth.htm).

Henderson, S. (2007) 'Neighbourhood' in M. Robb (ed) *Youth in Context: Framework, Setting and Encounters* London: Sage/OUP, pp123-154.

Hillyard, P., Rolston, B. and Tomlinson, M. (2005) *Poverty and Conflict in Ireland: An International Perspective* Dublin: Institute of Public Administration/ Combat Poverty Agency.

Horgan, G. (2005) 'Why the Bill of Rights should protect and promote the rights of children and young people in Northern Ireland. The particular circumstances of children in Northern Ireland' in G. Horgan and U. Kilkelly *Protecting children and young people's rights in the Bill of Rights for Northern Ireland. Why? How?* Belfast: Save the Children and Children's Law Centre, pp2-17.

Horgan, G. (2007) *The impact of poverty on young children's experience of school* York: Joseph Rowntree Foundation (available: www.jrf.org.uk/sites/files/jrf/2146.pdf).

Horgan, G. (2009) *Speaking Out Against Poverty* Belfast: Save the Children.

Horgan, G. and Kilkelly, U. (2005) *Protecting children and young people's rights in the Bill of Rights for Northern Ireland. Why? How?* Belfast: Save the Children and Children's Law Centre.

Include Youth (2004) *Response to Measures to Tackle Anti-Social Behaviour in Northern Ireland Consultation Document* Belfast: Include Youth.

Jamieson, R. and Grounds, A. (2002) *No Sense of an Ending: The effects of long-term imprisonment amongst Republican prisoners and their families* Monaghan: SEESYU Press Ltd.

Kilkelly, U. (2008) *Children's Rights in Ireland. Law, Policy and Practice* Dublin: Tottel Publishing.

Kilkelly, U. et al. (2004) *Children's Rights in Northern Ireland* Belfast: NICCY.

Kitzinger, J. (1995) 'Qualitative Research: Introducing Focus Groups' *British Medical Journal,* No. 311, pp299-302.

Kohl, H. (1993) 'In Defense of Public Education: Can It Be Saved?' *Dissent,* Spring, pp226-232.

Kuusisto, A. (2001) 'Territory, Symbolism and the Challenge' *Peace Review,* Vol 13, No 1, pp59-66.

Leitch, R. and Kilpatrick, R. (1999) *Inside the gates: Schools & the troubles* Belfast: Save the Children.

Leonard, M. (2004) *Children in Interface Areas: reflections from North Belfast* Belfast: Save the Children.

Magadi, M. and Middleton, S. (2007) *Measuring Severe Child Poverty in the UK* London: Save the Children.

Mayall, B. (1994) 'Introduction' in B. Mayall (ed) *Children's Childhoods Observed and Experienced* London: Falmer, pp1-12.

McAlister, S., Gray, A. and Neill, G. (2007) *Still Waiting: The stories behind the statistics of young women growing up in Northern Ireland* Belfast: YouthAction Northern Ireland.

McClelland, R. (2006) *The Bamford Review of Mental Health and Learning Disability (Northern Ireland): A Vision of a Comprehensive Child and Adolescent Mental Health Service,* July 2006, Belfast: DHSSPS.

McGrellis, S. (2004) *Pushing the Boundaries in Northern Ireland: Young People, Violence and Sectarianism* London: Families and Social Capital ESRC Research Group.

McKittrick, D., Kelters, S., Feeney, B. and Thornton, C. (1999) *Lost Lives: The stories of the men, women and children who died as a result of the Northern Ireland troubles* Mainstream Publishing: Edinburgh.

McLaughlin, E. and Monteith, M. (2006) *Child and Family Poverty in Northern Ireland* Belfast: OFMDFM Equality Directorate Research Branch.

Mika, H. (2006) *Community-based Restorative Justice in Northern Ireland* Belfast: Institute of Criminology and Criminal Justice, Queen's University.

Millward Brown Ulster (2003) *Public Opinion Survey: Integrated Education in Northern Ireland*, June 2003, Belfast: NICIE.

Monteith, M. and McLaughlin, E. (2004) *The Bottom Line* Belfast: Save the Children.

Monteith, M., Lloyd. K. and McKee, P. (2008) *Persistent Child Poverty in Northern Ireland: Key Findings* Belfast: Save the Children.

Muncie, J. (1996) 'The Construction and Reconstruction of Crime' in J. Muncie and E. McLaughlin (eds) *The Problem of Crime* London: Sage, pp7-41.

Muncie, J. (1999) *Youth and Crime: A Critical Introduction* London: Sage.

Muncie, J. and Fitzgerald, M. (1981) 'Humanizing the deviant: affinity and affiliation theories' in M. Fitzgerald, G. McLennan and J. Pawson (eds) *Crime and Society: Readings in History and Theory* London: Routledge & Kegan Paul/ The Open University Press.

Murray, C. (1994) 'The New Victorians … and the New Rabble' *The Sunday Times*, 29 May.

Northern Ireland Executive (2007) *Children and young people to have their say*, Press Release, 25 September 2007 (www.northernireland.gov.uk/news/news-ofmdfm/news-ofmdfm-september-2007/news-ofmdfm-250907-children-and-young.htm).

Northern Ireland Executive (2008a) *Children to take over Stormont Assembly*, Press Release, 30 January 2008 (www.northernireland.gov.uk/news/news-ofmdfm/news-ofmdfm-january-2008/news-ofmdfm-300108-children-to-take.htm).

Northern Ireland Executive (2008b) *Junior Ministers welcome United Nations Rights of Child report*, Press Release, 3 October 2008 (www.northerirleand.gov.uk/news/news-ofmdfm/news-ofmdfm-october-2008/news-ofmdfm-031008-junior-ministers-welcome.htm).

NIHE (Northern Ireland Housing Executive) (2006) *Mixed housing scheme is launched*, 30 October 2006 (www.nihe.gov.uk/index/about-us-home/media_centre/news-2.htm?newsid=6630).

NIHRC (Northern Ireland Human Rights Commission) (2004) *Measures to Tackle Anti-Social Behaviour in Northern Ireland: The Response of the Northern Ireland Human Rights Commission* Belfast: Northern Ireland Human Rights Commission.

NIHRC (Northern Ireland Human Rights Commission) (2008) *A Bill of Rights for Northern Ireland. Advice to the Secretary of State for Northern Ireland*, 10 December 2008, Belfast: NIHRC.

NIO (1998) *Belfast/ Good Friday Agreement* Belfast: Northern Ireland Office (available: www.nio.gov.uk/agreement.pdf).

NIO (2002) *Creating a Safer Northern Ireland through Partnership: A Consultative Paper* Belfast: Community Safety Unit, Northern Ireland Office, April.

NIO (2004) *Measures to Tackle Anti-Social Behaviour in Northern Ireland: A Consultation Document* Belfast: Criminal Justice Policy Branch, Northern Ireland Office.

NIO (2006) *St Andrews Agreement* Belfast: Northern Ireland Office (available: www.nio.gov.uk/st_andrews_agreement.pdf).

NIO/CSU (2008) *Together. Stronger. Safer. Community Safety in Northern Ireland: A consultation paper* Belfast: Northern Ireland Office/ Community Safety Unit.

OFMDFM (Office of the First Minister and Deputy First Minister) (2006) *Our Children and Young People – Our Pledge. A ten year strategy for children and young people in Northern Ireland 2006-2016* Belfast: OFMDFM.

OFMDFM (Office of the First Minister and Deputy First Minister) (2008) *Building a Better Future. Northern Ireland Executive Programme for Government 2008-2011* Belfast: OFMDFM.

O'Rawe, A. (2003) *An Overview of Northern Ireland Child and Adolescent Mental Health Services* Belfast: Children's Law Centre.

Patten, C. (2000) *A New Beginning: Policing in Northern Ireland*, The Report of the Independent Commission on Policing Northern Ireland Belfast: Independent Commission on Policing in Northern Ireland.

Pearson, G. (1983) *Hooligan: A History of Respectable Fears* London: Macmillan.

Pearson, G. (1993/4) 'Youth Crime and Moral Decline: Permissiveness and Tradition' *The Magistrate*, December/January.

PSNI (2009) *Statistics relating to the security situation 1st April 2008-31st March 2009* PSNI Annual Statistics Report No 5 Belfast: PSNI Central Statistics Branch (available: www.psni.police.uk/5._08_09_security_situation.pdf).

Punch, S. (2002) 'Research with children: the same of different from research with adults?' *Childhood*, Vol 19, No 1, pp321-341.

Qvortrup, J. (1994) 'Childhood Matters: An Introduction' in J. Qvortrup et al. (eds) *Childhood Matters: Social Theory, Practice and Politics* Aldershot: Avebury, pp1-23.

Radford, K., Hamilton, J. and Jarman, N. (2005) '"It's Their Word Against Mine": Young People's Attitudes to the Police Complaints Procedure in Northern Ireland' *Children and Society*, Vol 19, pp360-370.

Roberts, K. (1995) *Youth and Employment in Modern Britain* Oxford: Oxford University Press.

Roche, R. (2008) *Sectarianism and Segregation in Urban Northern Ireland: Northern Irish Youth Post-Agreement. A Report on the Facts, Fears and Feelings Project* Belfast: Queens University.

Sadler, J. (2008) 'Implementing the Youth 'Anti-Social Behaviour Agenda': Policing the Ashton Estate' *Youth Justice*, Vol 8, pp57–73.

Save the Children (2007) *A 2020 Vision: Ending Child Poverty in Northern Ireland. Annual Child Poverty Report 2007* Belfast: Save the Children.

Scraton, P. (2007) *Power, Conflict and Criminalisation* London: Routledge

Shirlow, P. (2001) 'Fear and Ethnic Division' *Peace Review*, Vol 13, No 1, pp67-74.

Shirlow, P. (2003) 'Ethno-sectarianism and the reproduction of fear in Belfast' *Capital and Class*, Vol 80, pp77-93.

Shirlow, P. and Murtagh, B. (2006) *Belfast: Segregation, Violence and the City* London: Pluto Press.

Smith C., Stainton Rogers, W. and Tucker, S. (2007) 'Risk' in M. Robb (ed.) *Youth in Context: Framework, Setting and Encounters* London: Sage & The Open University Press, pp219-250.

Smyth, M. et al, (2004) *The Impact of Political Conflict on Children in Northern Ireland* Belfast: Institute for Conflict Research.

Spence, L. (2002) *Unheard Voices – the experiences and needs of the children of Loyalist Political Ex-prisoners* Belfast: EPIC.

Tisdall, E.K.M., Baker, R., Marshall, K., Cleland, A., Plumtree, A. and Williams, J. (2004) *'Voice of the child' Under the Children (Scotland) Act 1995: Volume 2 – Feasibility Study* (www.scotland.gov.uk/cru/kd01/red/voc2-05.asp).

Tomlinson, M. (2007) *The Trouble with Suicide. Mental Health, Suicide and the Northern Ireland Conflict: A Review of the Evidence* Belfast: Queens University.

UK Children's Commissioners (2008) *UK Children's Commissioners' Report to the UN Committee on the Rights of the Child*, June, Belfast: NICCY.

UK Government (2007) *The Consolidated Third and Fourth Periodic Reports of the United Kingdom of Great Britain and Northern Ireland*, 16 July 2007, CRC/C/GBR/4.

UN Committee on the Rights of the Child (2008) *Concluding Observations. United Kingdom of Great Britain and Northern Ireland*, 20 October 2008, CRC/C/GBR/CO/4.

Willow, C. (2008) 'Children's Human Rights' in B. Goldson (ed) *Dictionary of Youth Justice* Cullompton: Willan Publishing.

Wyn, J. and White, R. (1997) *Rethinking Youth* London: Sage.

YouthAction Northern Ireland (2001a) *Work with Young Men in Northern Ireland: Everyday Life – Young Men and Violence Project* Belfast: YouthAction.

YouthAction Northern Ireland (2001b) *Everyday Life: Young men, violence and developing youth work practice in Northern Ireland* Belfast: YouthAction.

Youth Council for Northern Ireland (YCNI) (2004) *Barometer 2004: A Portrait of Young People in Northern Ireland* Belfast: YCNI.

YJB (2006) *The Common Assessment Framework: Asset and Onset. Guidance for Youth Justice Practitioners* London: Youth Justice Board (available at: www.yjb.gov.uk).

YJB/CYPU (2002) *Establishing Youth Inclusion and Support Panels (YISPS): Draft Guidance Note for Children's Fund Partnerships and Youth Offending Teams* London: Youth Justice Board.

YouthNet (1999) *Young Men and Violence Thematic Initiative: Summary* Belfast: YouthNet.